MURDER AT SMALL KOPPIE

MURDER AT SMALL KOPPIE

The Real Story of South Africa's Marikana Massacre

Greg Marinovich

Michigan State University Press
East Lansing

⊚ The paper used in this publication meets the minimum requirements of ANSI/ NISO Z39.48-1992 (R 1997) (Permanence of Paper).

 Michigan State University Press
East Lansing, Michigan 48823-5245

Printed and bound in the United States of America.
27 26 25 24 23 22 21 20 19 18 1 2 3 4 5 6 7 8 9 10

LIBRARY OF CONGRESS CATALOGING-IN-PUBLICATION DATA
Names: Marinovich, Greg, author. | Alegi, Peter, writer of foreword.
Title: Murder at Small Koppie : the real story of South Africa's Marikana massacre / Greg Marinovich.
Other titles: African history and culture.
Description: East Lansing : Michigan State University Press, 2017. | Series: African history and culture | Includes bibliographical references and index.
Identifiers: LCCN 2017012765 | ISBN 9781611862768 (pbk. : alk. paper) | ISBN 9781628953244 (epub) | ISBN 9781628963243 (kindle)
Subjects: LCSH: Massacres—South Africa—Rustenburg. | Strikes and lockouts— Miners—South Africa—Rustenburg. | Miners—South Africa—Rustenburg—So- cial conditions. | Police brutality—South Africa—Rustenburg. | Police shoot- ings—South Africa—Rustenburg.
Classification: LCC HV6535.S63 R87 2017 | DDC 968.074—dc23
LC record available at https://lccn.loc.gov/2017012765

Book design by Ryan Africa
Cover design by Shaun Allshouse, www.shaunallshouse.com
Cover photo: 'Bhele' Tholakele Dlunga shows how he was tortured by police while in custody 1 November 2012, as part of what seems to be a systematic intimidation campaign against witnesses to the Marikana Massacre of August 16th. (Photo Greg Marinovich.)

g green press INITIATIVE Michigan State University Press is a member of the Green Press Initiative and is committed to developing and encouraging ecologically responsible publishing practices. For more information about the Green Press Initiative and the use of recycled paper in book publishing, please visit *www.greenpressinitiative.org*.

Visit Michigan State University Press at
www.msupress.org

To Luc and Madeline

Contents

Foreword

Peter Alegi

The morning of 16 August 2012, I was in my campus office in East Lansing when my Twitter timeline suddenly exploded with shocking news from South Africa: police had gunned down mineworkers on strike at the Lonmin platinum mine in Marikana. Within minutes, gut-wrenching photographs of the carnage and video footage of the shooting appeared online. I sat in front of the computer utterly transfixed. The pop-pop-pop-pop coming from a thick line of heavily armed police officers; the bodies of black miners dropping to the ground in a cloud of dust; the deathly silence that followed a white police officer's order to "Cease fire!" My eyes welled with tears. The police massacre of thirty-four miners at Marikana struck at the heart and soul of a country whose long, painful, and ultimately victorious anti-apartheid struggle buried white minority rule in the early 1990s and replaced it with a parliamentary democracy led by Nelson Mandela, possibly the world's most respected political leader. As a professional historian of South Africa, the Marikana Massacre struck me as an atrocity eerily reminiscent of the Sharpeville Massacre of 21 March 1960—a watershed moment in the nation's history that triggered the liberation movement's turn to violent resistance and the rise of a police state.

To begin to make sense of the awful events taking place on South Africa's platinum belt, which produces about three-quarters of the world's platinum, I relied on Greg Marinovich, a Pulitzer Prize–winning photojournalist, and a few other local journalists present in Marikana. Marinovich had been reporting on the miners' strike for several days before the massacre, mainly for the *Daily Maverick* online newspaper. Upon arrival he found as many as 3,000 strikers sitting on a rocky outcrop on public land between the mine and the shack settlements that many miners called

home. In an *Africa Past and Present* podcast interview, Marinovich told Peter Limb and me that he realized immediately that this strike was unusual: "Men with blankets and handmade spears, knives and such. . . . It looked very filmic. It looked like a movie set in some ways. It was beautiful. The light was great. There was singing and chanting." The tension, however, was palpable. "There was that edge of violence," Marinovich said. "As you drove up you passed all these heavily armed cops in SWAT-type uniforms. There was certainly a sense of foreboding," he recalled. The black miners, who were demanding a large wage increase to R12,500 [approximately $1,500], granted Marinovich, a white South African, interviews and allowed him to take photographs.

While *Murder at Small Koppie* is not the definitive account of the Marikana massacre, it is one of the most illuminating books about contemporary South Africa to come out in recent years. This North American edition will appeal to both academic specialists and general readers interested in the anatomy of the massacre and in the wider social, political, and economic context in which it took place. The opening chapters of Marinovich's book ably demonstrate how the rock-drill operators' strike of August 2012 did not happen in an historical vacuum. Twentieth-century segregation and apartheid bequeathed an ongoing collusion between mining conglomerates and the state at the expense of black male migrant workers from materially impoverished rural communities. Vivid descriptions of the dangerous and gendered nature of underground mining are helpful in underscoring the changing hierarchies between ordinary workers and how multinational corporations and the promise of post-apartheid riches effectively coopted ties between the ruling African National Congress (ANC) and the National Union of Mineworkers (NUM), until recently the country's largest labor union. The complex and controversial figure of Cyril Ramaphosa, the current deputy president of South Africa, looms large in this context. After leaving politics, where he had proven himself as a NUM leader in the 1980s and as the ANC's chief negotiator in the early 1990s, Ramaphosa became fabulously wealthy and joined numerous corporate boards, including Lonmin's. His position and influence exacerbated the bitter rivalry between the NUM and the upstart Association of Mineworkers and Construction Union, an antagonism that poured fuel on the fire of worker resentment at Marikana.

Murder at Small Koppie's painstakingly researched forensic account of the massacre represents the book's second major contribution to our knowledge and understanding of Marikana. Each day of the strike receives comprehensive treatment in chronologically organized chapters. Written in lively prose, these chapters tell the story of who did what, when, where, and why. The methodology blends investigative journalism, history, sociology, and political analysis. A rich and diverse source base supplies the empirical and ethnographic evidence. The author's personal observations, oral interviews, and stunning photographs are complemented by media accounts and government records, none more valuable than the trove of written and multimedia evidence from the Marikana Commission of Inquiry, including its final report submitted to President Jacob Zuma in March 2015. (This report was released to the public, after much controversy, two months later.) The revelation that police killed seventeen miners at Scene 2 (the "Small Koppie" in the book's title), one thousand feet away from the killings at Scene 1 witnessed around the world, is explored in gruesome detail. A whistleblower's tip to commission investigators revealed that authorities' decision to break up the strike was made known at an "extraordinary meeting" of the monthly National Police Management Forum on 15 August 2012, the day before the massacre. The authorities ordered four thousand rounds of ammunition, razor wire, and four mortuary vans to be delivered to Marikana. This startling evidence and the subsequent police cover-up of the secret meeting's audio recording and minutes raised a deeply troubling question: Was the massacre premeditated? The closing chapters grapple with the human, material, and ideological consequences of the massacre. The focus is on police torture of survivors, assassinations, the crucial role of women supporters of the strike, and the pyrrhic quality of winning a relatively small salary increase at a time of layoffs.

The book's third significant contribution is its steadfast refusal to romanticize the victims. Throughout, *Murder at Small Koppie* portrays miners as three-dimensional flesh-and-blood human beings with distinct biographies and motivations, attributes and flaws, ambiguities and contradictions. In fact, the book carefully unpacks the category of "strikers," presenting them respectively as drill operators mainly from Pondoland, Eastern Cape province, divided into several groups: strike leaders, none more charismatic than Mambush Noki, the soccer-playing

"Man in the Green Blanket" (the subject of a particularly splendid chapter); a hardcore group of several hundred strikers who dutifully remained on the koppie for five days; and the rest of the rank-and-file miners, many of whom moved back and forth between the koppie and their humble homes nearby. To the book's credit, the strikers are not portrayed as angels. It is noted how their actions contributed to the escalating tension and violence in the lead up to the massacre. Angered by management's obstinate refusal to negotiate and by Lonmin security guards' use of rubber bullets, miners killed six people, including two police officers, while the police, in turn, killed two miners. The same fairness and objectivity is afforded to a representative sample of the members of the NUM, Lonmin management and security, and police officers on the scene. Toward the end of the book, the author returns many times to Marikana and earns the friendship and trust of traumatized survivors. Long after the media spotlight has faded, Marinovich takes readers along with him into the zinc shacks and hostels where miners eke out a living and work tirelessly to support two families: one at the mine and one back home in the rural areas. By telling the stories of how workers made their own history to a significant extent, the book humanizes the miners and generates empathy for the victims.

The fourth contribution made by *Murder at Small Koppie* is its implicit and explicit demonstration that the massacre is "bigger than Marikana itself," as Sean Jacobs and Daniel Magaziner wrote in an August 2012 article in *The Atlantic* online. This book highlights how South Africa's platinum mines are enmeshed in a dialectic process in which the structure of the global political economy shapes, and is shaped by, local conditions and interests. In this way, *Murder at Small Koppie* de-exceptionalizes South Africa without marginalizing the tangible legacies of the apartheid past, the enduring importance of migrant labor, and various other micro-level factors. Marinovich's powerful truth-telling narrative raises fundamental questions about social justice, human rights, race, class, gender, and power. In a twenty-first-century world marked by extreme inequality, widespread insecurity, and structural violence, the story of the Marikana massacre resonates locally and globally.

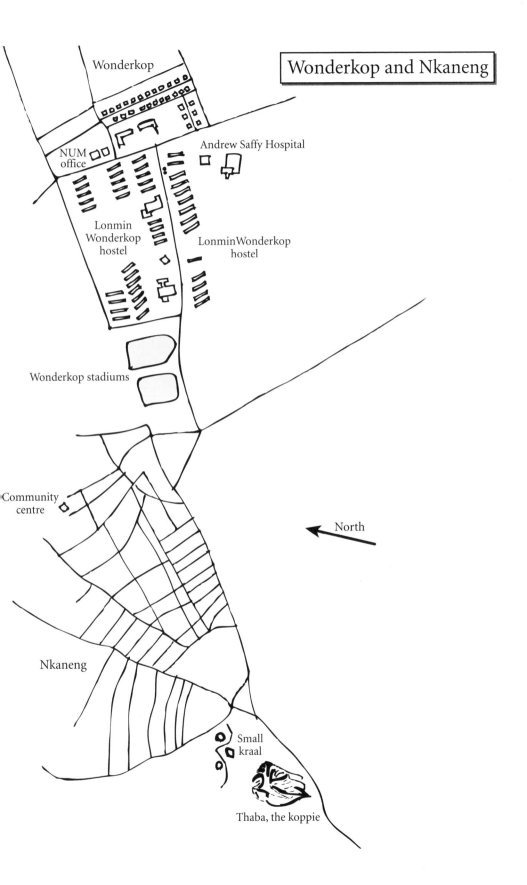

Wonderkop and Nkaneng

Wonderkop

NUM office

Andrew Saffy Hospital

Lonmin Wonderkop hostel

Lonmin Wonderkop hostel

Wonderkop stadiums

Community centre

North

Nkaneng

Small kraal

Thaba, the koppie

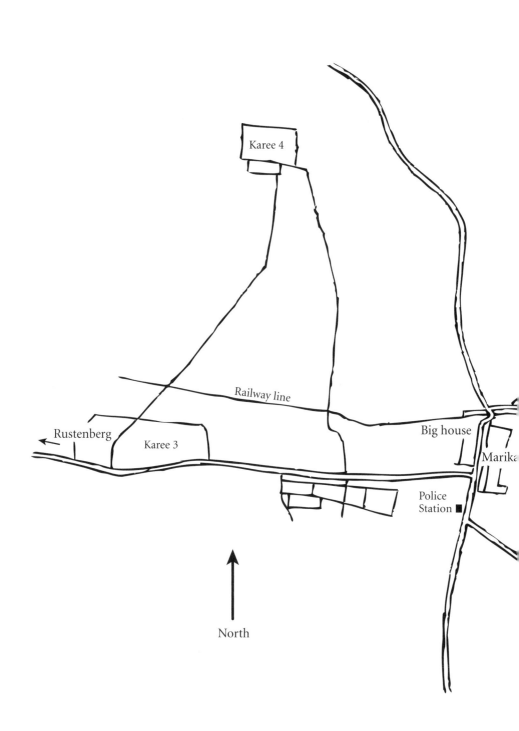

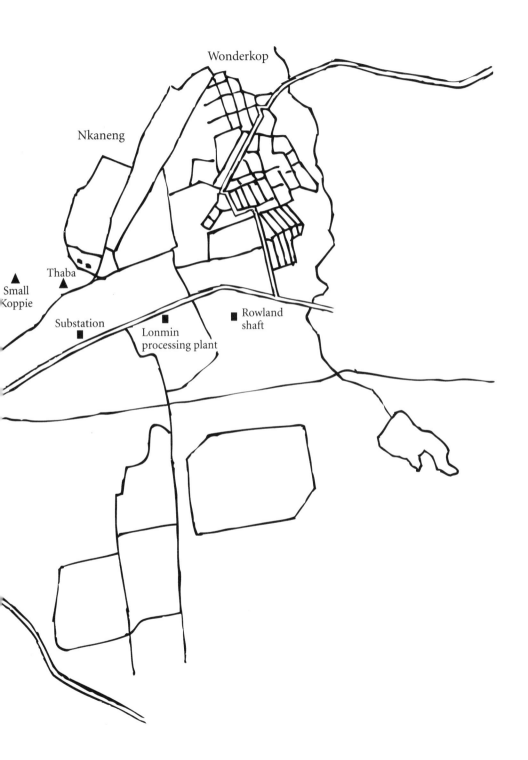

Marikana Area

Wonderkop

Nkaneng

Thaba

Small Koppie

Substation

Lonmin processing plant

Rowland shaft

Wonderkop Hostel, Taxi Rank and NUM Office

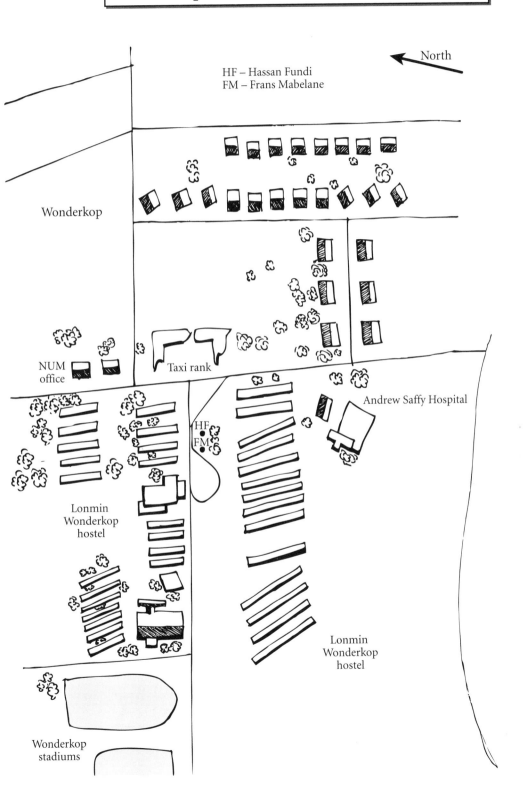

North

HF – Hassan Fundi
FM – Frans Mabelane

Wonderkop

NUM office

Taxi rank

Andrew Saffy Hospital

HF
FM

Lonmin Wonderkop hostel

Lonmin Wonderkop hostel

Wonderkop stadiums

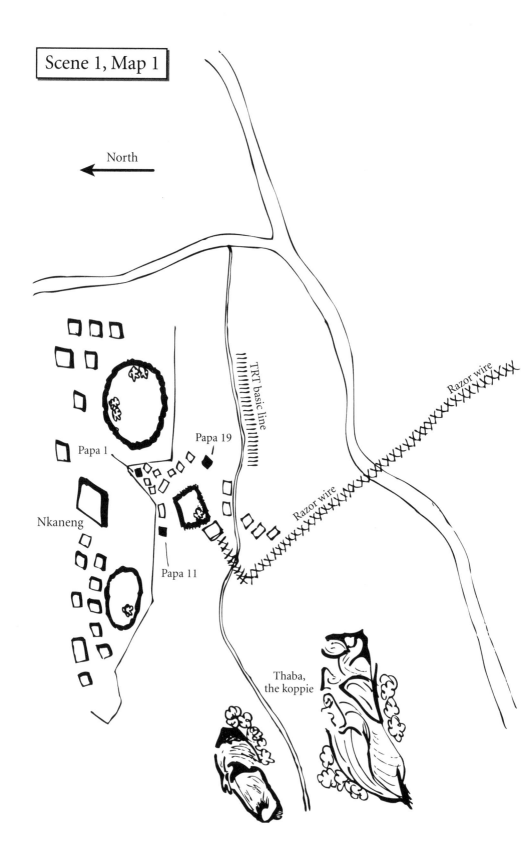

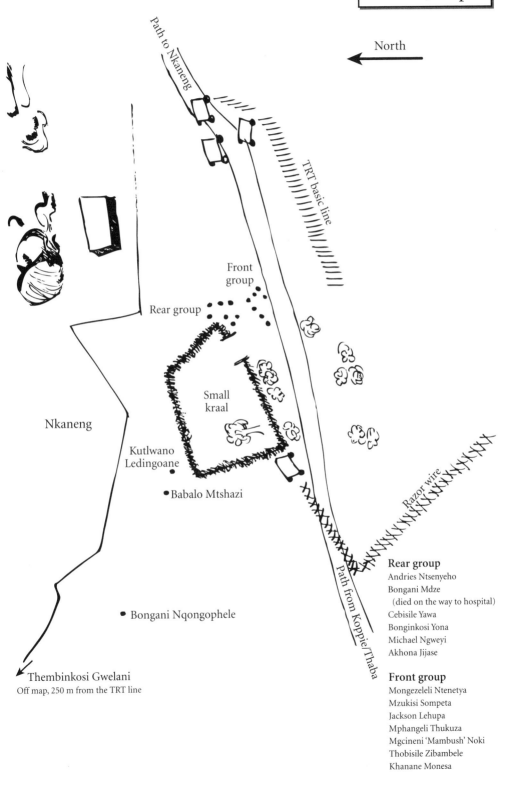

Scene 1, Map 2

North

Path to Nkaneng

TRT basic line

Front group

Rear group

Small kraal

Nkaneng

Kutlwano Ledingoane

Babalo Mtshazi

Bongani Nqongophele

Path from Koppie/Thaba

Razor wire

Thembinkosi Gwelani
Off map, 250 m from the TRT line

Rear group
Andries Ntsenyeho
Bongani Mdze
 (died on the way to hospital)
Cebisile Yawa
Bonginkosi Yona
Michael Ngweyi
Akhona Jijase

Front group
Mongezeleli Ntenetya
Mzukisi Sompeta
Jackson Lehupa
Mphangeli Thukuza
Mgcineni 'Mambush' Noki
Thobisile Zibambele
Khanane Monesa

Scene 2, Thaba Nyana, Small Koppie

Shotgun ━━━━
R5 rifle ━━━
Pistol ━

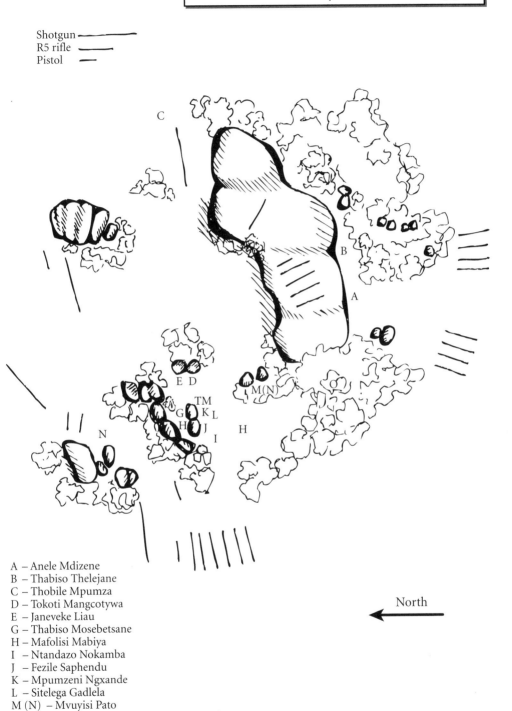

North

A – Anele Mdizene
B – Thabiso Thelejane
C – Thobile Mpumza
D – Tokoti Mangcotywa
E – Janeveke Liau
G – Thabiso Mosebetsane
H – Mafolisi Mabiya
I – Ntandazo Nokamba
J – Fezile Saphendu
K – Mpumzeni Ngxande
L – Sitelega Gadlela
M (N) – Mvuyisi Pato
N – Makhosandile Mkhonjwa (Mkhonyane?)
O – Nkosiyabo Xalabile
TM – Telang Mohai (died on the way to hospital)
Modisaotsile Sagalala and Molefi Ntsoele also died on the
way to hospital. It is not known where they were shot.

Introduction

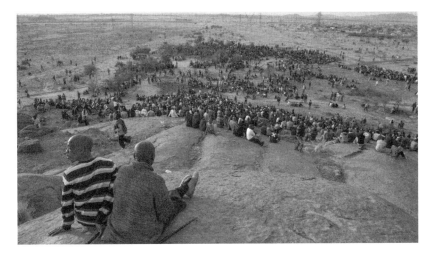

Striking miners gather on and around Thaba, with Nkaneng in the background, Marikana, 15 August 2012.

'The invisibility of the poor: when noticed they are met with violence.'
– Nomzamo Zondo, director of litigation, Socio-Economic
Rights Institute of South Africa (SERI)[1]

T he koppie was a place imbued with power. During the rock drillers'
strike of 2012, this low hill at Marikana was a space jealously guarded
from contamination, where no one dared wear a hat or carry a cellphone;
women were prohibited. To point with a finger earned an instant reproach
– on that sacred ground only a fist could be used to point. Even proffered
handshakes were shunned silently, a dark look settling on miners' faces
when approached with an outstretched hand. The power of the magic was
not to be trifled with; breaching a host of taboos could dilute it, or endanger
the transgressor.

It was this hill that the early Afrikaners had long ago called Wonderkop
– which can best be translated as 'hill of marvels or magic', though the
intentions of the original Boers who named it are lost to us.[2] When the
setting sun caused the rock to turn blood-red, it indeed seemed to be a site
of enchanted potency. The striking miners thought of the koppie as a place
where the otherwise god-like reach of the mine ran out. It was their redoubt,
a place where they felt like *men*. Here, they were not *malaishas*,[3] drillers or
chisaboys;[4] not *boys* of any kind.

Yet as they left the koppie on that fateful late-winter's day, its protec-
tion grew feeble, even if the striking miners did not yet realise it. As the
sparkling coils of razor wire were rolled out, the miners were forced to run a
gauntlet of police gunfire to escape arrest. They were prepared to withstand
the thunderous double crack of the stun grenades, the fierce bite of the tear
gas and the painful impact of rubber bullets fired at close range. Drillers
have more physical fortitude than most; perhaps those who choose this
work are born with hearts so stout, perhaps they acquire it while labouring
underground in conditions beyond our comprehension. Yet nothing could

1 Zondo was speaking at the *Daily Maverick*'s 'The Gathering', Johannesburg, 2015.
2 There are innumerable hills or mountains named Wonderkop across South Africa,
 sometimes named thus because of a geographic or geological feature that evoked wonder, or
 based on the legend of a miraculous or wondrous event that was said to have taken place
 there. The Afrikaans word *wonder* is translated as 'wonder', 'marvel' or 'magic', while
 wonderwerk means 'miracle'.
3 Fanagalo for 'the person who wields the shovel', the lowest-grade worker in the underground
 social hierarchy.
4 Fanagalo for 'assistant miner'; literally 'fire or hot boy'.

prepare them for the terrible fusillade emerging from the funnel of police vehicles, which ripped through muscle and bone, hundreds of high-velocity bullets tearing through legs, chests and skulls, and kicking up a cloud of beige dust like a curtain.

A single, strangled cry of 'Cease fire!' from a lone policeman with a jammed weapon triggered a chain of calls that finally stilled the gunfire. As the dust settled back onto the men prone on the blood-drenched earth, nothing would ever be the same again. It was as if the nation had spent eighteen years dreaming of an idealised society only to be violently awoken to a living nightmare.

As horrifying as the televised killings were, there was worse that happened out of sight, at a jumble of rock and thorn trees not imbued with any symbolism other than that it being an open-air latrine for nearby shack dwellers. The place was dismissively known as Small Koppie, or Thaba Nyana, if people acknowledged it had a name at all.

The winter shadows were long, blue and deep by the time police encircled the men seeking refuge there. None of the miners expected this forlorn site to be the place where they would face execution at the hands of police out to avenge their slain fellow officers, themselves pawns in a high-stakes game of neglect and oppression that allowed both the state and big business to benefit from a perpetually impoverished citizenry.

The Marikana massacre swiftly became a platform for all types of opportunists to exploit, and for the state to belittle the extrajudicial executions as an unfortunate incident provoked by criminals. Activists and civil society who had been quiescent for too long were jolted into action. People of conscience, from veteran human rights activist George Bizos to grassroots activists too young to have experienced apartheid *kragdadigheid*,[5] were galvanised. Many of these well-intentioned people failed to understand, or perhaps chose to ignore, just how brutalising it is to endure a lifetime of scrambling to survive, and tried to gloss over the acts of violence perpetrated by the striking miners themselves, lest it undermine their struggle. Violence was an essential component of the drillers' strike. South Africa continues to be one of the world's most physically, economically, socially and psychologically fractured states. The poor are politically, commercially and socially invisible until they force themselves into view. The only way

5 An apartheid-era South African policy of using brute force to quell political opposition; Afrikaans, meaning 'forcefulness'.

that neglected and impoverished communities ever manage to break the spell of invisibility is when they use sufficient violence to be noticed. An evocatively titled paper, 'The smoke that calls',[6] encapsulates the political struggle for visibility, as does the otherwise incomprehensible phenomenon of *Izikhothane*[7] publicly burning money and designer clothes they only wear once. That boys who live in their grandmothers' Reconstruction and Development Programme (RDP) houses can show off how easily they can replace the materially desirable is a result of the psychological damage of poverty juxtaposed with extreme wealth. In the same vein, the miners' rejection of their invisibility demanded that they be publicly annihilated. It was just politics, and economics.

I first began to understand properly what had occurred at Marikana's Small Koppie, or Scene 2, while standing in a low granite defile, stooping to avoid thorn-covered branches and trying not to stand on the rich, blood-steeped soil where Henry Mvuyisi Pato died, shot through the back of his neck with an R5 bullet. That death was marked with a spray of fluorescent yellow-green paint on an ancient boulder. Once I understood that the letter N stood for the disappeared remains of a human being,[8] I began to see each and every one of those crime-scene signifiers for what they were: the bloody remains of miners' bodies marked by an almost incomprehensible alphabet. It was the first step towards unravelling the dual massacres of Marikana, and the state's cover-up of the police's deadly labour. Yet this spectacle of brutality, a contemporary adaptation of human sacrifice, a part of which resonated around the world within minutes, did not purge either Lonmin or the ruling party and its abetters of their opponents. Marikana has instead become a rallying cry against the collusion of parasitic elites. The echoes of those gunshots have not yet stilled.

6 Karl von Holdt, Malose Langa, Sepetla Molapo, Nomfundo Mogapi, Kindiza Ngubeni, Jacob Dlamini and Adele Kirsten, 'The smoke that calls: Insurgent citizenship, collective violence and the struggle for a place in the new South Africa', Society, Work & Development Institute, 2011. Available at http://www.wits.ac.za/humanities/17416/ (last accessed September 2015).

7 From the isiZulu word meaning 'bush', it is now township slang referring to impoverished gangs of youth who live extravagant lifestyles.

8 The N was mistakenly painted instead of M, the correct designation of Pato's body.

1

Underground City

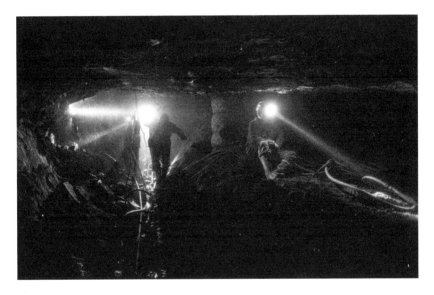

A supervisor sits while loose rock is blasted off the hanging wall or ceiling before drilling begins. Level 31, Rowland shaft, Lonmin mine, Marikana, North West province, 2013.

'If I go to the mines, where shall I find the courage to get into the cage?'
— Extract from a Mozambican Chopi migrant
miners' song, recorded by Hugh Tracey

L ines of men in heavy-duty white cotton overalls stride swiftly in thick rubber boots along the eroded pathways that criss-cross the loamy Bushveld soil. They join to form larger streams in the pre-dawn dark, and finally become broad white rivers that pour into the mine shaft complexes marked by tall headgear, the vertical structural frames where thousands of metres of thick steel cable await, tightly wound onto massive iron wheels. The chill winter wind whips away the topsoil kicked up by thousands of hurrying feet. Their destination is the lamp room, where they are slowed by a bottleneck at the turnstiles. A low wall separates them from management's single-storey offices, from where the rich aroma of freshly brewed coffee drifts into the cold corridor. In the rudimentary boardroom at Lonmin's Rowland shaft, the coffee drips into a glass jug. A cheap wooden table and sturdy office chairs crowd the room, which is dominated by a series of unfathomable maps and schematics running the length of one wall. The charts with their coloured key and pins trace where the ingenuity of man chases the narrow reefs of precious ore. It looks ordered, manageable.

Once kitted with the lamps that fit on the front of their white helmets, the miners wait to squeeze through the next turnstile, where their plastic identity cards clock them into another working day. They follow the met-alled corridors marked by the anodyne official graffiti that repeats the safety mantra, and then they are back outdoors, braving the chill as they await their turn to step beneath the headgear into the cavernous elevator shaft that will carry them down into the deep. Some of the miners crowding into the cage elevator have sweaters and jackets over their overalls; others seem not to feel winter's bite. Down below, in that vast subterranean world, there are no seasons; yet the climate is as varied as above.

The elevator, known as the cage, is big enough to carry a company of a hundred men. Once full, it swiftly leaves the pale winter sunlight, descending to the underworld. As it passes each level, a pall of greenish light washes over the miners crammed inside. The men face the cage's steel roller door. Almost all have switched off their headlamps; a lone light skitters uncertainly over the other helmets, now and then catching an indistinguishable profile. Men drop their chins onto their chests, avoiding the blinding glare. As the lift drops, a few talk in low voices, but most say nothing, isolated with their thoughts. The rush of the descending cage washes icy air over them, and they press against the welcome warmth of their fellows.

The descent ceases abruptly and the steel door opens, spilling men into a spacious cavern. As the miners surge forward, the whine of the massive fans that drive chilled air downwards is deafening. The wind whips at loose bits of clothing and thrusts its icy tendrils into every opening; hands grip at exposed throats to keep out the cold. The men either rush or stoically walk away from the most intense wind, where the elevator shaft intersects with the vast chambers below the earth. Almost imperceptibly flickering fluorescent lights illuminate the grey-painted tunnels that wind and slope away. Further down these tunnels, the wind eases, slowing against the hot humid air rising from the depths.

The miners walk along seemingly endless clean, well-lit corridors. Painted pipes of varying diameter carry water and perhaps other necessities of mining from the shaft out to the working areas. Brightly coloured mini locomotives flash safety lights as they slowly trundle past. The engineering here is an exemplar of late-industrial mining. Soft clanking alerts the miners that they are nearing the chairlift station, where they are required to swing themselves onto hanging question marks of steel tubing with tricycle-like seats. African pop – Zahara's 'Umthwalo wam' – plays out loudly from speakers as the seats sway off, one after the next. The conveyor takes the miners down several more levels to the depths of Rowland shaft – a thousand metres below the surface at level 31. At the last station, the miners deftly climb off and head deeper into the mine. Within a short distance, the brightness gives way to a dark lit only by the stabbing headlamps of walking men. Their faces are rendered invisible beneath the glare of the light on their safety helmets. Here, the atmosphere grows increasingly warm and humid as the refrigerated air peters out in the warren of small, cramped tunnels. Sweat begins to roll down faces and darken armpits. The neatly painted walls give way to rough-hewn rock, and the going underfoot becomes trickier.

It is impossible to walk upright. An occasional hanging lightbulb illuminates a juncture between low tunnels. All is a maze; the neatly drafted maps from the shaft office above ground make no sense here, at least not for the uninitiated. The men duck under low-hanging cables and pipes, skirt mud pools, and step over channels of rushing water before climbing up steel ladders into ever more cramped spaces. Following the beam of one's headlamp induces a vague nausea. In that labyrinth, a miner tells of his secret delight. Every day on his way to work, he thinks about the people whose business does not carry them below, and is thrilled that they have no idea of what lies hidden beneath their feet. For those who have undergone that second initiation into a select manhood, the journey from above to below ground is a transformative one.

Finally, they arrive at the stopes, deep shelves that resemble caves like those in which hominids first sheltered in the nearby Magaliesberg. It is here that the platinum-bearing ore is torn from the rock. The men shed their warm clothing, dressed only in their clean white overalls, thick rubber boots and plastic helmets. At the start of the shift, the stope is oppressively hot and dank, but bearable. Soon that will change. Most of the men eventually strip off their overalls and don rags in which to work, to avoid the grease and mud that irredeemably sully their gear.

There is a meeting between the shift boss and the various workers, in which they run through the safety reminders and production goals for the shift. The safety drill is repeated by rote, the enthusiasm saved for the production target and bonuses. Some of the men pry open galvanised-steel *skaf'tins* and savour their packed lunch. Others aim powerful streams of water from thick rubber pipes at the roof and walls to blast away any debris that might vibrate loose. Pickaxes test the rock. The air slowly grows, improbably, more humid. The general noise, already unnerving to a neophyte, is punctuated by jets of water onto rock, an unexpected hiss and a roar combined into a single sound. The team leader paints Xs on the exact places on the rock face where holes must be drilled for the explosives.[1] The atmosphere by now is akin to that inside a steam room. He then sprays a fine mist of aluminium particles into the air as a malaisha counts off how long it takes the metal dust to drift. The little cloud moves sluggishly, almost imperceptibly, yet it is enough to satisfy the legal safety requirement for ventilation.

1 Only a mineworker who has a blasting certificate can do this. It was a job previously forbidden to black Africans.

Now is the time of the hard men. The drillers have been reclining against the mounds of rock and earthen debris, watching with a feline stillness. In a hunched stoop, they drag the heavy hydraulic drills and the water and air hoses into the ever-narrower space of the stope.

Everyone else recedes into a support role as the rock drill operators take centre stage. None wear overalls, and one driller uses thick plastic wrapping as a rudimentary over-nappy to stay dry as he sits in the mud behind his machine. They fiddle, fixing inscrutable things with bent pieces of heavy-duty wire. Suddenly, an air hose bursts off a machine, shooting blinding bits of fine gravel as it whips around the stope. Men leap to escape the debris, fearing the worst. A driller calmly steps forward, grasps the hose and forces it back onto the drill, fixing it in place with a bit of scrap wire. It is a minor incident, yet one man's safety glasses are smashed from the driven rock particles.

Bent double under the low overhang, hard men start their drills and bedlam ensues. An infernal din that drowns out every other sound takes over the cramped stope. All human communication is reduced to hand signals and the rapid shake of headlamps to attract one another's attention, the miner's nod. A mist of rock dust and water begins to fill the cavern. The psychic shock of that level of noise cannot be anticipated. So consuming is the bone-deep vibration that it seems as if you could lose a finger and not notice it. If the underground mine is indeed a city, as in that miner's fanciful imaginings, then these stopes are its slums.

2

Of Sissies and Men

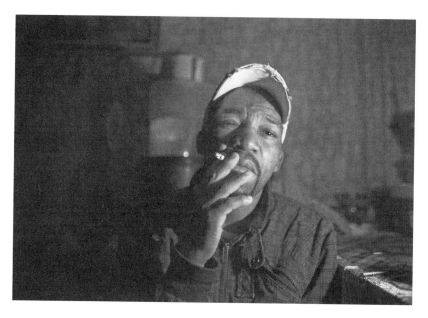

Shadrack Mtshamba smokes by the light of a paraffin lamp in the corrugated-iron room he occupied in 2012, at the Big House slum on the outskirts of Marikana.

'Going to be black, if white.'
— Shadrack Mtshamba, Lonmin rock driller,
on wearing white overalls underground

M arikana boasts a single patchwork tar road on which banks and chain supermarkets jostle for attention alongside Chinese general dealers and Pakistani hardware stores. On a cool spring day in 2012, a slight man of medium height wearing a fraying white cap picks his way between groups of migrant women with ochre-marked cheeks gossiping loudly. Lethargic security guards watch over an array of wares spilling onto the grimy concrete sidewalk. On the corner the man hesitates, looking down the dirt road branching off to his left. That way is the shortest route home, but choosing the best route to the single-roomed shack that Shadrack Mtshamba calls home is usually weather dependent.

During the dry season, when the probing winds of winter carry a choking mixture of fine dust and acidic smog from the smelter, there are several paths he can take. The shortest route follows a gravel shoulder alongside the railway tracks for a while, before taking a raised road up over the tracks. From there it is a little more than a hundred metres to his door, but on that last stretch, Mtshamba has to make his way past a large, reeking black pool of sewage leaking from a never-repaired broken pipe somewhere below the dirt road. Sometimes the pool shrinks, allowing easy enough passage along its edge. At other times, it stretches across the entire width of the road. A series of unevenly spaced rocks allows Mtshamba to pick his way carefully across, or he can gingerly make his way along the edge, only getting sewage on the soles of his shoes. Vehicles make their way through in low gear, keeping enough momentum going to avoid getting stuck but not moving fast enough to cause the pool's pungent water to splash up. That dense stench of festering human excrement sits fog-like over the closely packed shacks. This is not Mtshamba's sewage; he has no plumbing. The

stink of other people's forgotten faeces is a constant reminder of the amenities he lacks.

Sometimes Mtshamba simply chooses the longer route, but in the rainy season, the violent downpours turn the earth into glutinously thick mud that adheres to his boots. Every step weighs him down more, until he feels he can go no further. Nearer his home, it is a matter of navigating between muddy furrows dug by passing vehicles, trying not to slip into the turbid water that pools in every hollow.

Mtshamba lives on a tiny plot of land a stone's throw from the sewage pool. The inhabitants share a single long-drop pit latrine enclosed by a dilapidated corrugated-iron structure that stands just outside the entrance to the yard. The smell here is quite different from that of the sewage: less loathsome to inhale, but still distinctly that of human shit. On the plot, his landlord has erected two long and crudely constructed sheds of corrugated iron. Painted dark green, each shed is divided into six small rooms, with their doors opening onto a narrow strip of dirt separating the sheds. Discarded fragments of polished granite slabs from nearby quarries serve as stepping stones for when it rains, and stumbling blocks to drunks when it is dry. Any configuration of such rudimentary compounds is locally known as a line. Mtshamba's windowless room is the last on the right. Most of the floor space is consumed by a double bed with a coral-coloured duvet. The floor is a slab of rough concrete, and the corrugated-iron walls are bare of any insulation save a voile curtain. The roof has no ceiling.

That early September, Mtshamba is finally home again. Throughout the long dry winter of 2012, he has taken the shorter route, but soon he will once again have to find the least treacherous way to his door. The air is heavy and flies move indolently. With a sudden chill downdraught, the first storm of the rainy season sweeps across Marikana. The crash of hailstones on the roof drowns out any possibility of conversation. Mtshamba slowly rolls a cigarette from loose tobacco, then lights it. He squints as the smoke rises past his eyes; one leg is comfortably crossed over the other. A single paraffin lamp illuminates the room. The smell of cheap cooking fuel permeates the air, making it difficult to identify what bubbles gently in a battered aluminium pot atop the paraffin stove. Suddenly Mtshamba springs up, grabbing a plastic washbasin to catch the stream of water now leaking from the roof, soaking his bed.

Mtshamba is a Lonmin rock drill operator, one of the rough princes of the underground. These are the men whose nerve, perseverance and

strength are essential to extracting platinum ore from deep under the earth. The drillers are members of a macho subculture – a cult of manliness. Once the hailstorm has ceased, Mtshamba puts it plainly: 'You are a strong man if you are a driller. If you are not a driller, you are a sissy man.'

The notion of men as opposed to sissies is well established on the mines. In the bars and shebeens of mining settlements, the rock drillers observe a strict hierarchy. As Mtshamba explains, 'They say you don't drink with them if you're not a rock driller. Malaishas are not man enough to drink with them, they must drink on the other side.'

Mtshamba is in many ways the quintessential driller. His grandfather left his ancestral home in the Pondoland area of the Eastern Cape to find work on the gold mines. He started at the then thriving mining town of Barberton in the malarial eastern lowveld of South Africa, before slowly making his way west, hopping from mine to mine along the gold-bearing Witwatersrand reef to its most westerly reach in the Western Transvaal town of Klerksdorp. It was here that he settled, eventually leaving mining and taking work as a farm labourer in the area. His son, Mtshamba's father, was also a gold miner for a time, albeit briefly, before he too settled for a lower-paying but less deadly life on the farms.

Mtshamba grew up in a world of manual labour and grinding poverty; a life marked by varying degrees of privation, underpinned by the institutionalised violence and humiliation that was the lot of a black person in apartheid South Africa. It was inevitable that he would try a stint on the mines. Yet, unlike his father and grandfather before him, he stuck with it. In the winter of 2011, just over a year before the Marikana massacre, Mtshamba was between jobs. He had been let go from a uranium mine and was at home near Klerksdorp with his wife and three children.

Just as he was getting desperate, recruiters for Lonmin plc came looking for experienced hard-rock drillers, known as RDOs.[1] Mtshamba, like hundreds of others, eagerly applied. It was on the three-hour bus ride to Marikana that he met a man who would become his neighbour and closest friend. Jackson Mjiki had been working at the Vaal Ridge gold mine, but applied to Lonmin anyway as he had heard that the platinum belt paid better. Mtshamba and Mjiki didn't know each other then, but they noticed one another in the bus that transported the new recruits from Klerksdorp to the Karee hostel at Marikana. They went through the same induction

1 Rock drill operators.

process, where an exchange of nods led to a few words being spoken, allowing them to recognise that they were both isiXhosa-speakers. When they were assigned to the same shaft, their friendship took root. Both were strangers in this place, where thieves and con men roamed the shantytowns looking for easy marks. They each needed a trustworthy friend to watch their backs in the rough drinking joints and eateries, and decided to seek housing near one another. They took a pair of rooms opposite each other in the green-painted compound of a slum known as the Big House.

Their lives took on a rhythm. Every workday – Monday to Friday and two Saturdays a month – Mtshamba and Mjiki would rise well before first light and wash swiftly in plastic basins balanced on old beer crates. Their girlfriends made them tea on the paraffin stoves, served with a couple of thick slices of bread or a few handfuls of leftover cold porridge, before they walked to the shaft.

In the world of hard-rock mining, be it gold or platinum, it is mostly the isiXhosa-speaking amaPondo and Bomvana, and the Basotho from Lesotho, who choose the back-breaking and dangerous work of rock drill operators. They see it as labour worthy of a man. Underground work, and especially drilling, is work few are willing to take on. A gold-mining company once decided that they wanted to employ drillers who had finished school and were functionally literate, a change from the rough peasants who had been doing the job for over a century and a half. The mine proceeded to recruit a hundred unemployed young men from Soweto to train and work as drillers. Only one of them lasted beyond two weeks before he too quit.

A generation ago, drilling was seen as prestigious labour. That was when the value of the South African rand was high and the men tasked with drilling into the hard ore deep underground were well paid in comparison to other mineworkers. The combination of hours of arduous labour and an abundance of good food ensured RDOs were noticeably more muscular than other miners. Mtshamba recalls, 'In the olden times, our fathers who were working in the mines were recognised as being a driller, just while walking, coming this way. They had necks like bulls. You could see this one was a driller.'

The drillers always had folding money in their pockets, and ate well at the mine hostels and rough eateries serving *shisanyama* and *pap* (braai meat and maize porridge). Back home, they married well, and had a desirable *nyatsi* (girlfriend) near the mine. The drillers in today's mines are not the Herculean men of old. While a few are noticeably muscular, most would

not draw a second glance in the street. If people saw Mtshamba walking down a road, it is doubtful they would take him for a machine driller. He is a slight man. 'Some judge you by your weight. I'm only sixty-two kilograms; they say, "Why are you so thin but you are doing this job?" I just tell them I am an RDO and I enjoy that job, and I know that when I wake up there is nothing I will do but to just drill the machine.' Innovations in drilling technology have made the work less taxing, yet the basic need for brute force over many hours, day in and day out, has not changed. The reason that Mtshamba gives for not matching up to the bruisers of his childhood is that drillers can no longer earn enough to afford the food for bulking up. 'Now we get less pay. We are working a heavy job, with lots of stress. We earn peanuts and can't afford meat every day. That is why we are thin.'

The unionisation of black mineworkers under the National Union of Mineworkers (NUM) in the late 1980s saw a gradual equalisation of pay for all the various underground jobs below the supervisory grades. This was a good thing for miserably paid general workers and assistants, but a blow to the drillers. By 2012, in the run-up to the Marikana strike, the rock drillers no longer commanded wages superior to those of the men who assisted them: the chisaboys who pushed the explosives into the holes, or those who swept the debris – the shovel boys or malaishas. Outside of the claustrophobic, hot stopes and away from the shanty speakeasies, drillers were not regarded with quite the same awe as in the past. Their own union, the iconic NUM, even described them as illiterate and gullible rural bumpkins.

While employed, the miners deliver a vital injection of cash into the financially strapped economies from which they hail. Most miners support a second family or at the least a mistress near the mine where they work. Mtshamba's wife and three children stayed at his home 200 kilometres south-west, while he lived with a girlfriend in Marikana. Much has been written about the 'small house' phenomenon and its effect on the spread of diseases like HIV when migrant men have concurrent intimate relationships. Yet it is not only sex that motivates such liaisons. 'Every day, after I wash myself, my lady has to rub me with salve. I cannot straighten after bending like this all day,' says Mtshamba, crooking his forefinger to mimic how he spends his working day at the stope underground, bent double.

The actual drilling of the hole is relatively easy, as the modern hydraulic drills are designed to assist the men operating them – all they have to do is control and guide it and the spiral draws the drill into the rock. But extracting

the drill bit back out from the hole once it has been bored is fraught with difficulty. Sometimes 'the rock is cracked inside, or it won't come out because of mud inside; it is closed. Then you have to use all your strength to pull it out,' explains Mtshamba. On occasion, men collapse for a time on the muddy floor of the stope, before getting up and drilling the next hole.

Mtshamba and Mjiki explain exactly what their work entails, deep below the surface. Mjiki works in development while Mtshamba drills at the ore-producing rock panel. This is where a tunnel tracks the elusive vein of platinum and its associated metals through the hard rock. Every working day, Mtshamba crawls into the 1.2-metre-high stope and readies his drilling machine. The immense drill bits, which miners call sticks, are almost as thick as a man's wrist and either 1.2 or 1.5 metres long.

The first difficulty Mtshamba faces is in starting the hole. The point of the drill stick has to dig in precisely on the spray-painted X, but the vibrating, spinning steel tends to veer off the marked spot. Denied an assistant to hold the tip at the right place, Mtshamba has to use one hand to guide the front of the bit, and the other to control the handle at the rear. Stretched out as he is, if his glove gets caught in the spinning drill bit, he can be badly injured, even disabled. The other danger is that under the immense pressure of the weight of thousands of metres of rock, the drill stick sometimes breaks, with grave consequences for the driller, whose face is perilously close to the spinning metal rod.

Furthermore, working alone, Mtshamba has no one to see if a chunk of the rock ceiling above is about to collapse. The driller just has to risk it, relying on an acquired sense of the nature of the rock to avoid disaster.

Mjiki's work in development is even more of a solitary occupation. His role is to 'make a road for those coming behind us'. The development tunnel is not low like Mtshamba's working stope; most of the time, Mjiki works upright, but he has other difficulties. Sometimes he has to drill up into the roof of the tunnel he is making, struggling to control the vibrating machine, while water and mud gush down onto his face. The drill stick that he manhandles, without an assistant, is more than twice his height – an immense 3.4 metres long.

Once he drags his drill and hydraulic hose away from the drilling area, he often has to set the explosives himself. If he waits for either the miner with the blasting certificate or the assistant miner, the work would never get done. 'I do that job. They say that is the law at Lonmin: no chisaboy here in development.'

Mjiki has no malaisha either; he has to clear the blasted rock himself. In some Lonmin shafts, other shortcuts are allegedly taken, including with ventilation. Miners work for a short period and then come out gasping for air before returning to carry on.[2] These practices lead to rumours in the shantytowns that underground mining deaths are made to appear as accidents on the surface, off the mine's property, so as not to slow production with enforced safety stoppages.

'We are working the same jobs but they don't treat us like each other,' Mjiki says of the drillers. 'In Karee, they didn't give you even half of the money of the guy who can be your assistant.' The way Mjiki and Mtshamba see it, if they have to work alone and endure the extra hardship and dangers, they deserve at least a portion of the savings the mine gains by not paying for an assistant's salary.

For the drillers, financial survival is all about bonuses and overtime. The bonuses are calculated on attaining a set target of metres of rock blasted and removed. At Karee, the drillers say that the mine wants a twelve-metre advance from the face every twenty-four-hour shift. The mining supervisor and shift boss attain their bonus on the 'true' advance – a simple tape measure of how many metres of rock are blasted and hauled away in the shift. Yet the advance for lower-grade workers – the drillers, malaishas, chisaboys and winch operators – is adjudged complete only when the floor has been swept clean of rock dust. This usually takes an extra two days. Perhaps this is a hangover from the days of apartheid, when the underground supervisory jobs were reserved for whites – yet another dose of discrimination to those already heaped upon black employees.

In the late afternoon, after work, once they have scrubbed off the day's grime, Mtshamba and Mjiki share a quart or two of Black Label beer, sitting opposite each other on their rough concrete door-sills. It is here that they chat and gossip, and complain about work and the tyranny of the white overalls. One of the most universal complaints among Lonmin's underground workers is that they are obliged to wear the distinctive white overalls. The overalls with strips of reflective safety tape are a worthy idea, ensuring better visibility above and below ground, yet the company issues each worker with just two, replacing one every six months.

Underground, at the rock panels and in the development tunnels, water

2 Philip Frankel, *Between the Rainbows and the Rain: Marikana, Mining and the Crisis of Modern South Africa* (Bryanston: ASR, 2013).

is sprayed constantly and mud is everywhere. Whenever miners work at the rock face, they are quickly soaked through. The pneumatic drills are lubricated with thick black grease, which has no respect for the white overalls. At the end of their shifts, which range from eight-and-a-half to twelve hours, Mtshamba and Mjiki's overalls are caked in the black grease and mud. And the next morning they have to do it all over again, reporting at the shaft in clean white overalls. At least, that is how it went for their first couple of days, until the novice underground workers wised up. Mtshamba and Mjiki quickly learnt to take old clothes with them. On arriving at the rock face, they strip off the overalls and pull on stained, ragged work clothes, negating the intended safety benefits of the white overalls where they are needed most. Lonmin does have a company washroom for the overalls, but miners say that it is regularly overwhelmed by demand.

To wash a white overall, caked in machine grease, in a basin of cold water is no trivial matter. 'We wash them with our bare hands,' Mtshamba says. 'We take cold water and wash them. They will never be white because of the stains, those black stains, even if you take a brush and you scrub it. It doesn't ever get clean like it was.' Mjiki's closest water faucet is 800 metres away. Sometimes there is a queue. Mtshamba, on the other hand, has managed to befriend the Motswana landlord across the road at the Big House, which has its own standpipe in the yard.

An overall has to be washed three times to get it clean. Miners leave it to soak while they fetch another twenty-five-litre container of water. They estimate it takes them three to four hours to wash an overall. Throughout the shanties and settlements around Marikana, the distinctive white overalls are spread out on barbed-wire fences to dry. A glance into most yards reveals a woman bent over a bucket or a basin, washing the soggy white material between her glistening knuckles.

Were the miners to use the overalls correctly, they or their girlfriends would spend hours every day washing them.

As they describe this, Mjiki sometimes finishes a sentence that Mtshamba has begun. Then Mtshamba adds a thought or a detail to what Mjiki has said. Their narrative blends into a single tale, a story of men expert at working deep underground yet returning to a life on the surface lacking services and conveniences that most other salaried people take for granted.

As tough as the job is for drillers like Mtshamba and Mjiki, their employment is a source of pride, and a lifeline to many. Every one of the half-million South African miners supports, directly and indirectly, between

nine and sixteen dependants.[3] This rather startling figure makes sense within the greater statistic that out of a population of fifty-four million people, a third exists on less than R290 a month per person. Seen another way, eighteen million South Africans survive on less than a dollar a day each.

3 Gavin Hartford in an interview with filmmaker Rehad Desai (2012).

3

Genesis of a Tragedy

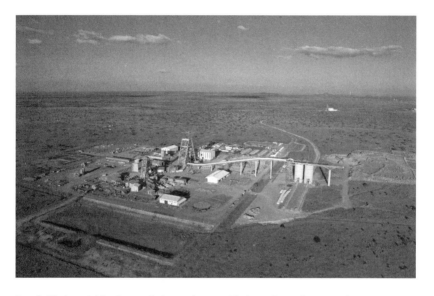

Impala Platinum's Number 20 shaft complex near Phokeng, Rustenburg, North West province, 21 April 2008.

'If you are not benefiting, you must fight until you benefit.'
– Julius Malema to striking Impala Platinum
employees in February 2012[1]

It was neither the white overalls nor the indignity of their shanty living conditions that drove Lonmin's Marikana drillers to organise the strike of 2012. These were mostly accepted as difficulties to be tolerated. The real grievance was that they were underpaid; they needed a wage they could live off.

South African labour grievances are usually expressed through strikes, be they procedural, balloted strikes in conjunction with a recognised union or unprotected, wildcat strikes that leave the workers vulnerable to being fired. Businesses employing mass labour expect periodic strikes when operating in a country with such high levels of inequality. The two richest South Africans earn as much as the poorest-paid twenty-six million of their countrymen.[2] The international gauge of income inequality, the Gini coefficient, measures South Africa as the worst in the world, occasionally rising to second or third worst.

International capitalism thrives by investing in high-profit ventures in the developing world, where massive rewards accrue to those willing to take on great risk. The extractive industries, to a large degree, attract and reward those with a frontier approach to business, labour relations and the law. Belligerent strikes and lost production are borne by investors as a necessary evil in high-risk, high-gain environments.

1 In Greg Nicolson, 'Malema to striking miners: It's time to negotiate', *Daily Maverick*,
29 February 2012, http://www.dailymaverick.co.za/article/2012-02-29-malema-to-striking
-miners-its-time-to-negotiate#.VcfCShNViko (last accessed September 2015).
2 Oxfam International, 'Even it up: Time to end extreme inequality', 2014, https://www.oxfam
.org/sites/www.oxfam.org/files/file_attachments/cr-even-it-up-extreme-inequality-291014-en
.pdf (last accessed September 2015).

South Africa's history is one of brazen exploitation of black labour by white capital, initially under Dutch and British colonialism, and then the home-grown white supremacist regime. The right to the mineral wealth and power over the labour of the conquered population were defining characteristics of empire, capitalism and apartheid. When a left-wing black nationalist government seemed certain to replace the right-wing white one prior to the first democratic elections in 1994, big business and the mining giants scrambled to position themselves close to the socialist African National Congress (ANC) elite, wishing to lessen their risk.

Once the ANC took power, the right to strike and protest was enshrined in the new constitution. The ruling party was formally allied with the massive labour federation the Congress of South African Trade Unions (COSATU) and the small but influential South African Communist Party (SACP). While the ANC dominates, it draws heavily on its junior partners for leadership. Top party leaders Gwede Mantashe, Kgalema Motlanthe and Cyril Ramaphosa all came through the ranks of the National Union of Mineworkers. Despite the avowedly socialist bent of the alliance, the ANC and its partners bought into a decidedly neoliberal approach to the economy, privatising many state-owned entities. Their concessions to socialism were mostly to pacify the poor – old-age pensions, child grants, disability grants and free, sub-economic RDP housing – and they favoured being known as a progressive developmental state.

In the first two decades of freedom, there was a huge release of commercial energy by the 80 per cent of the population previously thwarted from fully participating in the economy by apartheid. This coincided with the commodities boom and there was a sense that anything was possible. Massive amounts of money went around, enough to fulfil pro-poor state intervention and boost the rich, both old and new. The buoyancy of the black middle classes and an ostentatious new elite – the Black Diamonds – were the stuff of stories told and retold around the globe. The politically connected labour union elite became an integral part of the commercial environment. Despite their professed public antagonism to unfettered capitalism, top union officials and office bearers earned corporate-level salaries sitting on company boards, and clinked champagne flutes with business and political elites. At socialist gatherings, artful terms such as 'the working class', 'white monopoly capital', 'the people's cause' and 'anti-majoritarian liberal offensive' were bandied around without irony by people driving luxury cars and wearing shoes expensive enough to feed several rural families

for a month. The rhetoric of revolution is a political lubricant, legitimising rent seekers squatting atop every conceivable source of wealth.

It was the tectonic shift in world politics with the end of the Cold War and the victory of capitalism over communism that forced open the doors of South Africa's political jails. Yet those very changes that ended racial domination also irrevocably changed the economic landscape; the end of sanctions exposed South Africa to the temptations and tempests of globalisation. World markets and investors were looking for ever-increasing profits in ever-shorter times. The well-to-do populations of the earth, somewhat misleadingly referred to as the Global North, demanded ever-higher returns on investment – 'passive income'. The mobile-phone revolution, coupled with deceptive costing strategies, made desirable personal communication readily available. These were a signifier of a new age of consumerism that put increasing financial pressure on the middles classes and the poor. A new generation of South Africans, born without the yoke of apartheid, wanted to join in the world's consumer frenzy. The Born Frees' ambitions were not stunted by the past; they sought to enjoy the fruits of freedom and were unwilling to live under the regime of poverty enforced on their parents. As the mantle of leadership passed from Mandela to Mbeki to Zuma, there came the realisation that the ANC increasingly ruled a state as predatory and kleptocratic as the corrupt apartheid regime.

Despite this purported golden age of the left in South Africa, these years of plenty had failed to push the majority of blue-collar workers above subsistence wages. In the shantytowns that surround the platinum mines of South Africa's North West province, these pressures were keenly felt by middle- to low-income earners. Even though salaries had grown at unprecedented rates, they could not keep up with the cost of living. Every payday, relief soon turned to angst. Expenses, and expectations, outweighed earners' wages with depressing predictability.

The lives of the vast majority of black mineworkers had been massively improved by unionisation through NUM. It was the largest union in the country, with hundreds of thousands of dues-paying members. Under apartheid, the best-paid supervisory jobs in the mines (and elsewhere) had been reserved for whites. As these discriminatory laws were rescinded, blacks gradually got access to better-paying and less physically demanding jobs. These jobs required full literacy, and better-educated black workers soon began to dominate the union branches, creating a gulf between the union

officials and the lesser-educated miners who made up the majority of the workforce.

The union negotiations with the mining companies, dictated from NUM headquarters, took on a more corporate nature. Instead of dealing with specific wage grievances, union policy was to pursue across-the-board increases. This increasingly annoyed a small but influential group – the rock drillers. They were vexed that their wages were drawing near parity with lower-status workers with each successive round of negotiations. Rock drill operators believed they were being sidelined despite their essential and dangerous role underground. Discontent led to strikes breaking out at mines on the platinum belt from 2006 onwards, affecting all of the platinum companies. Despite this, NUM repeatedly failed to take up the drillers' issues. The drillers saw this as confirmation that their union had been co-opted by *clevas*[3] who had sold out to management, using their positions to snag lucrative contracts – supplying the mines with everything from toilet paper to tyre repair services.

The workers regarded their elected officials as more obligated to the employer than to their comrades. They took to referring sarcastically to NUM as the 'National Union of Management'. Platinum mine RDOs led the challenge to NUM's monolithic power.

There were two distinct events that laid the foundations of the August 2012 Lonmin strike. Looking back, it is easy to see an almost fated trajectory which led to the massacre on the 16th, but hindsight was a view not available to the individuals immersed in the day-to-day events.

Karee is one of the three operations that make up Lonmin's mining operations at Marikana, all of which feed their ore into a shared processing unit and smelter. Working conditions here were widely acknowledged by miners to be the worst across the company's several operations and the workers at Karee were the most discontented. It is not clear whether it was this discontent that motivated them to elect a plain-speaking, uncouth mineworker as NUM shaft chairman, or if the maverick unionist had fanned the dissatisfaction to feed his populist rhetoric. At any rate, the Karee elections were due in early 2011, and the regional NUM elite did not want Joseph Steven Mawethu Khululekile, known to all simply as Steve, re-elected.

Things came to a head at NUM's regional conference that preceded the

3 Educated Africans, perceived by some rural folk as out of touch with their roots.

elections. Steve told the branch that there was no need for elections as he and his team would be re-elected. The Rustenburg branch responded that this was unacceptable, unconstitutional, and that he would have to be elected if he wanted to continue serving.

Adding to the discord was the chaotic state of Lonmin's employee share participation portion of their compulsory black economic empowerment (BEE) scheme. The year before, Lonmin had bought out the workers' shares in order to bring a political heavyweight aboard. NUM wanted those shares paid to their coffers for broad redistribution or to shore up its investments, while the workers were demanding that it be paid directly to them. Steve, representing the Karee miners, was not backing down. He and the miners saw the election as an opportunity for NUM to finagle him out, and to deprive the Lonmin miners of their money. Steve called a meeting of all Lonmin miners at the company soccer stadium and asked for a show of hands from those who wished for him and his sidekick, branch secretary Dan Moeketsi, to stay on. This rather unorthodox bit of democratic theatre resulted in a healthy showing for Steve. The NUM regional office obviously insisted there had to be a proper election. The situation continued to simmer for a couple of months until NUM suspended Steve and Moeketsi for misconduct. Steve immediately went back to the members and asked them to decide what they wanted to do about it. The entire mine went out on an unprotected strike. The following day – which happened to be the day municipal elections were being contested, 18 May 2011 – they marched to the local polling booth calling on the popular COSATU general secretary Zwelinzima Vavi to intervene. Vavi has always been seen as a man of the people, unstained by the kleptocracy of the state and its vassal unions. Despite this, Vavi was then a staunch supporter of the ruling party.[4] Over the years, COSATU might have been the ANC's sometimes bothersome junior partner, but it had always closed ranks to deliver votes come election time. The miners say that Vavi responded with a cynical text message: 'Vote ANC and everything will be resolved.'

It is unclear what those miners voted, but the ANC won the ward and the province handsomely. The situation of the miners was not resolved.

Within days, Lonmin management (with NUM's approval and connivance) got a court order compelling the strikers to return to work or be

4 Vavi was forced out of COSATU in a bruising political battle in 2015, long after many of his supporters thought he should have walked.

fired. They predictably refused and the mining company fired all 9 000 striking Karee miners. Lonmin then invited all workers to reapply for employment. Most were rehired, except for 1 400 identified as 'trouble-makers' by the company and NUM.[5] The company and the union had succeeded in ridding themselves of Steve and his most fervent supporters.

A few months later, in October 2011, Impala Platinum, known as Implats, the world's second-largest platinum producer, signed off on a routine two-year wage agreement with NUM. The agreement rejected the demands by RDOs for significant increases. Then, in December, there was a surprising 18 per cent increase in the wages of a supervisory grade known as 'miners',[6] the men who oversee the work of the drillers at the rock face. The news of this raise came just as the migrant drillers were going home for their annual vacation. Across the rolling hills of Pondoland and the precipitous mountains of Lesotho, the areas from which most drillers hailed, mine-workers came together to drink sorghum beer and discuss the treachery of NUM. On returning to work in January 2012, a course of action had been set. The drillers embarked on a wildcat strike, without involving the union. Implats quickly fired the 5 000 striking drillers, prompting the rest of the workforce to walk off the job in sympathy. The strike persisted for six weeks and eventually 17 000 out of a total workforce of 53 000 were fired and four miners were killed. By April, Implats agreed to reinstate the fired miners and increase drillers' salaries from R6 540 to R9 991.[7]

The Implats strike was also an opportunity for a brash and reckless young ANC politician to entrench his personal power and popularity just as the party faction surrounding President Jacob Zuma focused their considerable might on sidelining him. Julius Malema, the president of the ANC Youth League, was facing an internal ANC disciplinary process for overplaying his kingmaker hand within the ruling party. Malema had believed himself untouchable ever since he had been key in securing Zuma's

5 At the time, *Socialist World*'s Liv Shange reported on the *Star*'s story of 26 May 2011, in which NUM national spokesperson Lesiba Seshoka reportedly said: 'We will make sure that the workers are reinstated.' Shange further noted that the same spokesperson, a day later, told *Mining Review*, 'Unfortunately the company cannot have such people and has to let them go', and 'the union would not support those that are on the wrong side of the law'.

6 An underground supervisor who has a blasting certificate; it does not mean a mineworker in general. This was a position previously reserved for whites.

7 The RDOs were all promoted from category A4 to B1 on the Paterson banding system, resulting in an overall increase of their salaries, including a holiday leave allowance, a living-out allowance and a retirement contribution. Report of the Marikana Commission of Inquiry, 2015.

victory against the incumbent president Thabo Mbeki during the bitter leadership battle that culminated at Polokwane in 2007. Malema misread Zuma's strategic genius for encouraging allies as personal loyalty, and by August 2011 found himself facing an ANC disciplinary hearing led by Cyril Ramaphosa.[8] On 28 February 2012, while the strike was peaking, Malema addressed the miners in typically populist mode, telling them that they deserved the doubling of their salaries that they sought. He urged them never to allow a white person, the employer, to divide them, and declared: 'You must benefit from the mine. If you are not benefiting, you must fight until you benefit.'[9] This appearance at Implats was just days after Malema's failure to have the ANC charges against him set aside, and he was facing expulsion from the party. While Malema was wearing the regulation black beret with the ANC logo on it, he also wore a black T-shirt sporting a picture of slain leftist icon Chris Hani and the phrase 'Economic Freedom Fighters'. The young lion of the ANC who had proclaimed he would die for Zuma was clearly preparing to beat his own path, independent of the party at whose breast he had been nursed.

It was also during the Implats strike that a little-known union came to the notice of the industry. The Association of Mineworkers and Construction Union (AMCU) had been founded by a former NUM official, Joseph Mathunjwa, in 2001. Mathunjwa had been dismissed by a coal mine in Mpumalanga province, which led his comrades to launch a ten-day underground occupation of an Ingwe colliery. The mine agreed to reinstate Mathunjwa, who then faced a NUM head office disciplinary hearing for bringing the union into disrepute. Two leading NUM unionists found there was no case, but general secretary Gwede Mantashe insisted there was, and he wanted to chair a further hearing himself. Mathunjwa, citing a previous clash between him and the general secretary, insisted a neutral person chair the hearing. Mantashe refused, so Mathunjwa resigned,[10] going on to launch his own union.

Initially, AMCU had struggled to make inroads outside of the coalfields, but NUM's ham-fisted handling of the 2011 and 2012 Implats strikes had

8 Internal disciplinary charges were laid against Malema on 19 August 2011. He was found guilty on 10 November 2011, and expelled from the party on 24 April 2012.

9 Nicolson, 'Malema to striking miners: It's time to negotiate'.

10 Jan de Lange, 'The rise and rise of Amcu', *miningm*ˣ, 2 August 2012, http://www.miningmx. com/special_reports/mining-yearbook/mining-yearbook-2012/A-season-of-discontent.htm (last accessed September 2015).

opened the door to them. Mathunjwa's stand against NUM resonated with the rebellious miners.

Back at neighbouring Lonmin's Karee mine, the company believed that by firing Steve Khululekile they had got rid of the source of their problems. Instead, they had inadvertently paved the way for a far less compliant union to court their workforce. Beginning as an upstart union sniffing around the outside, AMCU managed to recruit a popular leader who hated NUM as much as they did. Even though Steve was forbidden to enter Lonmin property, he busied himself in the shanties and bars organising for his new association. The union war was far from over.

One of the other immediate consequences of the 2011 firings was that Lonmin had 1500 vacancies to fill in a rush. Production was down and Lonmin's creditors and shareholders were agitated. The company decided to forego their usual practice of selecting raw recruits from the rural areas and instead targeted seasoned miners from the vast yet declining gold-mining industry[11] – men like Shadrack Mtshamba and Jackson Mjiki. The Lonmin recruiters who went to Klerksdorp and the other mining towns of the southern North West province and the northern Free State were essentially scouting for a kind of scab labour, but it would not take long for Mtshamba and Mjiki to become disillusioned with their new bosses, and with NUM's attitude. The reality they experienced at Karee was far from the world of the imperious driller of legend, the prince of the underground whose skill and strength were cosseted by the grateful employer. A storm was building.

11 Paul Burkhardt, 'Gold town turns to dust as metal decline shutters mines', *Bloomberg Business*, 18 December 2013, http://www.bloomberg.com/news/articles/2013-12-18/gold-town-turns-to-dust-as-metal-decline-shutters-mines (last accessed September 2015); Ed Cropley and Agnieszka Flak, 'Special report – why South African mining's in decline', Reuters, 4 February 2011, http://uk.reuters.com/article/2011/02/04/uk-south-africa-mining-idUKLNE71303020110204 (last accessed September 2015).

4

Build-up

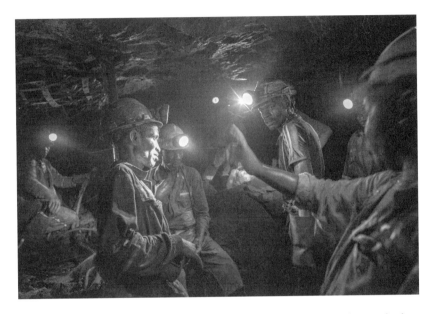

A team gathers for a safety and production meeting at the start of a shift. Level 31, Rowland shaft, Lonmin mine, Marikana, North West province, 2013.

'First of all: what is work? Work is of two kinds: first, altering the position of matter at or near the earth's surface relatively to other such matter; second, telling other people to do so. The first kind is unpleasant and ill paid; the second is pleasant and highly paid.'
— Bertrand Russell, 'In Praise of Idleness'[1]

The Lonmin drillers had been watching the Implats strike with great interest. Even before the Implats increases, Lonmin had been paying their drillers less. NUM had also concluded a two-year wage deal with Lonmin, in December 2011. The 8-to-10 per cent increase was not a deal that came close to satisfying the drillers. Some looked to jump ship to the larger Implats for the higher salary and easier working conditions; others wanted to push for a better deal at Lonmin.

Lonmin's executives were well aware that their underpaid workers would likely agitate for a raise, and had asked their human capital manager and member of the executive committee Barnard Mokwena to look at various scenarios that might play out. The mine's chief fear was the high probability that the drillers would strike. It was in this period, the calm before the storm, that the demand for higher wages was described as a disease. Across the highly polished rare wood of boardroom tables, men with more than their fair share of hubris and money dubbed the workers' demands 'the Impala Contagion', where they feared the idea of a grassroots movement taking hold at other mines. Despite this, Lonmin's executive committee did not formulate a cohesive plan for the inevitability of driller unrest spreading to Lonmin.

The vice president of mining at Karee mine, Mike da Costa, followed the Implats strike closely and with trepidation. He feared either an exodus of drillers or a strike. By midwinter, handwritten posters in the name of the Karee rock drillers were appearing. They called for a salary of R12 500. On the afternoon of 21 June 2012, 300 drillers marched to Da Costa's office

1 *In Praise of Idleness and Other Essays* (London: George Allen & Unwin, 1935).

with a 'request' that they be paid R12 500 a month. Da Costa asked for two of the men to represent the group. One was an AMCU man and the other was from NUM, though the latter may have been in the process of switching his allegiance to AMCU. Despite their affiliations, they insisted that the drillers were not there as unionists but as Lonmin employees.

It was, recalled Da Costa, a cordial meeting. The men told him that they wanted their basic monthly salary upped to R12 500, as they would consider this fair compensation for their labour. It was a large leap from their then basic salary of between R4 500 and R5 600 a month. Instead of telling them that a wage negotiation outside of the bargaining structures was unacceptable, and that they were bound to the wage agreement for another year and a half, Da Costa discussed the matter with the drillers. This was part of a Lonmin 'line of sight' guideline for managers to engage directly with workers whenever possible. It is unlikely that Da Costa was empowered to actually open what were in effect wage negotiations, but he did. He advised the men that Lonmin would find the demand too steep, but he promised to take their request to his directors. The drillers left with the promise that Da Costa would give them a response by 2 July.

The Contagion had indeed spread to Lonmin. Even though just such a demand had been anticipated by them, management dallied. The executive committee asked Mokwena to compare their drillers' salaries to others on the platinum belt, even though these figures were already well known to Mokwena, and had probably been languishing unread in a pile of such dispatches in all of the executive committee's inboxes. The deadline of 2 July came and went. A delegation of five drillers, all AMCU members, met with Da Costa to see what the delay was about. Da Costa told them it was unlikely that the executive committee would agree to the demand. Da Costa asked them how they had come to the figure of R12 500, as this would be a massive leap that bumped their salaries to higher than that of a supervisor. The miners simply responded that it was a good number.

In a series of meetings from 23 to 30 July, Da Costa told the delegates that Lonmin would not entertain the R12 500 demand, but that it could offer all drillers a monthly 'allowance' of R750 for a driller working unaided, R500 for a driller working with an assistant and R250 for the assistant. Some of the delegates seemed attracted to the offer, while others were unhappy with it. Nonetheless, they agreed to take the allowances back to the drill operators for consideration. At best, Lonmin must have hoped just to defer a strike. The company did not refuse to discuss money matters

with its workers. From the drillers' perspective, they now understood that Lonmin was indeed willing to open wage negotiations outside of the usual channels. The expectation had been established that if the workers approached the employer directly, they would get a response.

The scene was set for a confrontation, even as Lonmin behaved publicly as if the issue had been resolved through this high-handed action. Da Costa was less convinced and placed mine security on high alert. Mokwena, who would play a key role over the next weeks as the face of Lonmin's intransigence, even mooted a plan to fire the workers and recruit others, as they had done during the unprotected strike at Karee the year before.

In the days following the offer, unhappiness swiftly escalated. The R12 500 demand spread from just Karee drillers to the other operations. Each shaft chose five workers to represent them outside of union structures, even where NUM dominated. Those entrusted to speak for the miners approached their local shaft management, and all met with the same response – there was no way they were empowered to increase salaries. One of those worker representatives was a driller from Rowland shaft called Tholakele Dlunga, known to all as Bhele. Bhele had never been a shop steward, but he was a bishop in his Africanist Christian church and had a powerful if quiet presence. He would emerge as one of the first of the overall strike leaders.

A meeting of all RDOs was called for Thursday 9 August at the Lonmin sports stadium between Nkaneng shantytown and the Wonderkop mine hostels. When Lonmin security guards saw a crowd of 2 500 men gathered outside the locked gates of the stadium early that morning, they offered to open them for the RDOs. The drillers declined, in what would become a pattern of the strikers not making use of company facilities while on strike. While 9 August was a public holiday, overtime shifts had been scheduled, and the stay-away was 'unprotected' within South African labour law. The drillers were incensed to hear of the stingy allowance offered. And to add insult to injury, these unilateral allowances had not appeared on the last payslip, despite Lonmin saying they had implemented them. The drillers determined that they would march on the local Lonmin headquarters the following day. The strike was on.

Since the Implats strike victory, the drillers felt emboldened. They were also confident in the knowledge that if the RDOs did not drill, the entire mining operation would ultimately come to a standstill. The processing plant and smelter could continue to operate for weeks on the ore

stockpiles, but these would ultimately be depleted. If they held out long enough, the chimneys of the great furnaces would no longer belch smoke into the clear blue winter sky.

Strikes are wars of attrition. The miners faced the erosion of their scant savings, and prepared to draw their belts ever tighter. In many ways it looked like a David and Goliath situation, but for Lonmin it was equally a battle for survival, as they gambled that the miners' resolve would cave before their stockpile ran out. Lonmin was under pressure – their financials were shaky.[2] They had a debt covenant deadline coming up in a month, and a strike could force them to default. Lonmin had a long-term loan from a group of UK-based banks for $700 million, and a smaller one from a South African group of banks. Massive commercial loans, especially from a group or syndicate of banks, are usually governed by a fixed set of restrictions and milestones that have to be met during the course of the repayment period. These are called covenants, and breaching them can see the loan being called in for immediate payment in full, or penalties being charged. And once covenants are breached, the cost of lending goes up. A strike at such a critical juncture could take Lonmin to the brink.

The mine's network of informers immediately reported back to Mokwena's office that the drillers would call for a wildcat strike the next day, 10 August. Lonmin swiftly issued a memo to their workers that demands outside of the existing collective bargaining structures would not be tolerated. The workers were further reminded that any gathering would be in breach of the Regulation of Gatherings Act, and that Lonmin would not hesitate to fire them.

While the strike was primarily about workers trying to improve their lot, it was also closely linked to the breakdown in relations between unionised workers and the all-powerful National Union of Mineworkers. NUM had already been displaced as the leading union at Karee by early 2012. At the start of the strike, the Karee mineworkers' union of choice – AMCU – was not allowed to negotiate with the company, and the union which could, NUM, no longer had currency among Karee workers. Lonmin's other two mining arms at Marikana – Western and Eastern Platinum – were still firmly NUM turf. Despite AMCU having the majority at Karee, it had not yet gained formal recognition from Lonmin as the majority union. The

2 Alistair Osborne, 'Lonmin faces bank loan penalty', *Telegraph*, 22 September 2012, http://www.telegraph.co.uk/finance/newsbysector/industry/mining/9560177/Lonmin -faces-bank-loan-penalty.html (last accessed September 2015).

complicated and arcane 50-per-cent-plus-one-member system would give NUM several months to try to regain their lost ascendancy before Lonmin had to accept AMCU as the majority union.

Thus Mokwena and Lonmin could keep insisting that NUM had to be involved, even though the RDOs had clearly said they wanted no union involvement. There was great fear of AMCU across the industry, a fear of a radical union that would upset the delicate status quo. Lonmin knew through their informants that the fired former NUM shop steward Steve Khululekile had addressed Karee workers in the name of AMCU on 19 July. Lonmin and NUM feared Steve's popularity among the miners, and figured his return meant trouble. Mokwena and his office quizzed the NUM and AMCU head offices about the R12 500 demand. Both unions denied that they were involved, but Lonmin continued to believe AMCU was behind it.

Despite the apparent fixation on the R12 500, it was not a number that the drillers were in truth committed to attaining. It was what they knew would provide them with a proper living wage, but the rank-and-file drillers saw it as a preliminary bid against which Lonmin could make a counter-offer. In other countries, where mining is more mechanised, miners enjoy the benefits of middle-class incomes. In South Africa, they subsist from pay cheque to pay cheque, with little hope of saving anything for life after their time underground. Drillers, more than other miners, rarely manage to survive a long career underground. They get worn out, their backs trouble them greatly, and many suffer from lung disease as a result of inhaling dust. Many succumb to other diseases, mainly as a result of the appalling sanitary conditions in which they live. The rate of HIV and AIDS is high, the result of hard drinking and transactional sex in a country that has the highest number of people with HIV.[3]

Bhele was one of the initiators of the strike. He and others had come to the conclusion that their union would never do what they wanted it to. 'For more than ten years,' he said, 'NUM knew about our grievances ... but failed to listen. One day, two men sat down with me underground. We talked. The next day, there were four of us; the day after that, there were five. When there were enough of us, we decided it was time to move forward on our own.'[4]

3 World Health Organization, Global Health Observatory Data Repository, http://apps.who .int/gho/data/node.country.country-ZAF?lang=en (last accessed September 2015).
4 Extract from Tholakele 'Bhele' Dlunga's interview with Rehad Desai, director of *Miners Shot Down*.

Unlike Bhele, Shadrack Mtshamba was not one of the agitators for action. Like many of the miners, he feared a strike because he understood how long it would take them to recoup the losses suffered under a no-work no-pay industrial action. As it was, he and his comrades lived a hand-to-mouth existence: 'That amount I earn is too little. If I earn 4 000 [rand] a month, where I stay now, I pay rent. There is no electricity, I have to use paraffin. I must buy food and send money to my children, all from the same wage. I have three children in Klerksdorp that I must provide with food, clothes and all other things they need. I must buy myself clothes and entertainment too, all from R4 000.'

Entire extended families often live off one mineworker's salary, as the father of one of the miners who would be killed, Henry Mvuyisi Pato, explained: 'My son played a pivotal role in supporting our family by buying food and providing school fees for the children of the family, which included fees for his sister at Fort Hare University. We have lost our only breadwinner. I don't know what is going to become of us.' At the time of his death, Pato was financially supporting his two minor children and their mother, his father, his mother and three of his siblings. There is massive pressure on those with jobs to assist family and others back home in the labour-sending areas.

Nevertheless, a chain of events had led to the point where workers were prepared to lay down their tools in a strike that was not protected by labour law, where they could lose their jobs. And a financially beleaguered Lonmin was prepared to do anything to keep their wage bill down. Both sides were gambling from high-risk positions, with a confrontational approach that resembled a zero-sum game.

5

A Colonial Accounting

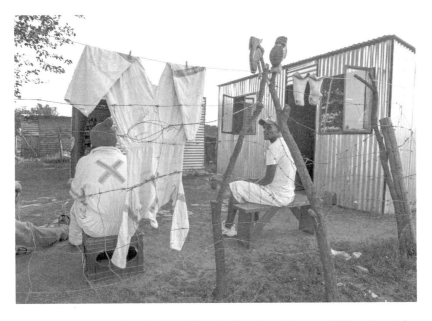

Retrenched contractor Xolani Mbombo (left) at a shack settlement known as RDP, near Lonmin's K4 shaft at Marikana. His payslip showed his earnings in 2013 at just over R2 000 a month after three years' employment with FHL, a subcontractor that does underground construction for Lonmin.

'You can never have enough enemies.'
– Roland 'Tiny' Rowland[1]

T iny Rowland just wanted to be loved, but the founder of the business
empire that birthed Lonmin sure spent a lot of energy making ene-
mies. Rowland was having fun in business only if it was on the edge and
nasty. So much has been written about Rowland, born Roland Fuhrhop,
yet little is widely known. He was born in 1917 to a British mother and
a German father, most likely in a British detention centre in India, where
they were interned as alien nationals during World War I.

After the war, the family returned to Germany, and in the 1930s Tiny
joined the Hitler Youth, even though his father was anti-Nazi. Yet, in what
would prove to be a typical contradiction in how he fashioned his history,
Tiny claimed to have been briefly jailed for befriending critics of Hitler,
though this was never substantiated. Through his English mother the fam-
ily received asylum in Britain, and Rowland went to a minor public school,
where he developed the right accent but apparently never quite mastered the
proper attitude. He would forever be at odds with the British establishment,
of both the left and the right. The ruling class hated him – not so much
because he was a bastard, but because he was not *their* bastard.

Tiny was a larger-than-life figure, in body, in character and in achieve-
ments, yet he was most famous for his ability to escalate a business dispute
into a fight to the death, or at least to financial ruin. As with many ambitious
young men with little means, Rowland went to seek his fortune in Africa
after World War II. He made a less than brilliant start in then Southern
Rhodesia, until he took up with a rather moribund small company called

1 Quoted in Youssef M. Ibrahim, 'Roland Rowland dies at 80: Outspoken British tycoon',
 New York Times, 27 July 1998, http://www.nytimes.com/1998/07/27/world/roland-rowland
 -dies-at-80-outspoken-british-tycoon.html (last accessed September 2015).

the London & Rhodesian Gold Mining Company (Lonrho). Here he blossomed, and swiftly built up the company into an international empire with interests ranging from car dealerships to sugar and mining.

Lonrho came of age under Rowland as white supremacist Rhodesia and South Africa were international pariahs, at least publicly, and the targets of sanctions. Rowland developed a knack for courting black nationalist leaders while simultaneously pillaging their resources. His African businesses were run with minimal 'hard currency' inputs, and maximum profits expatriated to London through an increasingly complex web of front and offshore companies. He groomed individuals close to those in power for political capital and used them to ensure he had the patronage he needed to smooth over the neo-imperialist nature of his exploitation. All the while, Rowland portrayed himself as a non-racist anti-imperialist, and used Lonrho to assist some African states and guerrillas, but always in exchange for or pursuit of business opportunities. It was all about cowboy capitalism. He once told a Lonrho director ahead of a business trip that he was prepared to be buggered if it helped Lonrho; he then inquired if his colleague was willing to do the same.

Rowland's gamut of friends and close acquaintants ran from right-wing African despots to left-wing dictators. He apparently forged a ceasefire in Mozambique and mediated for an end to the civil war in Sudan. One of Rowland's closest African associates was the long-serving Zambian president Kenneth Kaunda. Rowland was feted as a non-racist friend of black Africa, yet at the same time ran an amethyst mine which hid its massive profits from the Zambian authorities, depriving that struggling nation of millions of dollars of much-needed revenue. While Rowland was technically based in the frontline state of Zambia in an attempt to bilk Britain of taxes, he was continually breaching sanctions against the rebel white regime in Rhodesia. In a typically brazen move, he initiated a campaign against BP and Shell for their sanctions-busting. That he continued to own several mines and other companies in Rhodesia was kept secret; he would covertly enter the country in his private jet – the same jet he lent to African leaders from time to time. Lonrho's business interests in South Africa were also downplayed. Perversely, he ran his most profitable ventures – platinum and coal mines – in apartheid South Africa.[2] He touted it as a revolutionary move by claiming, 'We are buying because we are anti-apartheid.' He was never challenged.

2 Tom Bower, *Tiny Rowland: A Rebel Tycoon* (London: Heinemann, 1993).

British prime minister Edward Heath dubbed Rowland the 'unpleasant and unacceptable face of capitalism'. Rowland was unmoved, famously saying, 'You can never have enough enemies.' Despite distaste for his methods, and annual reports that were a year-to-year fiction designed to deceive, the financial status quo eventually backed him in forging a massive conglomerate.

Rowland backed guerrilla movements that he thought would benefit his business interests. In the last years of the war in Rhodesia, he chose to support the pro-Western Joshua Nkomo over Robert Mugabe, all while he was sanctions-busting for great profit. In Angola, he gave assistance to the National Union for the Total Independence of Angola (UNITA), under their reborn anti-communist leader Jonas Savimbi. When African leaders came to London, Rowland would wine and dine them, putting them up in the best hotels and paying for shopping sprees on Lonrho's tab. He once told one of his 'black ambassadors', the former Zambian minister Vernon Mwaanga, that African leaders were so corrupt, there was not a single one he could not buy.

To hide his fraud and dubious business dealings, Rowland developed the use of an array of holdings, partial holdings and front companies, all further camouflaged by a multilayered system of accounting. Ahead of his time, this swashbuckling buccaneer of globalised business, unfettered by laws or decency, conceived a style of capitalism that became a template for the economic rape of developing nations under the guise of globalisation. He perfected transfer pricing and the use of a network of offshore accounts in combination with the buying of public representatives and people of influence in both Britain and Africa.

In his book *Tiny Rowland: A Rebel Tycoon*, Tom Bower provides an example of how Rowland inserted himself into the highest levels of government, buying individuals who would be able to exert influence on Lonrho's behalf: 'The candidate was Mark Too, a local businessman. Rowland's test of Too's suitability was simple. Sitting in Too's home in the Rift Valley, Rowland asked, "Can you get the president on the phone?" Too dialled Nairobi and spoke to [Daniel] arap Moi, confirming rumours that Rowland was in the company of arap Moi's illegitimate son. Rowland appointed his new "runner" as Lonrho's deputy chairman in Kenya.'

In 1994, Rowland was ousted from the Lonrho board, and he retired to his family and cats. In 1996, Nelson Mandela bestowed South Africa's highest honour on Rowland, the Order of Good Hope. When Rowland died in

1998, aged eighty, *The Economist* commented, 'There was a vulgar streak in Tiny Rowland that upset other charming and ruthless tycoons who feared that he was giving money-making a bad name.'[3]

This was the same year in which Lonrho split off the African mining operations into their own company called Lonmin. Lonmin was later further streamlined to concentrate on just platinum. Those Lonmin mines straddle the now dismantled borders between South Africa and the patchwork of lands that once made up the bantustan of Bophuthatswana. While those boundaries no longer function, it is easy enough to discern where the legacy of destitution abuts what were once the far more prosperous lands of white South Africa. Even now, more than twenty years after the demise of the homelands, the legacy of the labour reserves is apparent, as if those borders are still in place.

The first known use of platinum was by the Mayans in pre-Columbian America to craft jewellery. In post-Renaissance Europe, though, the metal was viewed as more interesting than valuable. Like gold, platinum does not tarnish. It was because of its unique properties that this was the metal used to manufacture the official Mètre des Archives. This metal bar measures exactly one metre in the French-derived metric system, which has become almost universally accepted as a standard, save for a couple of odd birds sticking to the imperial system. Actually, the official metre bar is 90 per cent platinum and 10 per cent iridium, to strengthen it. At the temperature of melting water, zero degrees Celsius, thirty of these bars, perfectly made in 1889, are the standard measure of a metre. That metre bar of platinum is determined to be one ten-millionth of the distance from the equator to the North Pole, running through Paris. The bars are now obsolete, as a metre is determined to be the distance that light travels in a vacuum in 1/299 792 458 of a second.[4]

Not that platinum has lost its lustre because of this relegation. The metal was widely used in chemical reactions and came into its own as a catalytic converter of poisonous car exhaust fumes to innocuous gases as the age of the motor car reached its zenith. About half of all mined platinum is now

3 'Roland Walter (Tiny) Rowland, capitalism's outsider, died on July 24th, aged 80', *The Economist*, 30 July 1998, http://www.economist.com/node/170298 (last accessed September 2015).

4 'Mètre des Archives', Reddit.com, http://www.reddit.com/r/interestingasfuck/ comments/2fyrsk/m%C3%A8tre_des_archives_the_platinum_metric_stick_that/ (last accessed September 2015), and 'History of measurement', Metrology in France, http://www .french-metrology.com/en/history/history-mesurement.asp (last accessed November 2015).

used for vehicle exhausts and petroleum production. As stringent environmental legislation regarding exhaust emissions took hold in developed countries, platinum's price surged dramatically from an average of about $370 per troy ounce in the 1990s to over $2000 in 2008. The metal's other uses are jewellery, investment, electrodes, spark plugs, anti-cancer drugs and various high-tech innovations.

The platinum fairy tale began in the 1920s when an almost supernaturally talented geologist, Hans Merensky, discovered the world's richest reefs of platinum and its associated metals (palladium, rhodium, ruthenium, iridium and osmium, as well as chromium and a little gold and copper) near today's Rustenburg. Merensky was the first to divine just how ancient geological activity had left an interrupted ring of platinum across the central plateau of South Africa.

The multiple uses of this wonder metal saw massive riches eventually come to the sleepy Bushveld dorp about 120 kilometres north-west of Johannesburg. The little village became a town, practically a city. The mines themselves are in effect small towns, with a massive centre of gravity that attracts people, money and development. Some of the world's biggest players dominate the mining scene, as South Africa's vast supplies of the metal are estimated to be 80 per cent of the world's known reserves. As the demise of the Group Areas Act, which forbade free travel for Africans, coincided with a surge in the need for platinum, the area saw a massive influx of job seekers, almost all of them migrating to squalid shantytowns that still dot the landscape around the mines.

During 2003, Lonmin began to lay the groundwork for a complex deal that would meet the requirements of the new Mining Charter set forth by the post-apartheid South African government, as well as government BEE requirements. As part of the charter, mining companies were required to transfer 18 per cent ownership of their South African mining assets to historically disadvantaged South Africans within five years, and then 26 per cent over the next ten years, by 2014. The company set plans in motion to enact a BEE transaction in 2003, when it created Incwala Resources (Pty) Ltd.

The Lonmin empowerment deal was touted as a trailblazing example of how big companies should conduct business in a 'progressive' way. Then mining minister Buyelwa Sonjica is said to have worn a Lonmin shirt to Parliament in a spectacle that would have made Tiny Rowland proud of his business heirs. In addition to the BEE requirements, Lonmin had to help formulate and then fulfil a social plan, the largest component of which was

that the overcrowded workers' hostels be converted to family and single-occupancy apartments, and for Lonmin to build 5 500 homes for those dislodged by the renovations. That plan did not cater for those tens of thousands of their workers already living in shanties, so it was not an overly onerous burden put on Lonmin by the state. Lonmin was also required to improve water access and sanitation.

In the boom years, all of the mining houses had ramped up production and invested vast sums in new shafts and expansion. Lonmin had put between five and eight billion rand into a new shaft at Karee. The Big Three platinum miners – Anglo American Platinum, Impala Platinum and Lonmin – directly employed over 135 000 workers between them. That magical rise to $2 000 an ounce had made mining houses and investors greedy, hopeful of massive profits. Yet some saw Lonmin as weak, overburdened by debt and inefficiently managed. In 2008, the international mining firm Xstrata made a hostile bid for the company, buying 24.9 per cent of its traded shares. Xstrata needed just one more share to have control, but pulled back when the global recession hit, just weeks after their sally. Platinum mining shed 40 per cent of its income that year.[5]

Lonmin failed to deliver on most of the social and labour plan agreement with the state. Instead of 5 500 houses, they built just three. Water was scarce and sanitation abysmal in the shantytowns that housed their workers. Little progress was made on empowering or employing women. Interestingly, the World Bank said nothing, despite its International Finance Corporation (IFC) having invested $50 million into Lonmin in 2007, of which $15 million was specifically earmarked to improve the lot of the communities surrounding the mine. The World Bank appointed a board to ensure Lonmin would fulfil the social part of the contract, which fell under the IFC's mission statement 'Working for a world free of poverty'. Yet very little poverty was overcome during the years of plenty.

Just 20 per cent of the dividends paid out to Lonmin shareholders during the boom years of 2007 and 2008 would have paid for the entire cost of the 5 500 houses they had committed to build. It was during those good years that a soaring platinum price should have funded all of Lonmin's social responsibilities – workers' housing, water, contributing to local schools,

5 Raphael Chaskalson, 'Platinum, politics and popular resistance: Changing patterns of worker organisation on South Africa's Bushveld Igneous Complex, 1994–2012', BA Hons thesis, University of Cape Town, 2013.

infrastructure, etc. The company failed to meet these contractual commitments and the Department of Mineral Resources failed to force them to do so, even though it had the power to withdraw Lonmin's mining licence unless the company could provide compelling reasons. In reality, the requirements to uplift local communities are not enforced at all, even though the BEE quotas are zealously policed.

Yet despite the years of bounty, after the global recession Lonmin was in trouble. The company had over-expanded and underperformed in ore production at new and existing facilities. Lonmin had just abandoned a costly and foolhardy mechanisation project that was wholly unsuited to its narrow ore bodies. They had hoped the mechanisation would lessen their wage burden. Lonmin's woes were due mostly to what mining companies saw as an expensively run operation with poor management, exacerbated by production shortfalls because of industrial actions. Their high number of underground accidents, poor community relations and the conditions in which their workers worked and lived were problems that they thought could be fixed, or deferred at no penalty. Yet if the recession had held off a while longer, perhaps their gamble on extending production might have paid off. Few, if any, foresaw that easy loans to rental families living just above the breadline in the United States, and sold off around the world like hot potatoes to greedy investors, would result in a global meltdown.

Far from the electronic trading floors that drive world capitalism and Lonmin's luxurious London boardroom, further trouble was afoot. Workers were restive; their salaries had not kept pace with the heady rise of the price of platinum or the dividends of gleeful investors. Labour unrest on the platinum belt had become endemic and the strikes were increasingly unfettered by the dominant union. In fact, the strikes seemed to be taking place in spite of the unions.

As new car sales eased off through the enduring recession, it seemed the only thing buoying the metal price was the volatility of South African labour, which was keeping production under pressure. At the time, Lonmin's CEO was Ian Farmer.[6] Under his leadership, Lonmin had opted for appeasing its investors with hefty dividends in the good years rather than setting aside savings for the bad ones that would surely follow. When the crisis of 2012 exploded, Farmer was suddenly admitted to hospital with cancer. It

6 Farmer was CEO from 2008 to 2012.

would seem that the world's third-largest platinum producer, with 28 000 full-time employees and 10 000 contractors, and annual revenue the preceding year that nudged $2 billion, was ruled by committee and knee-jerk reactions. Even then, the company turnover in 2012 was $6 million a day.

6

Day 1:
Friday 10 August

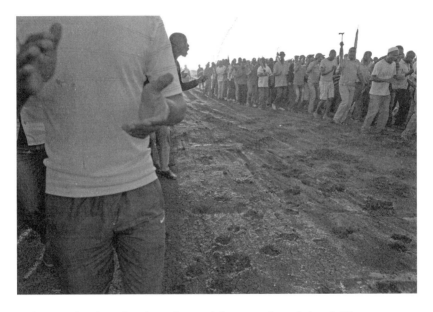

Striking Lonmin mineworkers sing as they march from a meeting at the koppie, Nkaneng, Marikana, 18 October 2012.

'I cannot talk to them now, I have exhausted that debate.'
– Lonmin counsel Advocate Schalk Burger paraphrasing Lonmin's
Barnard Mokwena regarding the strikers on 10 August 2012
during the subsequent commission of inquiry

It was just after dawn on Friday morning that the rock drill operators gathered at the entrance of Wonderkop stadium, an oasis of green lawn in the expanse of unlovable veld and spindly thorn bushes adorned with discarded plastic bags. That morning, the drillers came from their over-crowded rooms in Lonmin's hostels, from backyard shacks in Wonderkop village and the maze of shacks that was Nkaneng. As the sun lifted through the layers of Bushveld dust, the vibrant orange leached away to reveal its bleached winter mien. The crowd grew from a few hundred to three thousand men. By now, reports from the shafts to Lonmin were that just 10 per cent of RDOs had reported for their shifts. There would be no mining.

After four hours of debate, the miners resolved to march to Lonmin's local head office and put their wage demand forward in an unambiguous show of the power of withheld labour. One of the men who spoke was Bhele Dlunga, and by the end of the meeting the men called on him to lead them. Bhele recalled that they decided to present their demand for R12 500 with the expectation that they would be told this was unaffordable. They would agree to a much lower counter-offer, but not less than R7 000 a month.

The large crowd of drillers made their way along the road that led towards the Lonmin offices. Curious and anxious faces watched from behind the multiple layers of perimeter fences of the Lonmin smelter as the miners sang their way past. It was within that highly secured facility that the ore the drillers pried from deep underground was refined into something recognisably metallic. The effects of their refusal to go underground would take a long time to deplete the stockpiles that fed the white-hot furnaces, but they knew they had to break the chain of supply to have a chance of better wages.

By now, South African Police Service (SAPS) vans and an armoured Nyala had joined the Lonmin security bakkies that crept along with the phalanx of miners. At a four-way stop, Lonmin security attempted to stop them, but the miners simply walked on past. The mood of the miners was cheerful. The police drove alongside them with the sliding doors of their steel-shelled vehicles open. The men in blue were relaxed as they escorted the miners along the four kilometres of tarmac to Lonmin's management hub. The cluster of single-storeyed buildings was practically indistinguishable from many of the other utilitarian mine buildings, except for the increased number of shade trees. Here the marchers were again met by mine security.

What the miners did not know was that there had been a flurry of activity preceding their arrival at the local company headquarters. Lonmin's directors and managers there had hastily set up a conference call with the executive vice president of human capital at the Johannesburg head office, Barnard Mokwena. Together they came to the conclusion that they should not give an inch to the drillers' show of force. In Mokwena's opinion, the issue had already been discussed at the top level in the company – at the executive committee back in June, when they had decided to grant the drillers the unilateral allowance. As far as Lonmin was concerned, the issue was closed. Mokwena was much irritated by the presumption of the marchers, as well as their demands. Over the preceding weeks he had sent several 'communiqués' to the drillers, informing them that they should not breach the negotiating protocols that had evolved over the years.

On that Friday, he instructed the managers on the ground not to speak to the miners. On the face of it, this was because it would set a precedent that neither Lonmin nor any of the other mines desired. No one wanted workers airing their complaints, especially wage grievances, outside of established channels. But it ran deeper than that. Lonmin had for a long time practically outsourced employee relations to the unions. Mokwena and mine management across the industry had worked out a complicated dance with NUM, and to a lesser extent with the two smaller unions with dominantly white memberships. The main characters knew one another quite intimately on a shaft level, and as these elected unionists worked their way up the trade union ladder and as the mine managers climbed to higher corporate positions, there was a depth and a history to their relationships. In the South African context, these connecting strands were knotted together

in even more complicated ways by the requirement that mining companies have an 18 per cent black shareholding.[1] The face of Lonmin's black economic empowerment at that time was the founder of NUM, and ruling party prince, Cyril Ramaphosa.

On one of the three mines that made up Lonmin, that closed matrix was in danger of being unravelled. At Karee, AMCU had usurped NUM. To Mokwena and Lonmin, it was no coincidence that the rock drillers' R12 500 demand had originated from troubled Karee. They believed it was here that an outsider union, apparently spearheaded by the renegade former union firebrand Steve Khululekile, had fuelled and directed the drillers' unhappiness the year before.

The drillers' challenge was more than just what the mine considered an unreasonable wage demand – it was an attack on the entire way of doing business. The unsettling phenomenon of workers rejecting their own unions to make alarming wage demands that had begun earlier that year at neighbouring Impala Platinum had set a new and dangerous precedent.

Mokwena had also been in touch with the leadership of both NUM and the more militant new-kid-on-the-block AMCU. NUM general secretary Frans Baleni and AMCU president Joseph Mathunjwa told Mokwena not to engage with the drillers while they were carrying out an unprotected strike, and assured the mine that neither union was a part of it.

Despite Mathunjwa agreeing with Mokwena that Lonmin should not discuss wages with workers outside of union structures, Mokwena believed that AMCU was behind the strike. He was persuaded that AMCU was going to use the strike to force Lonmin to officially recognise them as the majority union at Karee, which AMCU had indeed become over the past months under the covert leadership of the incendiary Khululekile.

Mokwena instructed managers in the field office not to speak 'to a faceless crowd' and that any wage-related demands should go through NUM. The depiction of the miners as faceless would become a key part of Lonmin's strategy in dealing with them over the days to come. The claim was that since they were not going through recognised channels, and were not represented by unionists that Mokwena knew by name, the strikers were 'unknown' to Lonmin. The recalcitrant drillers would be dehumanised, de-individualised and treated by management as a commodity, a unit of labour that was the most troublesome part of the complex machinery of

1 From 2014, that requirement went up to 26 per cent.

mining. Despite being 'an indigenous sort of African',[2] whose own brother was an underground mineworker, Mokwena exhibited a patronising and dismissive attitude towards the strikers, treating them as if they were misbehaving children.

By the time the marchers arrived at their destination, the offices were marked off-limits to them by caution tape. A handful were allowed to go forward to speak with the head of mine security, Graeme Sinclair, flanked by several other security officers and policemen. Among these miners' representatives were three men who would feature repeatedly in the strike narrative: Bhele Dlunga, Andries Motlapula Ntsenyeho and 'Anele'. Sinclair, speaking in the pidgin lingua franca of the mines, Fanagalo, told the group's representatives that management was refusing to speak with them, and asked them for a copy of their demands. The drillers replied, part tongue-in-cheek, that this was not possible, as they were illiterate – they just wanted to speak to the CEO Ian Farmer about increasing their wages. Their demands, however, were indeed in writing, on a flattened cardboard box that simply read 'R12 500'.

Sinclair told them to put their demands through NUM, as there was an agreement in place until the following year, and that their strike was illegal. As would occur time and again, the unprotected though legal strike would be dubbed illegal by Lonmin, the police and the media. Under South African law, as well as the constitution, strikes are not illegal. They are either sanctioned by following due procedure with a representative union, thus protecting the strikers from unilateral dismissal, or they are wildcat and unprotected, leaving the strikers vulnerable to being fired. Neither is illegal.

Thwarted from the opportunity to meet their employer, the miners asked Sinclair what they should do next. They were dismissively told to do whatever they wanted, in contravention of Lonmin's clear and sensible procedure for dealing with such impromptu industrial actions. Bhele and the other leaders managed to convince the angered workers that while they had failed and the white man was taking them for fools, they should leave to discuss the next course of action. As the drill operators retraced their route, Mokwena issued yet another communiqué – that the striking miners must cease the 'unprotected march and work stoppage'. Lonmin's lawyers put together an application to the Labour Court for an interdict of the strike,

2 Advocate Dumisa Ntsebeza, Marikana Commission of Inquiry, day 291/2.

citing NUM, AMCU and the drillers who had not shown up for work that day. The interdict included an appendix of all the striking miners' names, showing that they were in fact not unknown or faceless to the company or to Mokwena.

NUM had not been idle during the mobilisation of the drillers. One of the regional officials, Daluvuyo Bongo, had for days been trying to persuade NUM loyalists not to support the strike. Two days previously, on the 8th, Bongo had orchestrated a NUM rally for the RDOs. His email reporting on the rally to several Lonmin executives and senior managers reveals a lot about his position, as does the reply:

> Good night
> Our mass meeting went peaceful and the attendance was very good. We educate the RDO and show the danger they will achieved in their wrong doing. Some NUM members advice them as well.
> Regards
> Daluvuyo

The first response was from Larry Dietrich, one of the vice presidents of mining:

> Good evening thank you very much greatly appreciated indeed you are a leader and a man of your word thanks Larry

The next was from Ettiene Hamman, a senior manager:

> Thanks Daluvuyo for the feedback. Hope the understand and can get back to adding value at the shaft. The rumour is that they will not be at work 2morrow, hope you Influence is effective. The visit from the DMR[3] was tough but good work done by the NUM guys that joined the various groups. Any info please let me know, thanks for your friendship.

The class and power differential was apparent in the contrast in exchanges between them, as well as in the way that Bongo was used more as a

3 The Department of Mineral Resources, ostensibly checking that the mine was keeping to its licensing agreements.

management surrogate than as a representative of the union members. This underscored the miners' grievance that NUM had drifted closer to management, and away from their members. It was one of the reasons for the anarchy on the platinum belt – the order of things was falling apart.

The drillers had been disabused of their initial optimism that they could discuss their demands with the Karee manager Mike da Costa, as they had previously done under the Lonmin 'line of sight' policy that encouraged direct communications between managers and workers to prevent work stoppages. The Karee drillers had just weeks previously been able to have their non-union representatives initiate a de facto negotiation with Lonmin about their salaries that had seen Lonmin's executive come back with the drillers' allowance offer.

At a meeting back at Wonderkop, the marchers voted with a show of hands to continue with the strike, and to ignore NUM. The men also agreed to prevent any other miners from going to work. Word soon got out that the drillers were going to disrupt the early shift that started at two in the morning. The accepted wisdom that drillers were tough bruisers who did not flinch from violence was a powerful factor in intimidating other workers who up until then were not involved in what was an RDO affair.

Bongo and NUM began to mobilise their forces to transport and protect drillers who wanted to defy the wildcat strike call. The confrontation was about to begin.

Lonmin security had called the Marikana police station several times for an extra police presence, and the perceived lack of a satisfactory response frustrated them. It was indicative of just how much influence Lonmin had that one of their security managers, feeling that the local Marikana police station was not responding to the company's needs with enough vigour, had earlier that day called the province's police commissioner, Lieutenant General Mirriam Zukiswa Mbombo, and urged her to deploy greater numbers of policemen to the situation. The two dozen policemen who had escorted the miners as they marched to and from the Lonmin headquarters were under the command of Marikana's Captain Veerasamy Govender. He and his men withdrew once he felt that their immediate presence was no longer required, much to Lonmin's chagrin. Lonmin's intelligence sources and information fed to them by NUM's Bongo convinced the company that the matter was going to escalate. The first overt manifestations of intimidation were reported from the local NUM office. It was probably this that prompted Bongo to try to organise an impromptu counter-rally

for that same afternoon, an idea that Lonmin had quashed in a brusque email: 'Bongo, no no.'

It became clear that the drillers planned to disrupt the next shift. A group of about 200 men armed mainly with sticks appeared at the Karee 3 mine, while other smaller groups of drillers skulked at key intersections and bus stops. Lonmin security officials drove around in their bakkies looking for groups of men they deemed suspicious. The officials were armed with shot-guns and some had sidearms, and at least two of them had fired on the strikers on three occasions.

In the first of these incidents, soon after darkness fell, security officers said a group of twenty to thirty men armed with sticks, spears and pangas were threatening employees coming off shift and those attempting to get to work for the next shift. The security men's reports said they aimed low, at the legs of the men, who swiftly scattered. Yet at that same time, and in the same place, Lonmin employee Thando Mutengwane was walking with a friend towards his home at Nkaneng settlement after alighting from a minibus taxi when white men in a Lonmin security double-cab bakkie opened fire. Mutengwane was painfully shot in the thigh with a rubber bullet. He fled to the nearby hospital. Over an hour later, another Lonmin employee, Bulelani Dlomo, was making his way home after being dropped off by a minibus taxi when he heard four or five shots fired from a group of Lonmin security men. He was hit in the head with a rubber bullet and regained consciousness in hospital.

In their occurrence logbook, Lonmin's security men described the various incidents as a conflated single incident. The Lonmin reports claimed that the police had been present at the shootings; the police report denied this. Furthermore, the injuries to the two workers shot by Lonmin security personnel were put down to a 'clash of rival unions', baldly stating it was the striking miners who shot Dlomo and Mutengwane. This despite the two men having opened attempted-murder charges at the local police station, in which they clearly stated it was Lonmin security who shot them.

The police's Captain Govender stated that he and his men were parked at a key crossroads as requested by Lonmin security officers. During the evening, the Lonmin men approached Govender and asked him to disperse a group of men who they claimed were intimidating non-striking workers. Govender says he walked over to the group, who were non-threatening and unarmed. Lonmin's intent was clearly to distort the facts and demonise the strikers, setting the tone for the days to follow.

7

Union Business

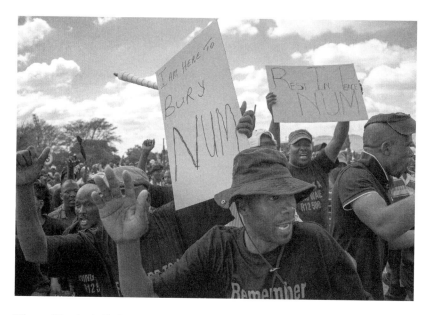

When striking Anglo Platinum miners tried to hijack a COSATU/NUM rally at Olympia Stadium in Rustenburg, clashes between workers ensued. NUM and the umbrella federation COSATU used the rally to start a campaign to try to regain lost members, and control of Lonmin and Anglo American Platinum mines, 27 October 2012.

'Not all animals are equal.'
 – AMCU president Joseph Mathunjwa on NUM[1]

T he antagonism shown by Lonmin's Karee drillers towards NUM was one of the key factors in the way the strike developed as it did. It also ruled out the possibility of a negotiated solution.

For two decades NUM was the largest union in the country, with 300 000 paid-up members at its peak in the first decade of the twenty-first century. It was also the cornerstone of the ruling-party-aligned union federation, COSATU. It wielded great power within the mining industry, and was able to call out huge work stay-aways that crippled the entire sector. Yet, unlike on the gold mines where NUM had first risen to prominence under Cyril Ramaphosa, the platinum-belt mines were split between South Africa proper and the then homeland of Bophuthatswana. Lonmin's Karee and Western Platinum mines were in South Africa, where NUM was allowed to operate, but Eastern Platinum was in the authoritarian Bophuthatswana, which did not allow the 'foreign-based' NUM to operate. It was only after the abolition of the homelands in 1994 that unions could campaign freely, unifying across the entire platinum belt.

Even then, other forces came into play. The mining companies had begun to use labour brokers to try to dilute the power of unionised labour. And NUM itself began to change from an altruistic workers' champion into an organisation that often served individual ambition and greed. An agreement was reached whereby the mines paid full-time shaft stewards a wage that was substantially higher than the elected official's original salary as, for instance,

1 Mathunjwa is paraphrasing a quote from George Orwell's *Animal Farm*, which actually reads 'All animals are equal, but some animals are more equal than others'.

a driller. This cosy relationship led to corruption and factionalism as groups vied for the handful of union positions.

The commodities boom at the turn of the twenty-first century did not reflect in the salaries paid to miners. There was a lag between the record earnings of the companies and what they paid their workers. In 2006, NUM's platinum sector members nominated union stalwart Archie Palane to run against Frans Baleni for the post of general secretary – the most powerful position in the union, then held by Gwede Mantashe. Just before the vote at congress, Palane was told he could not contest the election. The reason given was that while he had been an employee of the union for two decades, he had never worked as a miner and never been a dues-paying member of NUM. This regulation had been added at the previous congress. His supporters (including Ramaphosa) cried foul, and conspiracy theories abounded, but Baleni ran unopposed.[2] Palane's last-minute disqualification meant he was also unable to stand for the post he held – that of deputy president. He was pushed out of NUM altogether.

The Palane-versus-Baleni contest seemed a straightforward enough union battle, yet at the time there was a great rift within the ruling African National Congress caused by the leadership battle between then president Thabo Mbeki and his former deputy president Jacob Zuma, whom he had fired for corruption. Palane and his platinum sector supporters were seen to be sympathetic to Mbeki's cause, while Baleni was, and is, wholly supportive of Zuma.

In the squalid mining settlements and hostels, most unionists did not directly consider these power battles when making their choice. The majority of platinum miners backed Palane because he had engaged with their particular problems and struggles. He had been a champion of the platinum sector, being included in the central bargaining mechanism with the Chamber of Mines – the body that represents mining companies' interests. The gold and coal sectors have such an agreement, which standardises working conditions and allows for more orderly wage negotiations. The downside for the employers is that these councils tend to push up the cost of labour across a sector and force more stringent adherence to labour legislation. The platinum companies also feared that there would be greater control over the use of labour brokers and subcontractors to evade South

2 Baleni would hold the post until 2015.

Africa's pro-worker labour laws. All these changes would cost the companies and their shareholders more money.

What will never be known is if Palane had indeed been elected, would the platinum sector have been a more peaceful place in the turbulent years leading up to 2012? In any event, the platinum miners had not forgotten the treatment of the man they had considered their champion. In September 2009, when a NUM vice president, Piet Matosa,[3] tried to persuade his striking members at Impala Platinum's Steelpoort mine that management's wage offer was a fair one even though it fell short of their demands, they did not respond well. A rock was thrown at him, injuring one of his eyes so badly that he lost it.[4]

It is instructive to broadly examine the links between the union and the ruling party. Gwede Mantashe was NUM general secretary during the Baleni–Palane dust-up. The victor, Baleni, was Mantashe's protégé. Mantashe himself went on to become the ruling party's secretary general, the party's most powerful position. In December 2012, at the ANC's fifty-third conference held in Mangaung (Bloemfontein), Baleni's loyalty to Zuma and Mantashe was rewarded with a position on the ANC's National Executive Committee (NEC). Matosa went on to become NUM president.

It was at the 2012 conference that Zuma consolidated his hold over the ANC, and Cyril Ramaphosa was elected as ANC deputy president. Zuma's only challenger for the position of ANC president was his then deputy, Kgalema Motlanthe.[5] Motlanthe had also put in his time at NUM, having been elected general secretary in 1992. He too served as South Africa's deputy president and even as an interim president after Mbeki's ousting and before Zuma's ascension, from September 2008 to May 2009.

Superficially it seemed a natural fit – a socialist African liberation party teaming up with a militant union. The union would help deliver the working man's vote and the ANC would in turn defend the working man against the excesses of capitalism. The mineworkers' union was one of the left's pathways to power, and as such it had its collective eye fixed on matters far loftier than a fair day's wage for lowly drill operators.

3 Matosa was elected NUM president in 2015.

4 Jan de Lange, 'Platinum – a hotbed of unrest', *miningmx*, 7 September 2009, http://www .miningmx.com/opinion/columnists/jan-de-lange/Platinum-a-hotbed-of-unrest%20.htm (last accessed September 2015).

5 Motlanthe would be excluded from any politics of note after his defeat against Zuma at Mangaung.

The three partners in the tripartite alliance – the ANC, COSATU and the SACP – increasingly lived the contradiction of speaking the language of Marx and postmodern progressive developmental politics while openly gorging at the table of capitalism.

The unions affiliated to COSATU were obvious partners to benefit from the new relationships, and the unions invested heavily in the Johannesburg Stock Exchange and listed companies, raising a fund worth more than R5 billion.

Members and their families were promised a share of the largesse. Government-legislated employment equity saw miners allocated shares in the mines in which they worked, buying in at a fixed cost, with loans from commercial banks. Given the volatile nature of commodity prices, it was a risky arrangement. Lonmin was required to make 18 per cent of its shares available to the miners, as well as a peculiar mix of black benefici-aries, including state entities such as the civil servants' pension fund (PIC). The Incwala trust, through which these shares were held, was set up in a detrimental way for Lonmin's miners – the company itself did not guar-antee their employees the shares at a pre-set price. When the share price dropped in the recession, the junior BEE partners of Incwala were unable to service their debts as dividends stopped being paid. The situation was dire not only for the BEE partners but also for Lonmin. Were Lonmin to default on the BEE requirements under the Mining Charter, they would be in danger of losing their mining licence. The company came to a decision to jettison the small players and bring on board a black person who 'brought a lot to the table': a political heavyweight to further their influence with government.

Circling back to the relationship between the unions and the mines, it is worthwhile looking at how the mining industry is organised. Mining companies in South Africa are united in a forum called the Chamber of Mines. Just a year after gold was discovered in the Transvaal in 1886, the chamber was formed to promote the interests of the mining companies. It is within this forum, a century and a quarter later, that competing mining houses still work together on strategies to outwit the state, their employees and the unions. In recent decades, these arch-capitalists had forged a close working relationship with the ostensibly radical leftist NUM. Despite the public strikes and anti-capitalist speeches, all of the elected officials' gener-ous salaries were borne by the very mining companies against whom they represented their members. The same deal applied to the minority unions

UASA (formerly the United Association of South Africa) and Solidarity, but at much lower salaries.[6]

In the case of the lowly shaft or shop steward, elected by his working comrades, it made sense for the mine to pay a salary to the person who was the link in the relationship between workers and lower management. The elected shaft steward was suspiciously monitored by union members to ensure he worked on their behalf. Yet in the case of regional and national office bearers, the workers' ability to monitor individual office bearers' conduct was vastly diminished, and the massive salaries they received from the mining houses with which they negotiated was an obvious conflict of interest that was seemingly ignored.

'The Arrangement', as it is called, began in the late eighties, as a response to NUM's alleged financial vulnerability. Archie Palane, the man thwarted of a run at the NUM presidency and who was a hired employee (not an elected official) whose salary was paid by members' subscriptions, explains the background. The practice had its genesis in 1987, he says. 'The full-time position was negotiated and agreed upon as an outcome of the 1987 strike where James Motlatsi was fired by Anglo [American].' NUM had begun to look at its options, and wondered if any of its active and militant leaders would survive within the industry. Palane says that, back then, the mining companies had a strategy of either firing effective unionists or hiring them into a managerial role: 'Once there, they lose touch with the workers. That is why you would find union leaders would be moved into management and then management would find a way of getting rid of them because management don't forget what you cost them, what chaos you caused them.' According to Palane, The Arrangement was an executive decision from within NUM: 'We were not going to allow the leadership of the union to be intimidated and victimised by management … for being militant.'

Perhaps this was indeed the original motivation, but Palane recalls that the concept was so controversial that the iconic British trade unionist Arthur

6 Solidarity and UASA mostly represent white workers as well as higher-paid workers of all races. The salaries paid to these union leaders are far lower than those of the powerful NUM officials. AMCU at one stage also enjoyed the same benefit, but later ceased the practice. Mathunjwa claims he was earning R300 000 a year from BHP Billiton, while his counterpart at NUM was earning R1.4 million. See Greg Marinovich, 'Conflict of Interest, Inc: Mining unions' leaders were representing their members while in corporations' pay', *Daily Maverick*, 24 April 2013, http://www.dailymaverick.co.za/article/2013-04-24-conflict-of-interest-inc -mining-unions-leaders-were-representing-their-members-while-in-corporations-pay/# .Ve1fchGqpBc (last accessed September 2015).

Scargill scathingly attacked the South African miners' representatives for contemplating such a potentially compromising deal. Scargill's criticisms were ignored, and The Arrangement came into being. By 2012, NUM president Senzeni Zokwana was earning more than R1.4 million a year. Initially this had been paid by gold giant AngloGold Ashanti, but later this burden was divvied up among all the chamber's members. Zokwana, then also the chairperson of the SACP and a member of the ANC's powerful NEC, defended the secondment practice in an uncomfortable interview, insisting that he and others served the interests of the members, and that his repeated re-election to the post proved his integrity. 'The question is, is this person still relevant to lead us or not?' he asked rhetorically.[7]

Zokwana's deputy, Piet Matosa, was earning a similar salary, paid initially by BHP Billiton, for whom he had worked many years earlier. Top union officials also benefited from serving on a variety of boards. They were certainly no longer reliant on the working classes, except at the union electoral congresses. The estimated number of NUM officials who were part of such deals varied. Some insiders put the figure at 300, others at 40. It would seem that the correct number was closer to the top end, as one gold mine alone had seven elected officials on so-called secondment.[8] These top unionists advertised neither the source nor the extent of their salary packages to the rank and file. The mining industry also kept the arrangement quiet, burying the sums in their vast payrolls.

While it was the unions, desperately short of resources in the late eighties, who initiated the idea that the then reluctant mines pay the salaries of elected officials, it soon became clear that the arrangement had benefits for the corporations.

Initially, it seemed as if the all-powerful NUM was above being corrupted by the source of their new-found opulence. The unionists would meet with mining companies and intimidate them into paying higher salaries, not to the workers but to the national and regional officials. 'If you go in there and the employer shivers, he gives more,' chuckles Palane, years after he left the union for employment in the corporate mining world.

Once every elected official from the president to the provincial and regional branches and all the way down to shaft level was on the mining houses' payroll, the union began to change. They grew distant from their

7 Marinovich, 'Conflict of Interest, Inc'.
8 Author interview with source whose name has been withheld, 2012.

members. As much as NUM officials like Zokwana emphatically denied that those massive salaries had any influence on how the union represented their members in wage negotiations and disputes, it is clear that this was not the case.[9] NUM's own internal report for 2006 speaks of the union's failure: 'deep rot was taking the region into organisational decay'.[10]

One insider repeatedly witnessed breathtaking shenanigans during wage talks. The union would make bold, headline-catching demands of the employer, accompanied by threats of industrial action. The ever-desperate workers would be excited with the high percentage increases demanded. Yet at some critical stage, the union negotiator and the mine's representative would huddle in a corridor and exchange whispers before a much lower wage deal was somehow agreed to. That increase would then be touted as a major victory for the union, even though it sometimes fell short of even matching inflation. Of course, the union officials kept on drawing their salaries even as the miners gritted their teeth during lengthy unpaid strikes. It would usually take the miners many months, if not years, of the improved salary to catch up on lost wages from strikes.[11]

Over the years, as the leadership of NUM grew dependent on executive-level salaries, the benefits of the deal swung towards the corporations as their leverage increased over union decision-makers. By 2011, the power of NUM was on the wane. They were losing members to AMCU and the mining companies were eager to seize the opportunity. The members of the chamber had discussed their move at length and they quietly made preparations to terminate The Arrangement. When told of the upcoming end of payments in late 2012, the top NUM officials were appalled, and incredulously asked the chamber's chief executive, Bheki Sibiya, if he understood just how dire the financial implications for the unionists would be. As it turned out, it was not that simple for the mining houses to shed their burden; the unions threatened to fight and take out every worker on strike. By 2015, The Arrangement was still in place.

At the lower end, full-time shaft or shop stewards received a few thousand rand extra per month to bring them up to a Paterson C-level pay grade – roughly R12 000 to R14 000 a month. They also received a company vehicle, company petrol card and company cellphone. Then there

9 Author interview with Zokwana, 2012.
10 SWOP, Servicing Report for the National Union of Mineworkers (2005), p. 31; NUM, Annual
 Secretariat Report (2006), p. 12.
11 Interview with John Brand, dispute mediator at Bowman Gilfillan.

were additional perks such as *bosberaads* or company get-togethers and excursions. Most importantly, perhaps, they were freed from the arduous labour and conditions that had encouraged them to join the union in the first place.

For shaft stewards who failed to win re-election, the arrangement was such that their original employers would allow them to return to their old jobs. Palane explains how he watched union values erode: 'You are a full-time shop steward and you have a lifestyle change, you start driving a car. The danger was when people began to see material gains, the shop stewards lost touch with the rank and file.'

The officials would do anything to retain their positions. It became a cabal. The mines understood this, and encouraged union representatives to do training courses that qualified them for jobs that would allow them to retain their elevated salaries and avoid going back underground. The allure of these posts led to deadly competition. Many of the deaths related to strikes in the platinum belt were as a direct result of different factions vying for the full-time shop-steward positions, using the cover of the strike as a chance to get rid of a competitor.

Many of the mineworkers inevitably began to perceive that their union representatives put the interests of the mining companies and the share-holders ahead of the rank-and-file union members. Dues-paying members who toiled underground and lived in shacks without running water or electricity had a pretty good inkling of where the union's loyalties now lay. This sense of betrayal fed the anger and anxiety of the miners. Their power to combat exploitation by their employer lay in their collective strength. And the expression of that collective, the union, spouted empty rhetoric while supping with their adversary. It was this alienation from NUM that intensified an emotional vortex of despair and desperation, and led to seem-ingly anarchic wildcat strikes.

The first of the strikes that directly relates to what would later happen at Marikana was the May 2011 strike at Lonmin's Karee mine. At that stage, workers at Karee were still affiliated to NUM, but there were serious grievances between the elected Karee branch leadership and the regional headquarters in Rustenburg. The local mine leadership had been elected by miners opposed to the way the regional NUM office had become a 'sweetheart union'. It looked like a local turf battle between a rough-and-ready populist Karee shop steward (Steve Khululekile) and a dominating union leadership, but there were more strands to that tangled web. Many

believed that Khululekile was helping the workers fight the loss of their Lonmin shares to Ramaphosa, but others saw it as a power play by a strong-armed local official.

In a bitter contest that saw at least one miner murdered, NUM suspended Steve and his deputy, and, as has already been mentioned, on 17 May 2011 the entire workforce of 9 000 workers went out on strike to protest the attempted ousting of their champion. NUM and Lonmin agreed to fire the entire Karee workforce, and the union that represented the vast majority of fired workers went so far as to openly support the mass dismissals. National NUM spokesman Lesley Seshoka told a mining journal that 'unfortunately, the company cannot have such people and has to let them go' and that the union 'would not support those who were on the wrong side of the law'. Of the 9 000 workers who were fired, all but 1 400 were rehired. The process was meant to weed out the more militant miners and anyone who was perceived as too close to Steve.[12]

What looked like a decisive win for Lonmin and NUM would turn out to be a pyrrhic victory. Across the platinum belt, miners had begun to turn against NUM and their dominance was at risk. By late 2011, AMCU was poised to dislodge NUM at both Lonmin and Impala Platinum. The mining companies' reliance on a relatively compliant union that controlled the ambitions of the workforce was in danger. Some of NUM's otherwise inexplicably anti-worker actions and statements can only be explained as those of a union serving the ANC's political interest above that of workers, despite its struggling to retain membership.

From 2005 through 2012, NUM and COSATU were distracted by the internal politics of the ANC and their strenuous attempts to save Jacob Zuma from, at various times, destitution, jail and a fall from power. He was fired from his position as the country's deputy president by Thabo Mbeki because of a court ruling that businessman and ANC stalwart Schabir Shaik had been involved in a corrupt relationship with Zuma and an international arms manufacturer. But Zuma remained the ruling party's deputy president, allowing him to stage a political insurrection. COSATU, the SACP and the ANC Youth League under the bombastic Julius Malema gambled all to help Zuma defeat Mbeki at the ANC's fifty-second congress at Polokwane in 2007. There had been no need for Zuma to stage a coup to

12 Liv Shange, '1,400 Rustenburg mine workers still sacked', *Socialistworld.net*, 10 June 2011, http://www.socialistworld.net/print/5129 (last accessed September 2015); Marikana Commission of Inquiry.

seize power – all he had to do was seize control of the ruling party. Given the ANC's massive electoral majority, Zuma just had to wait until he inexorably walked into the Union Buildings. The next five years of the nation's political energies were squandered in purging the party and the state of Zuma's real and perceived enemies.

The character and culture of the organisations involved were critical to how and why the Marikana strike played out as it did. Lonmin can be seen as the zenith of a neoliberal late-capitalist international mining firm, based at one of the centres of global commerce – London. It is in the heart of the City, where the belief thrives that there should be no restraint on the pursuit of profits for shareholders and investors. Yet Lonmin's main sphere of operation is in South Africa, a state run by a formerly socialist liberation movement answering to an electorate that expects their liberators from the former colonial and apartheid rulers to eliminate the cruel excesses of capitalism and redistribute wealth more equally. South African law sets quite progressive requirements on employers to treat their workers decently as well as to do their fair share to alleviate the legacy of business's abuse of black labour.

The ruling African National Congress was once labelled a terrorist organisation by Britain and the US – the prime sponsors of unfettered capitalism around the world. In a new world, Lonmin courted champions from within the liberation movement. They sought to negotiate a cheap path through the rules on uplifting their workforce and the communities on whose land they mined. Before bringing Cyril Ramaphosa on board, they believed that they had frittered away a tidy sum to meet the black-equity requirements without gaining any political collateral.

Ramaphosa rose from the miners' union he helped create, the National Union of Mineworkers, as well as the ANC. The leftist unions under COSATU have their own distinct culture of militant socialist rhetoric and a history of strikes that initially saw massive advances for workers' wages and work conditions. The power of organised labour was harnessed to play a part in the larger political picture, of addressing how apartheid dehumanised black labour in particular. South African autoworkers famously used their own time to make Nelson Mandela a luxury Mercedes-Benz in 1990. It was a grand gesture from the unionists, who called it a 'labour of love' when handing over the vehicle. Throughout the first years of his freedom, Mandela drove the red Mercedes, a constant reminder of the workers' love for him and the ANC he led. Yet what is rarely spoken about, except in

a company video about that time, is that the parts and other costs were carried by the company – what the workers called 'Mercedes meeting them halfway'. This probably rendered the car less a gift from the workers and more a corporate branding exercise, and speaks to the uneasy relationship between politics, business and the theatre of perception.[13]

Through it all, the miners watched, growing more and more disillusioned with their union and their party, as almost all were ANC voters. A career path for a miner is a race to earn enough money to care for his family, to build a house in his home area and to be able to retire with a few comforts. The Lonmin miners' decision to embark on an unpaid strike was not reckless; it was born of financial desperation, of the knowledge that no matter how much sweat they shed or blood they sacrificed, they would end their life in poverty.

13 Mercedes-Benz *Labour of Love* short film, https://www.youtube.com/watch?v=ZLtYr3dowvs (last accessed September 2015).

8

Day 2:
Saturday 11 August

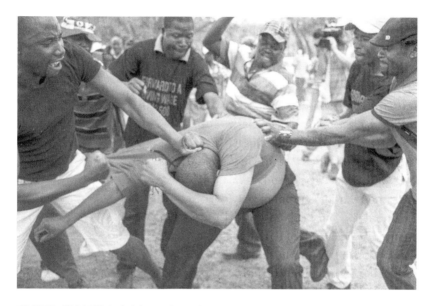

COSATU official Billy Zulu is beaten by Anglo American Platinum strikers attempting to prevent COSATU and NUM staging a 'Reclaim Lonmin' campaign at Olympia Stadium, Rustenburg, 27 October 2012.

'At the place where I grew up, I had never been told that fighting depends on numbers. What I know is that if there are two groups facing one another, one would lose the fight.'
— Saziso Gegeleza, Lonmin NUM shaft steward, who was involved in the skirmish with striking miners on 11 August

In the villages, settlements and shanties around the smelter, the heart of Lonmin's Marikana operation, few managed more than a little sleep on Friday night. The strike leadership and their opposing numbers among the NUM shaft stewards did not sleep at all. There were several incidents of intimidation by the striking drillers and a few flared into small-scale confrontations. NUM stewards were trying to counter the strikers' call, and they spent the night ferrying their members to and from their homes and the shafts in Lonmin minibuses.

By two in the morning, seeing how few miners had reported for the graveyard shift, NUM local leaders Daluvuyo Bongo and Malesela William 'Brown' Setelele led NUM stalwarts through residential areas with loud-hailers to dissuade workers from joining the strike. They prudently stuck to areas where the drillers had less influence, steering clear of the depths of Nkaneng shantytown. Setelele drove around the village of Wonderkop with a loudhailer, announcing that NUM was not endorsing the strike and that all workers should go to work. Setelele chose Wonderkop as this was a Tswana-speaking village of the Bapo ba Mogale people. Lonmin mines are on Bapo ancestral land, and the company pays rent as well as royalties into a central trust that is then meant to be drawn on by the community. Many of the indigenous Bapo, as they are known, work at the various western-most mines, and mostly in less arduous jobs than the migrants. None were drill operators, and very few worked at Karee mine, the epicentre of the discontent. Many Bapo residents of Wonderkop profited by erecting and renting shacks to migrants. These compounds are called 'ma-line', refer-ring to the line of shacks that are the dominant architectural feature of Wonderkop's backyards.

Other NUM officials crossed the road from their small brick office on the edge of Wonderkop village to Lonmin's hostels. Here they walked through the complex of mostly dilapidated company dwellings, calling out to workers in an attempt to persuade them to go to work. By five in the morning, Bongo had written an email to the Lonmin management and security officials, reporting that strikers had assaulted those wishing to go to work. Bongo asked for all NUM shop stewards to be released from work duty so that they could be available to counter the strikers' intimidation and for Lonmin 'security to work with the NUM as a team'.[1]

The striking miners were incensed. Their efforts to get a complete lockdown of the mine, by whatever means necessary, were being thwarted. It was clear that NUM was working hand in glove with Lonmin to break the strike.

One of the union officials who was unaware of the overnight clashes was Saziso Albert Gegeleza. He was hired by Lonmin in 2001 as a general worker and immediately joined NUM. Within months he managed to secure the better-paid job of rock drill operator. In 2011, he was elected as vice secretary of Rowland shaft at Lonmin's Western Platinum operation. That Saturday morning, he left his shack for work at five-thirty. On the way, he fell in with a group of NUM shaft stewards armed with knobkierries and pangas. Gegeleza stalked the sprawling Wonderkop hostel and nearby taxi rank calling on miners in both isiXhosa and Fanagalo to get to work. When the small band of NUM officials neared Lonmin's rugby/soccer stadium, they found a group of drillers gathered in the veld. It was the striking RDOs debating whether or not to march on the NUM office.

Gegeleza returned to the NUM Wonderkop office, and by eight o'clock a spy from within the RDO meeting phoned to warn that the drillers were coming, threatening to burn the office as well as the vehicles that had been used to ferry workers to the shafts. The call galvanised the NUM men. Bongo handed out an assortment of primitive but deadly weapons to those crammed inside the office. Some of these weapons belonged to NUM officials who had spent the night escorting workers and challenging the intimidating strikers; others had been taken off the striking miners. A pair of Lonmin security officers parked outside confirmed that the strikers were indeed coming and advised the unionists to vacate the building. Six kilometres away, Lonmin head of security Graeme Sinclair was making

1 Marikana Commission of Inquiry.

increasingly frantic calls to the Marikana police station for assistance. They went unheeded.

The Nkaneng/Wonderkop sprawl can best be described as a triangle, with its apex facing north. To the south, below the triangle's base, lie the smelter and the Rowland shaft complex, part of Western Platinum. The left aspect of the triangle, running south-west to north-east, is fully occupied by Nkaneng. The right side of the triangle is mostly occupied by the village of Wonderkop, though not quite reaching all the way to the apex. Caught between the two upright aspects, above the base, is the mine hospital, the hostel and the sports stadium. From where the strikers had met outside the stadium, the crowd of between one and two thousand marched along the mine road that led due east through the hostel complex to where it bisected Wonderkop's main road, at the minibus taxi rank.

The two branch leaders, Bongo and Setelele, discussed how best to defend the NUM office. The security guards drove off and parked several hundred metres away from the office and the oncoming marchers, and several of the less heroic NUM officials took this as a cue and departed. Setelele and Bongo decided that this was an appropriate time to take the Toyota Quantum mini-van and Bongo's personal car to the mine hospital for safekeeping. They selected a circuitous route to avoid the strikers' approach, which also conveniently ensured they were gone long enough to miss the confrontation.

The NUM men at the office could hear the singing of still-invisible marchers as they approached the intersection with the main road. They were twenty men preparing to oppose more than a thousand. Despite being the father of three children, Gegeleza was one of those who elected to stay and protect the office. A former driller himself, Gegeleza was a tough guy and fiercely loyal to NUM. He led five men armed with traditional weapons to the rear of the NUM office, where they had a clear view of the route along which they expected the marchers to approach. The rest took to a side road, where they were hidden by an adjoining building.

Almost as soon as Gegeleza reached his appointed spot, he saw the RDOs approaching. He and his small group ran across a patch of unused land towards the road. The strikers noticed them and stopped, shouting insults, calling them dogs. Gegeleza was afraid, but also determined to protect his beloved NUM, and was prepared to lay down his life for his organisation. He led his tiny band of men directly to the mob, and began singing. One of the marchers later recalled hearing the words 'AMCU' and 'Karee' being shouted before the fight started.

Gegeleza may have seemed foolhardy, suicidal even, but the NUM officials had hatched a plan in the time between the warning and the arrival of the marchers. Gegeleza and his men were the decoy, drawing the strikers' attention away from the rest, who were out of sight down a side street. The situation unravelled very quickly. Which group initiated the actual physical clash is disputed. The NUM members assert that the strikers were the first to throw stones, but the Lonmin security guards as well as the marchers maintain that Gegeleza's group, who ran to confront the much larger mass of strikers, first threw stones and then attacked them with knobkierries and spears. Whatever the spark, everyone agrees what happened next. Startled by the belligerent confidence of the handful of defenders, the front strikers turned and ran. Suddenly three or more gunshots were fired at the retreating strikers from where the slightly larger number of NUM men lurked out of view, down the side street. All also agree that two strikers were shot. Caught utterly off guard, the marchers scattered as they fled, with Gegeleza and the NUM men close on their heels.

One of the striking miners caught up in the melee was Vusumuzi Mandla Mabuyakhulu. As he turned to flee the initial clash, he saw one of his comrades, Bongani Ngema, fall to the ground, shot in the back. Along with several other strikers, Mabuyakhulu dashed across the road, making for a gap in the prefabricated concrete fence, known informally as a 'stop nonsense'. He was pursued by NUM men, including Gegeleza, who tore after him. It was only once Mabuyakhulu had plunged through the gap in the broken fence that he felt pain in his lower back and realised he too had been shot. He ran a little further but soon collapsed. Once down, his pursuers fell upon him, demanding to know where he worked. On hearing he was from Karee, they beat him with the handle of an iron spear and stabbed him with a butcher's knife until he lost consciousness.

The NUM men who had decided to retreat before the confrontation now saw how the tables had turned on the marchers, and rejoined their comrades. Many more of the fleeing strikers were assaulted with sticks and spears, though none fatally. The terrified strikers were harried for several hundred metres by their adversaries. Many of the hostel residents emerged to watch the clash. At some stage during the commotion, Lonmin security guards fired eight rounds of rubber bullets at the fleeing strikers. As the clash wound down, the Lonmin security boss, Sinclair, arrived and met up with two of his officers. The men apprised their astounded boss of what had happened. Sinclair approached Bongo and told him to 'cool it'.

In the volatile and shame-filled aftermath, the strikers again gathered in the veld near the stadium. Believing that two of their own had been shot and killed by NUM members, and unaware that both men would survive their wounds, they made two key decisions. The first was that they would no longer meet in their usual spot as it was vulnerable to possible attack by NUM and it was mine property. The second was that it was no longer safe to sleep in their own homes, which might be vulnerable to assassination attempts by NUM. They would base themselves at the oval-shaped reddish hill off the south-western edge of Nkaneng. This koppie was known simply as Thaba, 'the Mountain', despite its underwhelming height.

The strikers also decided to arm themselves. A rush of men came into Mohammed Cassim's hardware store in Marikana town that morning, all asking for pangas, the broad-bladed machetes used for cutting thick bush and sugar cane. Cassim found it suspicious, as they concealed the blades down their trouser legs instead of having them wrapped in newspaper as his customers usually did, to allow them to be carried without cutting themselves or causing others alarm.

A few hours after the RDOs had moved to Thaba, a triumphant Bongo and Setelele addressed a meeting of about 1 000 NUM supporters on the same stretch of veld previously occupied by the strikers. Bongo said that the union was opposed to the strike and that anyone who did not report for work would face dismissal. It was a gesture of bravado to convince the alarmed NUM members that the status quo would prevail over anarchy.

Lonmin was by now seriously concerned about the escalation in violence, as well as the degree of organisation shown by the strikers. Frustrated at the police's lack of response, they began to escalate their calls for assistance further up the police and political hierarchy. Calls were put in to both the North West provincial police commissioner, Lieutenant General Mirriam Zukiswa Mbombo, and the office of the premier of the province, from which promises were extracted that sufficient police resources would be sent. As the day progressed, the police machine slowly rolled into action. Mbombo instructed her deputy, Major General Ganasen Naidoo, to assign more policemen to assist Lonmin. Naidoo in turn called Brigadier Adriaan Marthinus Calitz, the provincial head of Operational Response Services. All of these top police officers would, in the days to come, play their part in the critical decisions made.

The fledgling strike had developed into a full-blown crisis, and a handful of leaders emerged. The man who had spoken for the miners at the march

to Lonmin the day before, Bhele Dlunga, continued in a leadership role, but a thirty-year-old soccer star with an easy smile and a booming voice was thrust to the fore as well. Mgcineni 'Mambush' Noki, a driller from Karee, came from an Eastern Cape family steeped in the history of migrant labour and would in the next few days become the face of the strike.

9

The Mountain and the Magic

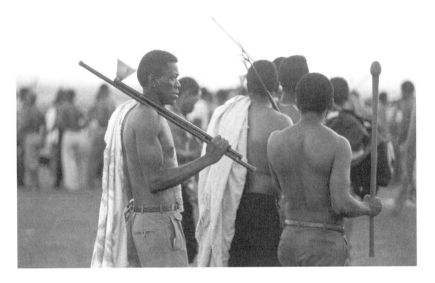

IsiXhosa-speaking ANC supporters line up at a place known as the Mountain to receive intelezi in a ritual before battle at Bekkersdal, a settlement that grew around a gold mine in the then Western Transvaal, 1994.

'Hulle trek kaalgat uit en doen iets saam met 'n sangoma.
Maak gereed om te baklei.'[1]
— Text message from Lieutenant Colonel Salmon Vermaak
while flying above the koppie (Thaba), Marikana, 11 August 2012

The angry, scared strikers who had fled in disarray from the NUM office believed, erroneously, that two of their comrades had been killed. In keeping with broadly held traditional beliefs, the miners who had been near the dead men had become polluted, so one of the strikers went to make up a herbal potion to spiritually cleanse them. These men had 'walked on the paths' of the dead men, and were thus under threat of spiritually induced misfortune. They stripped off their upper garments and stood in line to have their naked torsos sprinkled with *intelezi*, a magic potion imbued with any of a variety of powers by a traditional healer. Someone suggested they try to procure the services of the traditional healer or sangoma who, it was said, had assisted the Implats drillers to get their raise during the strike earlier in the year.

By now the imposing Mgcineni 'Mambush' Noki, with a knack for informally resolving workplace issues, had been popularly chosen as the strike leader. Noki's father had been a mineworker who died young, while Mgcineni was still in his mother's womb. Mgcineni left his family village of Twalikulu for the gold-mining area of Carletonville to find work. He was injured in an underground rockfall in 2008, and while being treated for his injuries at the local clinic he met an administrative assistant, Noluvuyo. A relationship blossomed and continued even when the shaken Noki moved to a job at Lonmin, where the harder rock was less susceptible to rockfalls. Noki and Noluvuyo married and had a daughter, Asive, who was two by the time the strike at Lonmin began.[2]

1　'They are stripping naked and doing something with a sangoma. Preparing to fight.'
2　Nick Davies, 'Marikana massacre: The untold story of the strike leader who died for workers' rights', *Guardian*, 19 May 2015, http://www.theguardian.com/world/2015/may/19/marikana -massacre-untold-story-strike-leader-died-workers-rights (last accessed September 2015); Marikana Commission of Inquiry.

Noki delegated five men to go and ask the sangoma if he was willing to assist the Lonmin miners, and what it would cost. The delegation included Xolani Nzuza, a twenty-seven-year-old winch operator who had worked for Lonmin since 2006. Nzuza had not been involved in the abortive march on the NUM office, but had met up with the retreating miners. Nzuza was the opposite of Noki, both in stature and personality. A slight, neat man, with intense, even obsessive mannerisms, he was rarely seen to smile. Nzuza's father had been an RDO at Lonmin and he brought his son to Marikana. Initially Nzuza had worked for a contractor, and then in 2007 was employed directly by Lonmin as a general worker before being promoted to winch operator.

Nzuza himself had been attacked by strikers the previous evening, the Friday, as he attempted to report for his night shift. As he had been on night shift throughout the week, he had not received the message that there was to be a strike. He had slept through most of Friday at his home, and on rising had heard two RDOs discussing that an unprotected or wild-cat strike had been called. Nzuza said he had heard no such thing, and was determined to go to work. When the usual company buses did not appear, he set off on foot. The path took him through a wooded area, where he came across four men. One of them said they recognised him and did not prevent his passing, but after he had covered just a few paces, he was pelted with stones. Nzuza turned and ran back to his compound.

On Saturday morning, Nzuza made his way to Wonderkop stadium, where he had heard there was a strike meeting. He arrived late, after the march on the NUM office. He found the agitated, frightened strikers gathered in the open veld, and he listened from under a tree to the side of the gathering. Even though Nzuza had not been a part of the strike action thus far, and was not a driller, Noki nominated him to be a part of the group to seek out a traditional healer who might grant the strikers ritual protection. Nzuza was the founder and coach of Noki's soccer team, and the Karee-based team had been named in memory of Nzuza's home area, Sterkspruit. Noki himself was a talented and popular footballer, who had been dubbed 'Mambush' in homage to his talents – Daniel 'Mambush' Mudau held the record as the national soccer league's all-time top goal scorer while playing for Mamelodi Sundowns.

Also in the delegation was Bhele Dlunga, the driller from Rowland shaft who had been one of the men chosen to represent the miners when they marched on the Lonmin offices the week before. Bhele was a fastidious

dresser with neatly ironed clothes, his trousers sporting perfect creases. He was also a priest in a small independent amaZioni[3] church. These Africanist churches bridge the world of Christianity and traditional African belief systems and practices. A Zionist church is usually founded by a person with a gift of mediumship, prophecy or healing, someone who has been called by the ancestral spirits to act for or speak to the living on their behalf. In most cases, those who are chosen as mediums can follow the traditional route as a diviner/herbalist in the sangoma or nyanga role, or use their gifts within a Christian framework and become a Zionist prophet or priest.

The group soon returned with the news that the sangoma was willing to assist them, but the price he set was R1 000 per striker. The men had a heated discussion and eventually sent Nzuza back with a counter-offer of R500, telling the sangoma that they expected 1 800 men to take part. If that was indeed to be the number of miners paying the R500 each, the sangoma could earn almost a million rand for his work.

The number of men likely to take part, much like the sangoma's price, was floated speculatively high. It was unlikely that more than a small number of the strikers would have participated in the rituals. Many were devout Christians, ranging from Catholic and Pentecostal to amaZioni, and the use of traditional potions and rituals was strictly taboo and viewed as satanic; most amaZioni shun any sort of herbal or even patent medicine, fearing it to be witchcraft. Regional and ethnic differences would also play a part in people's trust of the sangoma. The striking miners would have deliberately ignored this in their calculation, wanting to ensure that the sangoma found their proposition irresistible. Noki then instructed the strikers to decamp from the open field to the distinctive koppie, Thaba, to the west of Nkaneng settlement. At Thaba they would be able to defend themselves from any NUM attacks and it would also afford a degree of privacy for the rituals they would undergo. In light of their initial fruitless attempts to get the Lonmin bosses to address the salary issue, they believed that if they, Lonmin's workforce, stayed at Thaba long enough, their employer would sooner or later have to come to listen to their grievances. They then expected him to say that he either had the money or not, and make them an offer of what the company could pay.

The koppie was thus transformed into a ritual place in more than just a religious sense. The mountain was to become imbued with power – the site

3 The isiZulu word for 'Zionists'.

where the all-powerful and wealthy Lonmin boss would be forced to come to his workers. Thaba was where the miners believed they would find succour.

Over the decades, the koppie had been put to a multitude of uses. In a couple of places, its rough crystalline surface was worn smooth where the miners' children had over the years careened down the steep slopes on flattened plastic two-litre cool-drink bottles, shrieking with joy and fear. The top of the koppie had a white cross painted on it by a local Africanist church, while cattle herders also used it as a vantage point from which to watch their charges grazing below.

The people who live nearby, whether they speak Sesotho, isiXhosa or Setswana, all refer to the hill by the Sesotho and Nguni word *Thaba* (the Mountain). It is certainly no mountain; barely a hill, it can more accurately be described as a rock outcrop. In the language of the indigenous Bapo ba Mogale, it should strictly be called *lentswe* – a large rock or hill. But in time, the language of the migrants came to dominate and everyone calls it Thaba. It is not that the local Bapo are unfamiliar with more impressive heights close by, or that the migrant Sesotho- and isiXhosa-speakers have no experience with real mountains – they come from lands upon or beneath the towering Drakensberg and Maluti Mountains, after all. It is rather that the outcrop invokes a broader, more cultural interpretation.

Within many South African cultures, 'going to the mountain' often has a mystic and ritual connotation, linked to initiation schools and the tradition of finding spiritual healing in remote, inaccessible places. Despite a wide range of beliefs among the mineworkers, the koppie could, for all of them, resonate psychologically as a place of sanctuary and healing in times of stress.

When the sun is high, the koppie is unimpressive. The rock looks bleached, with a faint brownish-orange tint. In the early-morning or late-afternoon sun, however, the granite transforms into a rich golden orange-brown, and the protrusion of rock seems to be heaving itself from the molten mantle of the earth. Despite its underwhelming height, the dome calls out to be climbed; it draws a person to sit atop it awhile. The strikers thus looked to Thaba as a refuge from their enemies, a place to regain their balance, and to defend themselves spiritually and literally from harm. There they would make their stand. The men, angry and fearful in equal measure, made their way across the late-winter veld, past the hundreds of plastic bags pushed along by the breeze and caught on the thorny branches of scrubby acacia bushes. At a distance and against the sun, the litter looked like the blooming of exotic flowers vitalising the drab grassland.

The sangoma whom the miners had turned to was Alton 'Ndzabe' Joja. From the Bizana area of Pondoland, he was well known to the isiXhosa-speaking migrant workers on the platinum belt.[4] It was believed that Joja's intervention during the strike at the neighbouring Impala Platinum mine had brought the miners' victory and their substantial salary rise. There is a widespread and deeply held belief that spiritual intermediaries like sangomas are able to use their knowledge and mystical abilities, coupled with elaborate rituals, to impart magical protection or powers. Many South Africans accept, to some degree, that the barrier between the living and the dead is porous, with spirit mediums and shamans able to interpret and influence those on the other side. It is not unusual at a funeral for the family to ask the presiding priest or imam to step away for a time to allow for a traditional cleansing or 'cooling' ceremony to be performed.

One aspect of this belief, and here the reliance on the spirit world becomes a little opaque, is the ability of some sangomas to concoct potions with magical properties. The sangoma Joja was believed to be able to make intelezi, a generic Nguni name for a variety of potions widely administered prior to participating in a trying event. There are many variants of intelezi, some pretty banal. That the majority of sub-Saharan African football teams make use of potions to help them win is an example of just how wide-spread the belief is, whatever regional name it goes by. The goalposts are often sprinkled with the liquid. But whatever credence players give these beliefs, they do not supplant the need to train hard. Neither do the players abandon their belief in intelezi should they lose a match or get injured. Other intelezi is not quite as light-hearted.

The miners wanted a type of intelezi that would assist them to formulate a response to the attack on them by NUM officials. They wanted to be fearless in the face of their enemies and invulnerable to bullets. The contents of these potions, as well as the process of their creation, are continually evolving as individual practitioners devise new adaptations. While these rely on tradition and custom, they are also subject to trends. There is an understanding that intelezi powerful enough for battle should contain human tissue.

The sangoma himself did not initially go to the mountain. In his stead,

4 Joja would be shot to death in the Eastern Cape in 2013, a murder most probably linked to his interests in the taxi business. See Kwanele Sosibo, 'Marikana sangoma's mysterious murder', *Mail & Guardian*, 12 April 2013, http://mg.co.za/article/2013-04-12-marikan-sangomas -mysterious-murder (last accessed September 2015).

he sent his two sons. While only a relative handful of miners actually participated in the ritual, the entire group was told to adhere to strict taboos set by the sangoma. Some of these taboos were quite standard – do not have sex, do not wash, refrain from eating fish or pork, do not carry silver coins or mobile phones, and do not wear a wristwatch. Others were quite specific. The strikers were not allowed to shake anyone's hand. They could not use a finger to point, but rather had to indicate a direction or pick out a person at a distance by using their closed fist. It became one of the noticeable characteristics of the strikers that they would, mysteriously to outsiders, use a clenched fist to point. There were other taboos, including that women should not approach Thaba, that those who undertook the ritual should not change their clothes and, quirkily, that the miners should not kill rabbits or snakes for the duration. The sangoma also instructed all intelezi participants to sleep at Thaba until they attained their goal.

While the dominant religion in South Africa is Christianity, there are strong cultural ties to a belief in traditional animism and the active agency of the ancestors. The vast majority of black South Africans either practise or have a family member who practises traditional religion, at least in part. South African law recognises the validity of traditional healers and their diagnoses; sick-leave notes from sangomas and nyangas have to be accepted at the workplace. Almost all indigenous South Africans will perform traditional ceremonies to honour their ancestors at certain times of their lives, often if only for cultural or social reasons. Most will never participate in any of the rituals in the rather dark realm of traditional belief that intelezi falls under, but there is still a fear of these practices, and an unwillingness to dismiss its efficacy. This applied as much to the policemen as to the miners; many came from the same areas and grew up with the same cultural influences. The fear and uncertainty that the miners' intelezi evoked in many of the deployed policemen would influence how they would react in the confrontations to come.

Whatever their belief in intelezi, every one of the miners recognised its power as a social tool. Perhaps more important than any possible belief in the efficacy of the intelezi were the bonds formed among the diverse group of miners. It ritualised their demand for a wage of R12 500 from a purely industrial matter into a higher quest. But as with most matters of belief, there was a pragmatic element that tempered it: while some did indeed trust that the sangoma's muti would make them invulnerable to bullets, others were far less credulous. There were miners who strongly held to the

magical properties of the muti, but not all of the strikers took these taboos to heart. Most, including some of the leaders, did not follow all of the pre-scriptions, continuing to sleep at home and changing into fresh clothes daily.

The sun had just set on Saturday when approximately fifty men stripped off their shirts behind Thaba and lined up for the sangoma's two sons. It was then that a veteran cop, Lieutenant Colonel Salmon Vermaak, formerly assigned to the riot police[5] and hovering in a helicopter above Thaba, rec-ognised what he was seeing and sent a derisive message to the command centre: '*Hulle trek kaalgat uit en doen iets saam met 'n sangoma.*' It was a message that would colour police perceptions of the strike and the strikers, with disastrous results.

5 Later the public order police.

10

Day 3:
Sunday 12 August

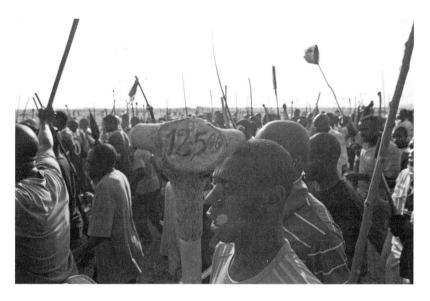

A striking Lonmin miner marches with a stick bearing the demand for a wage of R12 500, Nkaneng, Marikana, 12 September 2012.

'I realised that the person had been chopped on his face and he was lying between the burning cars and I realised I had to drag him away from there.'
– Hermanus Janse van Vuuren, subcontracted Lonmin
mechanic who tried to save Thapelo Eric Mabebe
after they were attacked by strikers

The marchers crossed the open veld between Thaba and Wonderkop stadium swiftly. Most wore their white Lonmin overalls with diversely colourful wool blankets either around their shoulders and held together at their throats with a large safety pin, or folded and draped over one arm. Unlike the day before, a multitude of traditional and less customary weapons were in evidence: knobkierries, thinner fighting sticks, long bladed spears and broad-bladed pangas reflecting the early-morning sun. What was also different was that the men acted in a far more unified manner – like a cohort. They sang songs in unison, and rhythmically tapped their iron weapons against each other to make a sinister clinking that carried ahead of them through the thin, dry air.

The striking miners had decided to take revenge for their fallen comrades, whom they believed to be dead, and also to be rid of what they saw to be NUM's treacherous and divisive presence. Lonmin security had been beefed up to try to avoid a repeat of the previous day's chaos, but the promised police presence was again nowhere to be seen.

Saziso Gegeleza and a few other NUM officials returned to the small red-brick office they had so successfully defended the day before. A cocky reliving of their heroics was short-lived. A friend of Gegeleza's called with the news that a large group of striking miners was coming his way. The NUM men decided to vacate the office immediately.

Lonmin security was fully aware of the threat, noting that the rituals undertaken by the miners were preparation for a revenge attack on the NUM office, and had changed the threat status to 'double red'. Despite this, they sent out relatively lightly armed security officers with neither hard-skinned vehicles nor police support to break up the marching strikers.

A pair of Lonmin security officers, Dewald Louw and Martin Vorster, had come on duty at six o'clock that morning. As they drove around in their Toyota Hilux bakkie, Louw noticed that the places where informal vendors usually sold their wares were deserted. The entire area was unnaturally quiet.

Their two-way radio came alive as a tinny voice from the control room directed them to where a crowd of a few dozen miners had gathered at Eastern Platinum – about nine kilometres to the east of Wonderkop. When Louw and Vorster arrived, they saw that several other Lonmin officers were there too. As soon as they pulled up near the crowd that had gathered outside a bank, the men turned and spread out, simply staring at the security officers. Sydney Mogolo, a fellow security officer, turned to Louw and said that he felt this was a diversion, a decoy. Louw and Vorster sped back towards the koppie to see what had become of the main group of strikers. On the way, Louw got a call on the radio from the Lonmin control room saying that strikers were making their way towards the NUM office, and they should try to stop them.

Louw and Vorster managed to reach the open area next to the Wonderkop stadium just ahead of a large group of strikers making its way swiftly east. They stopped their bakkie ahead of the crowd of about a thousand marchers led by a smaller group of about fifty men. Initially they thought that a show of force by shotgun-wielding officers would be enough to disperse the marchers. But once they got out the vehicle, Louw realised that despite all the years he had worked at Lonmin, this was a situation unlike any he had ever faced. It was just himself and Vorster facing a massive group of men advancing towards them in a weird crouch. Some were swearing and threatening them, another drew his spear blade across his throat in a chilling gesture. Vorster nervously asked Louw if he should shoot, and Louw told him to hold his fire.

Louw lifted one hand to indicate to the marchers that they should halt. They did not, and instead some among the group edged around on either side as if to outflank the security officers. Louw and Vorster pointed their shotguns at these men, and they retreated back to the main group, which itself was inching forward in that strange squatting position.

A striker in a white overall hurled a large stone just as the front group of miners charged at the security officers. Louw and Vorster fired off several rubber rounds in quick succession as they scrambled to get back into their vehicle. Louw was struck on the thigh with a stone and hit on his arm and

torso with the heavy wood knobkierries. Vorster was slashed with a panga from his armpit to his hip. The group of strikers surrounded their car, assailing it with their weapons. Vorster, who had been driving, had left the vehicle idling when they alighted from it. Now, as he tried to pull off, the car stalled. He struggled to restart it as the windows were shattered. Louw fired through his passenger window at the miners and screamed at his partner to get moving. The engine finally took and Vorster forced the vehicle through the mob.

Once the marchers had run off Louw and Vorster, they entered the hostel compound on their way towards the NUM office further to the east. It was here that they encountered a larger group of ten Lonmin security officers. As the armed officers spread out apprehensively in a line to try to halt the advance of the miners, there was a difference of opinion among them. One of the men was Joseph Mogomotsi Masibi, who had been with Lonmin just over a year. Masibi had been driving with Marcus Manamela in a Volkswagen Polo sedan when he heard Dewald Louw over the two-way radio saying that he and Vorster were being attacked and needed backup. Masibi pushed hard to get to the place described by Louw and took the shortest route – the road through the hostel. As he turned into the hostel he saw that there were several Lonmin security vehicles and officers in front of them. The crowd that Louw had described was already there.

As Masibi pulled up, Frans Mabelane, one of the two senior officers on the scene, called a hurried meeting. Mabelane told the gathered officers that the strikers meant to burn the NUM office and that they should form a line to disperse the miners with rubber bullets. Masibi disagreed, saying that they did not have armoured vehicles for their own protection and that they were too few to ward off the crowd. Mabelane overruled him and instructed the men to form a line against the advancing strikers. It is unclear whether the people manning the Lonmin security control room had passed on Louw's warning that the miners were dangerous and should not be approached. What none of the vulnerable Lonmin officers facing the crowd knew was that there was an armoured police Nyala less than a kilometre away, parked at the edge of Nkaneng.

The miners were a terrifying sight. They crouched low on their haunches and clinked their metal weapons together in unison, hissing as they came closer. Masibi thought they were somehow acting in unison, as if they had been coached, and their ranks seemed tightly packed. One of the security officers, Julius Motlogeloa, approached the strikers with his hands up in

a supplicating gesture, and asked them what the problem was. The miners gestured to him to move out of the way and slashed their weapons through the air as they continued forward.

A nervy security officer fired off a round and then all the Lonmin guards began firing. The miners crouched lower and advanced, using their thick wool blankets for protection. Motlogeloa turned and ran. After firing all seven of the shotgun shells each of their weapons could hold, the other officers too began to retreat towards their vehicles. The miners sped up, closing in quickly.

As Masibi reached his white sedan, he looked behind him and saw that the strikers were upon him. He abandoned the car and dashed towards the other vehicles further back. As he neared the closest vehicle, a blue and white Nissan Livina sedan, he noted that his two supervisors, Frans Mabelane and Hassan Fundi, were already in it, but that they had not yet started moving. He decided to keep running towards a bakkie still further away that was already rolling. He clambered onto the open back and fumbled to reload. Looking up, he saw that the strikers were swarming around Mabelane and Fundi's car; he could see neither supervisor. Masibi opened fire, hoping to drive off the miners. It was the stuff of the officers' worst nightmares.

The remaining Lonmin vehicles drove out of the hostel compound and regrouped outside the nearby mine hospital, where the frightened men met up with Louw and Vorster in their pummelled bakkie. Some of the security officers reversed cautiously back up the road to the hostel entrance. From there they could see smoke rising from Masibi's own abandoned vehicle. As they watched helplessly, Mabelane and Fundi's Nissan sedan began to smoke too. Both cars had been set alight. Some of the miners were coming out through the same entrance where the security men had now gathered, but they ignored the officers. As much as the men wanted to go to the aid of Mabelane and Fundi, the control room instructed them that they were not to approach the burning car, but to retreat and wait for reinforcements. The two armoured vehicles that were on standby for Lonmin as part of their contract with a security firm proved to be of little use. One caught fire spontaneously on its way to the hostel and the other had serious mechanical faults, with the driver struggling and on occasion failing to engage gears.

What happened to Fundi and Mabelane was later told to the Marikana Commission of Inquiry in gruesome detail by a striker-turned-police-

informer, known only as Mr X. He was the police's key witness against the miners. Mr X was a self-admitted murderer whose tale was riddled with falsifications and contradictions. His testimony was used to charge most of the strike's leadership with murder as well as other crimes. Mr X helped the police push the narrative that the miners were demonically driven by intelezi to kill. Even though much of his evidence was often clearly fabricated to suit the police's desire to paint all of the strikers as murderous primitives, there were many things he related that were indeed corroborated by others or by forensic evidence. His version of what happened is thus used for balance, but must be viewed with caution. Even his admission to being an enthusiastic participant in several murders might be untrue; the details might have been fed to him by the police based on the autopsies, but nonetheless these killings did indeed occur.

Mr X said the marchers, led by Mambush, Xolani (Nzuza), 'Anele' and 'Rasta', had taken the decision to attack the NUM office and fight anyone who stood in their way. This time the strikers were much more heavily armed than they were the day before. They carried an assortment of sticks, spears, knives and pangas, as well as a couple of handguns. When their way was blocked by the line of security officers, they obeyed the precepts of the sangoma. They clashed, and, as the officers fled, they trapped Fundi and Mabelane in their car. Mr X said that the security officers begged for their lives, but he nonetheless stabbed one of the men in the face with his butcher's knife, as other strikers also attacked, shooting and hacking at them.[1]

In Mr X's version, the officers were looted of their firearms, two-way radio and mobile phones before the vehicle was set on fire. Then followed the most gruesome part, as he described how two of the strike leaders cut off the chin and tongue of one of the security men and put these into a plastic bag, along with some of the man's blood. The purpose of this was to give the human body parts to the sangoma so that he could strengthen the muti. The men were then set on fire.

The use of human body parts in the darkest realms of traditional medicine has been well documented, and is widely believed to be an essential ingredient of intelezi, especially in times of conflict. The autopsy report does state that Fundi's lips were lacerated, as was his tongue, but that neither tongue nor chin had been removed. Yet Fundi's brother, who saw the body

1 The names of the alleged perpetrators are not included here as the evidence of Mr X is so contested, and shown to have been false in many instances.

prior to burial, claims that these parts *were* severed. Whatever the exact truth of what the security guards endured in their last horrific moments, or whether Mr X had even been at the scene, much less participated in the murders, it is indisputable that the officers were brutally and mercilessly killed by some among the striking workers.

The strikers moved on, surrounding the NUM office and smashing its windows in a rather pedestrian attack on what was meant to be their real target of the morning. By now, the armoured personnel carrier (APC) had managed to get to the hostel, and, as it approached, its occupants could see that both vehicles were still burning and that the two officers were prone on the ground alongside their Nissan. When the Lonmin security officers tried to get out of the armoured vehicle to see if Fundi and Mabelane were still alive, the strikers, now on their way back from attacking the NUM office, began running at them. The security men put the large and intimidating Mamba APC between the strikers and their fallen colleagues to try to protect the latter from further attack. The officers fired rubber bullets and then birdshot, to no apparent effect. The miners shot back at them with handguns. The security officials retreated to get more backup, chased by the mob of strikers, who then simply continued on their way to their redoubt at Thaba.

Eventually Louw and the others got to Hassan Fundi and Frans Mabelane. It was too late; they were now obviously dead, and had been further mutilated by the miners as they passed back. On seeing them, Louw broke down and cried.

There were more horrors to come. The miners were buoyant and planned to ensure that every one of Lonmin's employees and contractors heeded the stay-away. The local radio stations were broadcasting messages from Lonmin calling on workers to report for duty, despite the company knowing that the strikers had issued death threats against anyone reporting for work. Lonmin and their ally, NUM, were desperate to keep the operation running long enough to outlast the miners. The strikers, in turn, knew that they lost leverage with every worker who reported for work. One of the miners' targets was the outlying operation at the Karee 4 shaft (K4), which was still operating. Lonmin knew this from their informants among the miners, yet they made what they termed a 'pragmatic call' that they simply did not have the resources to protect K4. The entrance was protected by two subcontracted security guards armed only with batons. With the knowledge of the deaths that had already occurred and the fact that Lonmin knew they

could not provide adequate protection to miners who were not on strike, Lonmin made the callous and reckless decision to keep the mine open. The prime motivation in not telling non-striking workers to stay home was that Lonmin would have to pay those miners not to work.

The commission later heard Lonmin's Barnard Mokwena admit as much:

MR RAMPHELE: And that it was a known danger that Mr Langa, on his way to work, would in all probability if he were to meet the strikers, would be faced with the same fate of these people that were injured on the 10th.

MR MOKOENA [*sic*]: That is correct.

MR RAMPHELE: And therefore you would agree with me that not informing Mr Langa that he should not come to work because of the circumstances, was something that one can call irresponsible.

MR MOKOENA: That could be the case, Chair. If I may say, one of the options that actually we considered was to close the mine and we deliberated extensively and looked at what that could mean for employees who then we would have to pay because they'd had absolutely nothing to do with the strike. So it was a matter that was discussed extensively, let's close the mine. The question then was, if we close the mine the workers who are not on strike have to be paid because they're not on strike and we realised then it was going to be very difficult to determine who was actually on strike and who was not on strike if we were to pay people after closing the mine. Further, we also looked at the issue that if we close the mine, continue paying people who are not striking, the likelihood would have been, why would anybody therefore go back to work if they are paid because there is an unprotected strike? So it was a complex issue. Chair, I want to admit, however, it was a consideration on our part actually to close the mine as a tool to avoid further damage.[2]

Following the deaths of Mabelane and Fundi, increased pressure by Lonmin executives on the police and cabinet ministers started paying off. Lonmin's chief commercial officer, Albert Jamieson, was in touch with the director general in the Department of Mineral Resources, saying that the situation was unstable and out of control, yet at no time did Lonmin tell their

2 Marikana Commission of Inquiry, pp. 38212–3.

employees to stay away from work until it was safer. By the late afternoon, senior policemen had set up a command post at Lonmin's control room and dozens more police riot teams had arrived. No one, though, seems to have asked them to patrol at K4.

Shortly before nine o'clock that Sunday night, Hermanus Janse van Vuuren was driving up to K4 in his red Volkswagen Caddy bakkie to report for work as an underground diesel mechanic when the security guard at the gate told him not to enter as there was a strike under way. Janse van Vuuren reversed the bakkie and pulled off the road. He called his boss at the contracting firm Murray & Roberts, who told him to report for work nonetheless. Janse van Vuuren told the Protea guard he had to go in and drove his bakkie along the high security fence and into the parking lot. His Caddy was overheating, so he pulled up where there was better light, popped the bonnet and pulled out his tool bag. He called his foreman inside the shaft and told him he would be a little late as he had car trouble. Janse van Vuuren did not take long to repair the problem and he started the vehicle to find an open parking bay.

As he was reversing, he saw a group of men throw their blankets atop the razor-wire fence and climb over. There were about fifteen of them and some were wearing knitted balaclavas. The men stormed at Janse van Vuuren and he threw the car into first gear and attempted to escape. The vehicle was pelted with stones, one crashing through his side window. One of the attackers hit the windscreen in front of his face with a heavy metal pipe. Janse van Vuuren raced to the end of the parking lot, near to the turnstile-gate entrance to the mine. As he got out of his car, more stones were thrown at him. He was next to the turnstile, where he could swiftly get into the mine and away from the men, so he called to his assailants in Afrikaans to stop their nonsense. He then quickly swiped his card to get through the turnstile, but it failed to work. He managed to hide behind a low brick wall with a motorbike parked alongside it.

Janse van Vuuren lost his sense of time as he lay there, listening to the shouts and sounds of mayhem. He felt like a caged dog, powerless and consumed with the fear that he would be found and killed. The sounds were terrifying. What seemed like hours later, he heard the motorbike that had been parked near him roar to life and accelerate off. He pulled himself up to look and realised that several cars were on fire. He watched as the rider of the bike was assaulted by the strikers. A second motorcyclist who had abandoned his bike was climbing over the razor-wire fence when he

was stabbed in the buttocks with a knife or screwdriver; Janse van Vuuren could not be sure of the weapon used.

The attack on the bikers allowed Janse van Vuuren to try to get to his bakkie in the hope he could make an escape. The electric lights in the car park were no longer working and the only illumination was from the burning cars. As he neared his bakkie he noticed that there was a person lying alongside one of the fiery vehicles. Janse van Vuuren immediately went to drag him away from the flames and he saw that the man's face had been badly slashed. As he dragged the man across the parking lot, thirty-six-year-old Thapelo Eric Mabebe told Janse van Vuuren that he was in great pain.

The strikers disappeared as suddenly as they had appeared. Mr X, the police witness, later claimed that he had been among the attackers, and that he had personally stabbed Mabebe in the stomach with his butcher's knife, and had not known if he left his victim dead or alive.

By the light of the burning cars, Janse van Vuuren comforted Mabebe, unable to do any more for him. An ambulance arrived more than an hour later and took Mabebe, Janse van Vuuren and the two motorcyclists to the mine hospital. Mabebe was in a bad way. Besides sustaining many stab wounds, his skull was smashed with a rock so severely that his brain was extruding. At the hospital, Janse van Vuuren's and the bikers' minor wounds were swiftly dealt with – the men were all white – but the only treatment Mabebe, who was black, received was oxygen, the warmth of his breath steaming up the clear plastic mask that covered his mouth and nose. Once Janse van Vuuren's head wound had been stitched, he went over to Mabebe again and put his hand on the man's bare feet. They were ice-cold. He called to the nurses, saying that he thought Mabebe might be dead. The nurses harshly castigated Janse van Vuuren, saying he was no doctor. A little after eleven that night, a white-coated physician arrived and proclaimed Mabebe deceased.

Three men died that Sunday: Malawian-born Hassan Fundi, forty-seven, who left his wife Aisha and three children; Frans Matlhomola Mabelane, forty-six, who was married to Linah and had three sons; and Thapelo Eric Mabebe, thirty-six, who was unmarried but whose death left his elder sister Esther devastated – she had been forced by family circumstances to raise him as if he were her son.

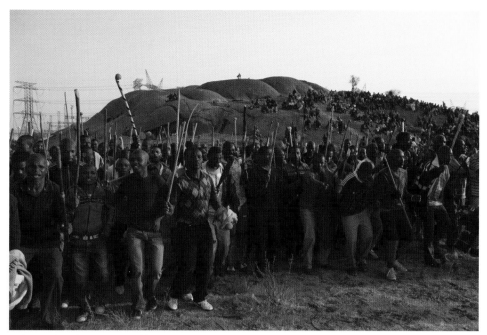

Strikers with sticks, pangas and home-made spears at Thaba, Marikana, 15 August 2012

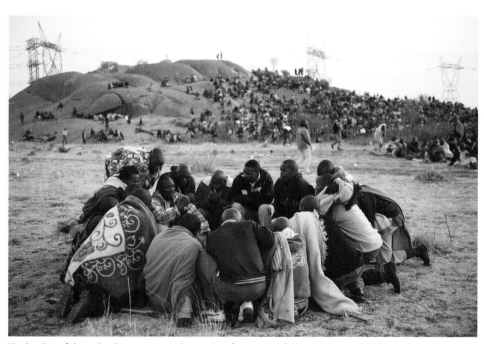

The leaders of the strike discuss a matter late in the afternoon at Thaba, 15 August 2012

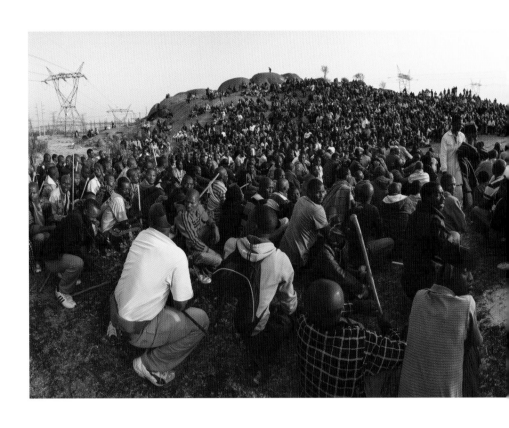

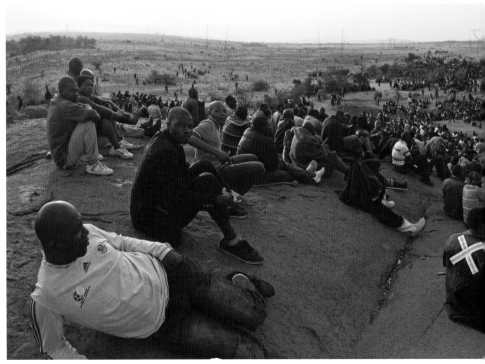

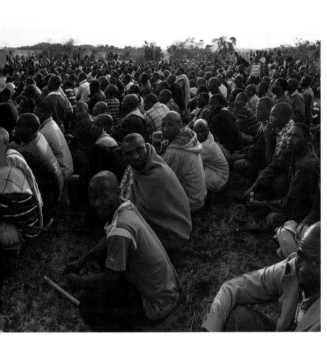

Lonmin employees gather at Thaba, 15 August 2012. The mostly isiXhosa and Pondo-speaking miners are calling for the minimum wage to be raised from R4 000 a month to R12 500. These images were digitally stitched together to encompass the full scene

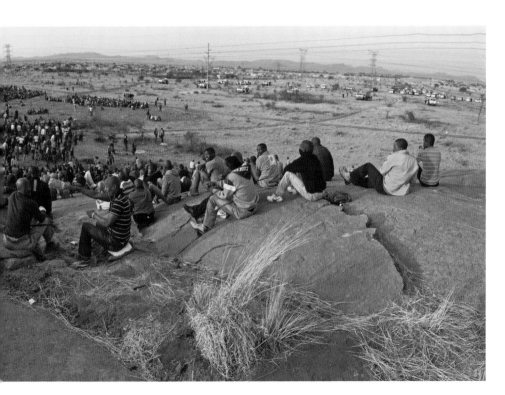

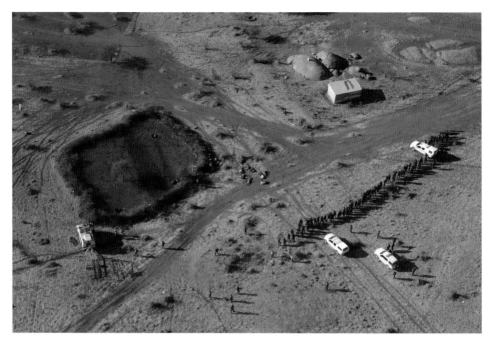

Aerial photograph of Scene 1, shortly after the police line (right) opened fire on Noki and his lead group of miners, 16 August 2012. Seventeen miners were killed here

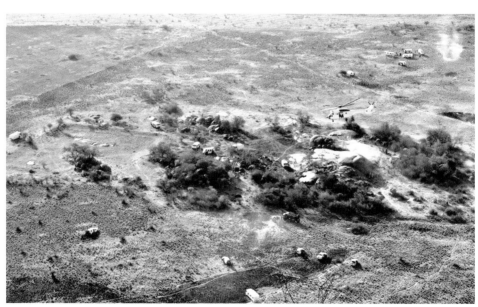

Aerial view of Scene 2, where another seventeen miners were killed, 16 August 2012. (Images supplied by SAPS to the Marikana Commission of Inquiry)

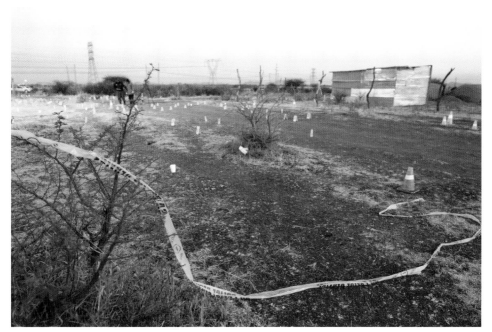

The scene of the massacre at Wonderkop 17 August 2012. The forensics officers ran out of cones for marking evidence and resorted to using plastic coffee cups

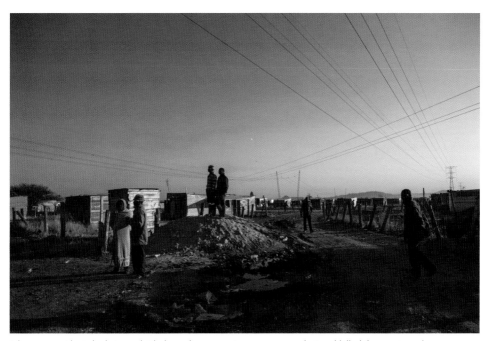

Nkaneng residents look towards Thaba, where seventeen men were shot and killed the previous day

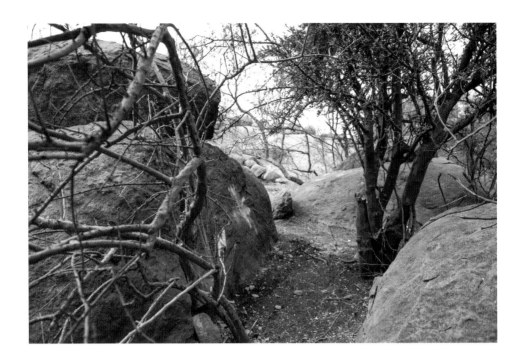

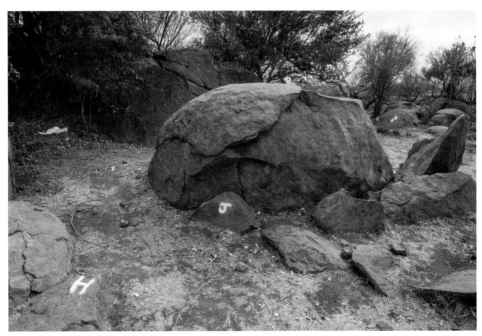

Yellow police paint marks where the bodies of some of the thirty-four men killed by police were recovered by forensics. Some of the rock crevices in which these bodies were found indicate that the men had to have been hunted down and shot at close range. At sites like N, the copious amount of blood made it plain that it was not a wounded person who managed to crawl there, but rather someone who was shot and killed in that position, where all four sides are hemmed in by rock. Not a single policeman was reported wounded. (Photographed on 27 August 2012)

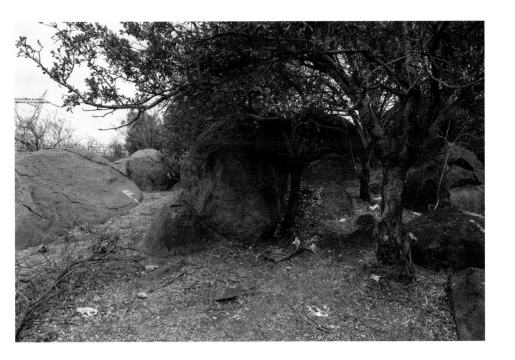

Julius Malema arrives at Nkaneng to address the strikers and community two days after the massacre

Striking miners who gathered to discuss the situation as Lonmin insisted they return to work or be dismissed were surprised by an inter-ministerial team led by Collins Chabane. The team was tongue-lashed by the miners' leaders Tholakele 'Bhele' Dlunga (right) and Xolani Nzuza, 21 August 2012

18 August 2012. Xolani Nzuza collapses after giving an impassioned narration of the events that saw several of his fellow leaders killed. The community had gathered for a meeting to discuss the deaths of thirty-four of their colleagues two days previously. They were addressed by strike leaders and expelled ANC Youth League leader Julius Malema

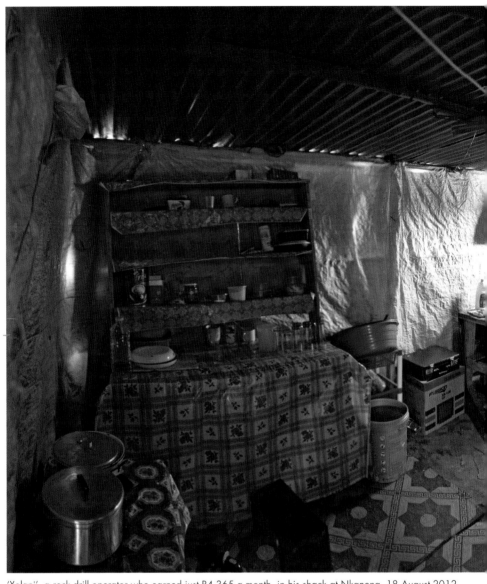

'Xolani', a rock drill operator who earned just R4 365 a month, in his shack at Nkaneng, 18 August 2012

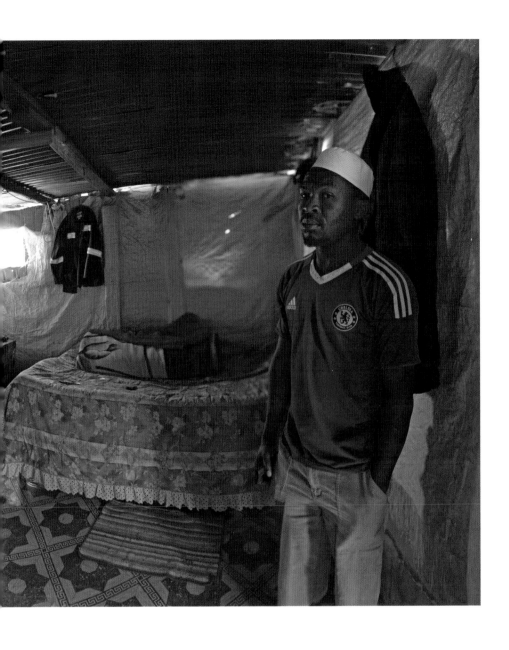

Jackson Mjiki (left) and Shadrack Mtshamba (right) at their compound, where they lived in single rooms, 2012

A goat eats trash next to a defunct long-drop pit latrine in Nkaneng, 2013

Inside Shadrack Mtshamba and Jackson Mjiki's compound, where they lived in single rooms opposite each other in 2012

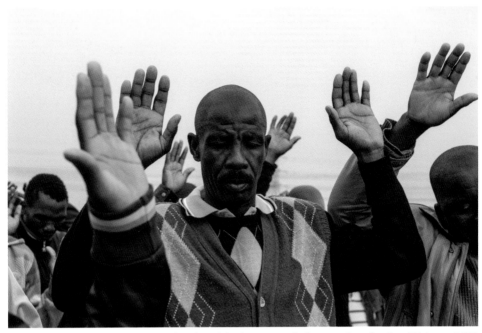

Striking Lonmin platinum miners pray at the edge of the shantytown of Nkaneng where they live, 27 August 2012

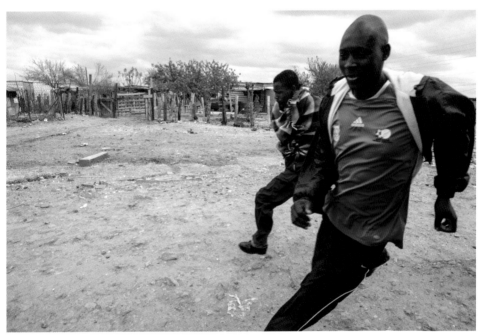

Residents of Nkaneng flee police rubber bullets, 15 September 2012

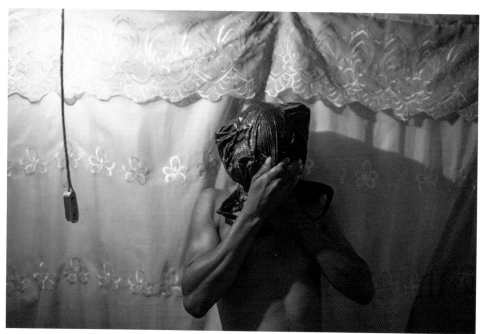

Bhele Dlunga demonstrates how he was tortured by police while in custody as part of what seems to have been a systematic intimidation campaign against witnesses to the Marikana massacre, 1 November 2012

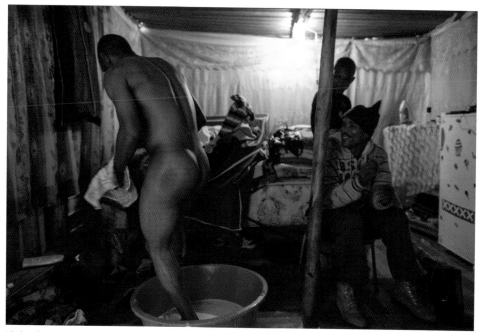

Bhele Dlunga washes in a basin while Anele Zonke (right) prepares to tell how he was tortured by police while in custody

Local ANC councillor Paulina Masuhlo (right) welcomes the government delegation at Marikana on 21 August 2012, five days after the massacre. Masuhlo was shot with a rubber bullet by police on 15 September 2012 and died in hospital

Inside the single-roomed shack of Lonmin miner Sobopha and his partner Mandisa Yuma, Marikana, 2013

11

Day 4:
Monday 13 August

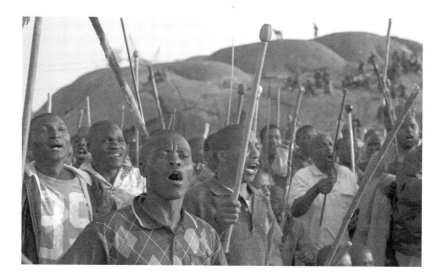

Striking Lonmin drillers and other miners sing at the base of Thaba, the koppie outside of Nkaneng shantytown, Marikana, 15 August 2012.

'No matter how big you make your balls, you are nothing.'
— The miners' chant when police gave them
an ultimatum alongside the railroad

O n the morning of Monday 13 August, the core of the striking miners who had spent the night on the koppie woke early. The night had been cold and, despite the thick blankets the men had wrapped around them, their limbs felt stiff and heavy. Many made their way back into the shantytown for tea and bread; others simply stood where the rising sun could warm them.

As the sun rose higher over the smelter, more and more men joined the miners at Thaba. The strike leaders received reports that miners at the Karee 3 shaft had not yet joined the strike, even after the bloody events of Sunday. Moving away from the few hundred men at Thaba, the leaders huddled in a circle on the dry grass near the base of the koppie, and agreed that another show of force was in order. If all of Lonmin was not shut down, their strike would most likely fail.

The mounting violence and the militancy of the strikers the previous day had finally caught the police's attention. The three most senior police officers in the province, Commissioner Mbombo and two of her six deputies, Major General William Mzondase Mpembe and Major General Ganasen Naidoo, travelled together to the temporary police joint operation centre set up at Lonmin's Marikana headquarters. From here, the police could monitor Lonmin's extensive network of security cameras, and easily access intelligence garnered by Lonmin and undercover police operatives.

The first news of the morning was that the body of another Lonmin mineworker, Julius Langa, the father of seven children, had been found. The police informer Mr X claimed that the striking workers had made a decision to kill those who chose to go to work, and that he and others had stabbed Langa to death near the railway line in the hours before dawn.

Other than Mr X's self-implicating and unreliable testimony, there is no information on how or why Langa was murdered. The post-mortem showed he had been stabbed and slashed eighteen times across his chest, back and arms. There were further wounds to his face and head. When a Lonmin security officer attended to the crime scene, there was a crowd of bystanders, none of whom volunteered any information. In the hours before dawn, there were several other incidents of intimidation against workers heeding Lonmin's repeated calls to report for work.

At ten o'clock, Lonmin executives and management briefed the police on the situation.[1] This briefing would set the tone of what can only be viewed as self-serving collaboration between the police and Lonmin, characterised by camouflaged mistrust and hidden agendas. While going over the events of the preceding days, Barnard Mokwena insisted that the strikers were unknown to Lonmin, that they were 'faceless', and that the strike was being orchestrated by people outside of Lonmin. This was a veiled reference to AMCU and the former NUM shaft steward Steve Khululekile.

One of the policemen at the briefing was Lieutenant Shitumo Solomon Baloyi from the public order police (POP) unit, who had been called in from Pretoria. At midday he noticed a Lonmin security officer come in and report that a group of miners was on the move. Baloyi told his superior officers and the meeting was suspended as everyone gathered to watch the strikers on Lonmin's security cameras. A band of 150 miners with Mambush Noki at their head was on its way to Karee 3. Commissioner Mbombo told her second in command, Mpembe, to take personal command of the situation. He had been appointed overall operational commander of 'Operation Platinum' just hours before.

Major General Mpembe is a large man with an impressive physique and a forceful manner, the very figure of the man to sort out a tough situation. In reality, at the time he did not have much experience with handling violence. The only training he had received in public order policing was a three-week course in 1987 and a brief retraining to be familiarised with new laws passed in 1993. Mpembe gathered a force of seventy cops from various units – the POP, the National Intervention Unit (NIU) and the Tactical Response Team (TRT). The police had switched from a laissez-faire attitude towards the disruption at Lonmin over the previous days to

1 The Lonmin team included head of mining Mark Munroe, Frank Russo-Bello, Natasha Viljoen, A.B. Kotle, Jomo Kwadi and Barnard Mokwena.

sending the second-highest-ranking officer in the province into the field. But Mbombo's decision to put her deputy in charge of scores of heavily armed men instead of one of the more suitable public order and active officers there was curious, and would soon bear bitter fruit.

As the convoy of police vehicles hastened to the area more than eight kilometres away, the strikers passed beneath a bridge as they approached the entrance to Karee 3. Atop the bridge was a group of Lonmin security officers including Julius Motlogeloa, the security guard who had been present at the two clashes near the NUM office. Unlike the previous, terrifying day, Motlogeloa saw that the men were calm, not belligerent. When they were told that there were no workers underground at Karee 3, the strikers asked if a delegation of five of their number could verify this. Their request was refused. Noki then addressed the group and they agreed to turn back. The security guards, knowing that a police contingent awaited the group, told the strikers to return to the koppie by the same route that had brought them, to which they agreed.[2] This display of reasonableness and restraint by the miners was surprising, given the events of the past few days, but was welcomed by the anxious security officers. Knowing that their appearance would send a message to any still working at Karee, the strikers began the return journey.

When they came across the waiting policemen, the miners sank to their haunches, intended to show that they meant no aggression towards the police. Hunkering down, they gently tapped their spear blades against each other, making an unsettling, eerie metallic sound that was almost musical, yet not. It was a similar sound to that which had preceded the attack on the security officers Fundi and Mabelane the day before. Unlike that day, however, the atmosphere was calm, not menacing.

Mpembe addressed them in isiZulu, his home language, and when he thought they did not understand him, he asked the mine security manager with him, Henry Blou, to provide someone to interpret into Fanagalo. Blou refused, saying that Lonmin would not negotiate with the strikers. Fanagalo might not have been the ideal choice – a language invented on the mines, it is intended purely as a language of instruction. Fana-ga-lo is derived from a string of Nguni words for 'like + of + that' and means 'do it like this'. The mostly isiXhosa-speaking miners had a fair idea of what Mpembe was saying, as isiXhosa and isiZulu are closely linked Nguni languages,

2 Author interview with a miner, 'Themba', present on the day.

though isiXhosa includes a fair influence from the autochthonous Nama and Khoi languages. To have switched to Fanagalo, the mine language, might have alienated them; for many it is a symbol of the *baasskap*[3] of the mines, and of their position at the bottom of the power hierarchy. However they might have articulated it, the miners recognised this bastardisation of African languages as part of the structural violence of the migrant labour system.

Mpembe told them that they had to give up their weapons: 'All I want is your spears; otherwise I won't let you go.' The miners, refusing to speak Fanagalo but sticking to their native isiXhosa, told Mpembe that they couldn't give up their sticks and pangas as they 'live in the bush' and needed to fend off wild animals and, more honestly, that they needed those weapons to defend themselves from NUM, who, they believed, had killed two of their fellow strikers.

Despite his apparent patience in listening to the miners' lengthy responses, the general was initially not moved by their explanations. Faced with the obduracy of the mine leaders who stood to speak one after the other, he realised that it would be no simple matter to disarm the miners. He called his commanders together to explain that he was changing the plan – the police would escort the miners back to the koppie, where they would then disarm them. Lieutenant Colonel Joseph Omphile Merafe, the most senior public order policeman in the field that day, disagreed with his superior. Merafe believed that the miners should be disarmed before they reached the koppie, and he also believed that he, Merafe, should have operational control.[4] Mpembe insisted that he would remain in charge. From the sidelines, Lieutenant Baloyi advised the general that stun grenades should be used to disperse the miners.

Mpembe then turned away and made two calls: one to the command centre and one to his boss, Commissioner Mbombo, telling them that he would let the miners proceed without disarming them. Yet what happened next contradicts his evidence that he agreed to allow the miners to continue with their weapons. Police video records Mpembe telling the squatting miners, in English, that they had to surrender their weapons at the count of ten. The general had reached three when the miners began singing in isiXhosa, again tapping their spears against each other. The song called on

3 Control by the white boss.
4 Police standing orders are clear: Merafe, as the senior public order policeman, should have taken charge of the operation.

the police to tighten their testicles in preparation for what was to come, and to a man they stood and moved away into the adjoining brittle-grassed veld. They were bent forward at the hip in the traditional way of a Xhosa warrior group, a stooping crouch that was oddly evocative of how drillers work underground. A couple of shotgun-wielding policemen holding the line retreated before the phalanx of miners. One of the cops stumbled a little as he walked backwards; the miners passed within a couple of metres of him without a glance.

It was the miners' understanding that the police had agreed to allow them to carry their weapons to Thaba, and that the police line parted to allow them through. The miners walked at a measured pace as a hastily assembled line of riot policemen ran alongside trying to keep up. On the far side of the miners, two armoured police Nyalas kept pace while others sped ahead along a gravel road, drawing ahead to the miners' anticipated path. General Mpembe seems, at some stage, to have been swayed by the arguments of Merafe and told Baloyi to get ahead of the strikers and delay their march before disarming them, apparently fearing that they would enter a nearby shantytown. Or at least that is how he justified it afterwards; the direction in which the miners were headed would not have taken them close to the settlement. What Mpembe really intended to do has never been made clear. At any rate, some of the armoured vehicles drove ahead of the strikers, and one flanked them on either side.[5] Lieutenant Baloyi had his armoured-vehicle driver pull in front of the marchers and he readied himself to use the single stun grenade he had taken from a subordinate. With him was Warrant Officer Tsietsi Hendrick Monene.

Warrant Officer Daniel Kuhn fired two tear-gas canisters in front of the miners, where a gentle headwind would allow the pungent gas to waft into the crowd. The miners simply kept going, walking through and beyond the cloud of gas. The effects of tear gas are not easily ignored; it is classed as a chemical weapon, and is manufactured to varying strengths and chemical combinations, most mimicking the effect of plunging your head into a bag of ground chilli peppers. The symptoms include an intense burning sensation wherever it makes contact with moist human tissue or skin. It blinds the eyes and burns the nostrils and lungs, inducing violent and often debilitating coughing and wheezing akin to an asthma attack.

Baloyi then fired his stun grenade, which exploded with a percussive

5 This is disputed by General Mpembe.

double flash several metres in front of the miners. To the uninitiated, the double crack of an exploding stun grenade sounds much like a rifle being fired close by, or a real grenade going off. Few, if any, of the striking miners had ever experienced stun grenades going off right next to them, and many believed that the police were using real grenades. The miners understood themselves to be under attack by the police. Some of the strikers believed that the reason they were not injured was because the witchdoctor's protective intelezi was indeed effective.

Within a few seconds, another stun grenade exploded right next to the heads of the leading strikers, its residual smoke obscuring them. The miners finally broke, running in various directions. Some tried to escape while others charged at the handful of policemen alongside them. From a police helicopter above, Lieutenant Colonel Salmon Vermaak and Captain Paul Bismark Loest watched in disbelief as the miners surrounded two of the riot policemen while other policemen fled in panic. The airborne police tried to use their chopper to chase off the attackers, dropping a score of tear-gas canisters and stun grenades.

Lieutenant Baloyi was caught unprepared by this sudden turn of events, finding himself under close-quarters attack. He tried to get to the open door of his Nyala, but then saw that some miners had beaten him to it and were trying to get at the policemen inside. He ran past the vehicle with strikers in pursuit, firing his shotgun at his pursuers to little effect. Realising that he was running away from his comrades and any assistance he might get, Baloyi stopped and turned, using his shotgun to blast his way through the group. But as he ran, he was stabbed from behind. He felt a massive blow to his head, probably from a panga, and one of the miners kicked at his feet, tripping him. Baloyi fell and his attackers began stabbing at his chest as he tried to twist away, kicking out at them. One of the strikers aimed a pistol at him, probably Baloyi's own that had been taken off him, but was disturbed by another policeman approaching. That officer, Warrant Officer Farmander Daniel Mkhabele, tried to help but was overcome by the tear gas and collapsed to the ground. Miners hacked at his head and back before moving away, themselves blinded by the gas, believing Mkhabele dead. Remarkably, he was not hurt at all, protected by his helmet and bulletproof vest, both of which were deeply marked from the blows that should have killed him.

In the deadly struggle, miners tried to wrest Baloyi's shotgun from him, but he bravely hung on to the weapon as he twisted away from his attackers'

spear thrusts. Then he was stabbed in his stomach, right at his belly button. The intense pain forced him to surrender the shotgun and the miners melted away into the tear-gas-tainted veld. At the same time, another band of strikers closed in on Warrant Officer Monene just fifteen paces away from the general. Monene was swiftly overcome by two spear thrusts into his chest and was slashed with a panga in his face. His assailants took his service pistol and shot him in the neck, though by then Monene was already dead.

On the opposite flank, forty-five-year-old Warrant Officer Sello Ronnie Lepaaku was retreating backwards towards a Nyala as miners closed in on him. Lepaaku stumbled and fell. He was wearing the armadillo-like scaled upper-body armour of the public order police, but one of the miners hacked him in the face with a panga. That single stroke cleaved his nose and much of his face from his skull. Other miners also struck at Lepaaku. One seized the officer's R5 semi-automatic rifle. General Mpembe roused himself from his shocked silence and screamed at his men to fire and move forward. Dozens of rounds were fired, almost all missing their targets, but the miners were finally driven off.

Vermaak instructed the police helicopter to land and Loest immediately went to the mortally wounded Lepaaku and spent twenty minutes trying to resuscitate him. Baloyi was screaming for medical assistance, shouting that he was the state's property and that his colleagues should use Vermaak's helicopter to take him to hospital immediately instead of waiting for an ambulance. Other policemen were just standing around the fallen cops, while Mpembe was running back and forth yelling, 'My policemen have been shot, my policemen have been shot!' He had lost control of himself and of his men. Vermaak quickly gathered a posse from among the stunned policemen and took off in pursuit of the stolen police firearms and radio; he was especially concerned about retrieving the R5 rifle.

Semi Jokanisi, a twenty-nine-year-old Pondo miner, was shot and killed by police in the melee. Fifty-year-old Tembelakhe Mati was wounded by the police gunfire. A group of miners, including Xolani Nzuza, picked him up and carried him from the scene of the fight. They argued as they ran with the stricken man slung between four miners, some not believing he would live and that they should leave him. A young woman living on the outskirts of a less established settlement had locked herself in her shack when she first heard the gunfire. Now she heard the sound of running, panting and arguing men coming ever closer. When they reached her shack, they

stopped. As she cowered inside, hardly daring to breathe, she could hear the anguished voices of the men as they argued about whether Mati was beyond help or not. Finally there was silence, but for the distant sound of gunshots. When she eventually opened the door, she found Mati sprawled on the ground, his dark red blood congealing. Initially the state pathologist believed that it was a spear thrust into his thigh and groin that had caused Mati to bleed to death, but independent pathologist Dr Reggie Perumal's report to the Marikana Commission of Inquiry found that it was a nine-millimetre bullet wound, likely fired by the police.

Among the miners who fled the confrontation was Phumzile Sokanyile, forty-eight, who made it all the way across a little stream, where he halted. Perhaps he thought he had done enough to evade arrest. Looking back he saw that a group of police were in pursuit but quite distant; they would not catch him before he disappeared into the warren of shacks west of Marikana.

Lieutenant Colonel Vermaak led that police posse. Vermaak's version is that he instructed his men to fire just one shot at a miner dressed in white overalls who kept pausing in his escape to turn and point the stolen rifle at them, threatening to shoot. The stories of who fired and who gave what commands have disturbing vagaries, and some of those police statements were shown by the commission to be false. Sokanyile was struck by a high-velocity round. The sound of the gunfire lagged behind the impact, and he fell to the ground, fatally shot in the head. On a slight rise on the opposite bank, a policeman lowered his R5 assault rifle, not bothering to collect the spent cartridge at his feet. Initially, the state pathologist stated that the bullet entered Sokanyile's cheek and exited the rear of his head. This was also shown to be incorrect by Dr Naidoo, who established that the direction of the shot was in fact the reverse. Sokanyile was shot from behind.

When Vermaak got to the body to secure the scene, he took photographs. These clearly show that Sokanyile was lying on top of a panga and a knob-kierrie. In later photographs, taken by a different policeman, somehow Sokanyile is grasping the panga in his hand. This suggests that one or more policemen tampered with the body and weapons to make it appear as if Sokanyile had been shot while threatening them. The other probability is that it was not Sokanyile who had the police's R5 rifle. Let us assume that the first photograph – Vermaak's – was an honest depiction of the scene as it was found: that the dead man had fallen onto the two weapons he had been carrying. If that were so, it is very unlikely that he could have been the

person threatening to shoot or shooting at police with a high-powered rifle that even an experienced user has to utilise two hands to fire. Vermaak's account of what happened is at odds with other policemen's initial and later renditions. Far from targeting a specific miner with a rifle, it is more likely that the pursuing cops fired into a group of fleeing miners, killing Sokanyile.[6]

Vermaak is a slight man with reddish-blond hair run through with grey and a matching bristly moustache. He had been the riot police commander in Klerksdorp during the turmoil of the 1990s, working in Kagiso, Bekkersdal, Swannieville and other hot spots on the West Rand. He is an interesting character who told the commission that he cannot attend a 'braaivleis' because of the memories that meat sizzling over an open fire evokes. During the nine-day police get-together after the massacre, and before the commission was due to begin its inquiry, Vermaak was the only policeman to challenge the clearly concocted narrative that sought to divert accountability from the senior cops and lay all the blame for events on Lonmin, the miners and junior policemen. For his troubles, Vermaak was dropped by the lawyers acting for the police who claimed he was a hostile witness, causing him to be painted as a brave and honest cop, but reality is a little more nuanced. Vermaak had a history of disciplinary measures raised against him and charges laid when he was in the POP, as well as in the former riot police and stability units that pre-dated it.[7] None of those charges ever went anywhere, but the list was alarmingly long. Of course, a riot cop is likely to face such charges, considering his job, but questions were raised that were not satisfactorily answered.

The Sokanyile killing was not the reason that Vermaak fell out with his fellow policemen, however. The most contentious incidents happened after all the shooting was done. As Vermaak and the Tactical Response Team members in his posse were walking back from the riverbank where they had shot at Sokanyile, the lieutenant colonel claims that the policemen told him they blamed General Mpembe for the deaths of their comrades. They said that Mpembe would lie dead beside the fallen cops that day. Once back with the rest of the police, Vermaak called his provincial commissioner,

6 Sokanyile's death was erroneously attributed to the shootings on the 16th. When Sokanyile's aged mother heard of his death days later, she herself collapsed and died.

7 It was all the same unit, of course, with the same members. The state tried to change the public's perception by renaming a unit that had an appalling reputation among black South Africans, who were usually at the receiving end of their harsh and biased policing.

Commissioner Mbombo, and told her that two policemen had been killed and that there was chaos, with General Mpembe having lost control. Mbombo said that the cell signal was poor and that she was nearly at the Potchefstroom provincial headquarters but would immediately turn around and return to Marikana. Vermaak's second call to Mbombo was to tell her that Mpembe's life was under threat from policemen and that he had to relieve the general of command and get him to safety. According to Vermaak, she agreed.

The provincial commissioner reported a markedly different recollection of those conversations. She says that Vermaak complained about Mpembe's demeanour, but did not mention any threats to his life, though she apparently agreed to the general's removal from the scene, leaving one with a sense of much left unsaid. What was never mentioned in the subsequent inquiry, but is spoken about among police, is that Mpembe had overseen Vermaak's removal from the POP unit to the Air Wing, away from direct contact with protesters or rioters in public-disorder situations. This may be linked to the list of complaints against Vermaak, or to other differences, but there was bad blood between the two officers.

At the time of these calls, as well as the earlier ones before the tragedy, Deputy Commissioner Major General Ganasen Naidoo was in the back seat of his boss's car. Naidoo remembers that Mbombo was sitting up front alongside her driver and that she received several calls, some of them in 'vernacular', as he put it, but he did not know what they were about. She was also chatting to her driver. It would seem that Naidoo was not paying any particular attention to his superior's conversations, mostly as he could not understand her home language, isiXhosa, nor could he comprehend isiZulu or Sesotho, in which she was proficient. He stated that Mbombo would often begin speaking to him in the 'vernacular' and he would have to stop her, reminding her of his linguistic deficiencies. It seems unlikely that Mbombo would not share the content of at least some of these calls.

Mbombo claims she received a call from General Mpembe telling her that two policemen had been killed and one severely wounded. She instructed her driver to turn around immediately and return to Marikana. Naidoo agrees that this happened, but could not specify who the call was from. The end result is that Vermaak claims he called Mbombo, while Mbombo says it was Mpembe who called her. Another phone-call anomaly is that Commissioner Mbombo claims not to have received a call from Mpembe before the killings stating that he was going to deviate from her

orders by escorting the miners to their koppie stronghold at Nkaneng instead of disarming them. There is police video showing Mpembe on the phone at the time of those alleged calls. If not Mbombo, who was he calling? The province's highest-ranking cop told the commission that her deputy was lying in his testimony. It is unclear what turns on these differences, but they demonstrate how the police have obfuscated every matter related to responsibility and how ambition and interpersonal relationships played a critical role in directing policing decisions.

By the time night fell, the police had arrested a total of eight miners, including two men who had been taken to hospital with bullet wounds following the clash. Lieutenant Baloyi was in an intensive-care unit struggling for his life. That evening, Warrant Officer Lepaaku's wife Petunia was watching the television news when she saw her wounded husband being carried away by his colleagues. She tried to call him repeatedly, but his cellphone rang unanswered. Images taken of their dead colleagues by other officers were swiftly circulated among police circles. There is little doubt that every police officer saw those images, and that anger swept through their ranks across the nation. General Mpembe had inadvertently precipitated a murderous clash that would determine the police mood in the days to come.

12

Day 5:
Tuesday 14 August

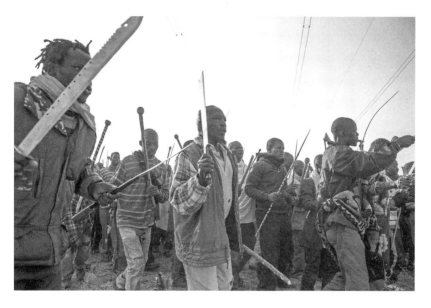

Marikana strikers with sticks, pangas and home-made spears at Thaba, Nkaneng, 15 August 2012.
One of the strike leaders, 'Rasta', is at far left.

'I just told these guys that we need to act such that we kill this thing.'
– Lieutenant General Mirriam Mbombo, North West
provincial police commissioner, Tuesday 14 August 2012

The killing of the two warrant officers Sello Lepaaku and Tsietsi Monene altered police behaviour and public opinion. The number of policemen deployed to the area immediately surged from 120 to over 500. More significantly, a large number of cops from specialised tactical units were called up. The afternoon before, Major General Ganasen Naidoo, on the instructions of his boss, Commissioner Mirriam Mbombo, had called on the services of a man holding a similar rank but with very different skills to the administrative Naidoo. Major General Charl Annandale was the operational head of two specialised tactical police units – the National Intervention Unit and the Special Task Force (STF). Annandale had initially dispatched a squad of the NIU to Marikana on the Sunday, but the killing of Monene and Lepaaku saw more NIU and TRT squads deployed, as well as two squads of the elite STF mobilised.

The STF is made up of just 120 members. They are a highly trained special operations unit whose skills concentrate on counterterrorism, counter-insurgency, hostage rescue and bush warfare – very similar to military special operations skills. The unit's lineage goes back to the police units that fought on the side of the Rhodesian minority government in their war, and the 'Border War' in South West Africa and Angola. One such paramilitary police unit became notorious during the Namibian war. Koevoet (Afrikaans for 'crowbar') was a search-and-destroy unit formed to fight guerrillas on the northern border area between South West Africa and southern Angola. They were feared by the Namibian population as a whole, but revered by conservative white South Africans for their deadly proficiency. The unit wore a distinctive police bush-camouflage uniform, very similar to what the STF wore on their deployment to Marikana. Like Koevoet, the STF in

Marikana were in military vehicles, a Casspir and a Scorpion, the latter rigged with a fifty-calibre mounted machine gun covered with a tarpaulin that did little to hide its menacing shape. While the STF is a much more disciplined outfit than Koevoet ever was, and operates in a different epoch, there are many similarities. The STF were particularly unsuited to be deployed against striking miners, but they were sent to make a statement.

That message was reinforced by Annandale taking over de facto command of the operation from Major General William Mpembe, and, late on the 13th, bringing in an STF officer, Lieutenant Colonel Duncan Scott, to do the planning. Scott was tasked with devising a plan to disarm and disperse the miners, though this plan never allowed for dealing with the full number of strikers who gathered later in the day, but rather with the much smaller number who overnighted at the koppie. The Scott plan of the 14th was presented to and accepted by the commanders, and was based on the common-sense approach of encircling the koppie with razor wire early in the morning to trap the hard-core strikers who spent their nights on Thaba. Almost inconceivably, Scott never consulted policemen who had done this type of wire deployment previously, and he was unaware that the various Nyalas could not roll out the wire simultaneously, but had to wait for the previous one to finish before the next one set off, much like a relay race. Scott's plan would continually be tweaked to compensate for the fact that the original plan needed more razor-wire coils than the operation had at its disposal. Crucially, the different police unit commanders were extensively briefed on the encirclement plan, and even when that plan later changed, the encirclement idea would stick in many commanders' heads.

In the course of the day, Mbombo called a meeting with the Lonmin executive who was in charge of the day-to-day handling of the strike, Barnard Mokwena. Without disclosing it to the police, one of Mokwena's staff was surreptitiously recording the discussion. When the existence of that recording was unexpectedly revealed during the Marikana Commission of Inquiry, it would play a critical part in understanding police and Lonmin motivations, and reveal the realpolitik behind their actions. The police were apparently more concerned with aiding the ruling party than solving the strike peacefully.

In that meeting, Lonmin and the police agreed to cooperate on four key points. The first was that they coordinate the issuing of an ultimatum that the workers return to work the next day or face dismissal, as per a court

interdict Lonmin had obtained earlier that day. Mbombo asked Lonmin to delay the distribution of pamphlets with the ultimatum that strikers return to work until early the next morning, instead of during the night. This would give the strikers less time to comply and thus ensure that the police operation would indeed have the chance to go ahead and catch the strike leaders.

The second point of agreement was an understanding that the proposed police operation to arrest the miners might well turn bloody. Mbombo told Mokwena that it did not matter if the ultimatum angered the strikers, as the police would then be 'prepared to move in a different direction'.[1] Mbombo said if the strikers did not surrender their weapons, there would be blood. Mbombo urged Mokwena to take a harder line with the strikers, to insist that they return to work by Wednesday, because the police plan was to move in then. She went on to explain that her police officers were 'annoyed' by the killings of Lepaaku and Monene, and despite calls from within police ranks to immediately move against the miners, she had held back, as emotions were running high. Despite Mbombo's understanding of her policemen's anger, she did not instruct those who had been involved in Monday's clash to take mandatory time off or to seek counselling, but instead allowed them to continue to take part in the operation. At one stage she complained that her police were 'tied up by these new amendments in our law that say we cannot shoot', and referred to the televised death of community leader Andries Tatane at the hands of police during an April 2011 protest in the Free State town of Ficksburg. While she depicted herself displeased at such constraints, she went on to say that she did not want to see '20 people killed'. It is clear that the police and Lonmin foresaw the dangers presented by the mental state of both the policemen deployed and the miners.

Their third point of agreement was about the unions. Mokwena expressed a fear that should the strikers succeed, then wildcat strikes by disgruntled miners across the platinum belt would follow. Mokwena insisted that Lonmin's priority was to have the strike leadership arrested and thus break the strike, as he had proof that the upstart union AMCU was behind it.[2] Mbombo agreed that it was politically unwise for Lonmin to negotiate with the strikers as this would undermine NUM. She advised Lonmin to

1 The meeting on the 14th was submitted as evidence to the Marikana Commission of Inquiry, and informs this chapter.
2 Such proof was never presented to the commission.

demonstrate clearly that the company was not trying to get rid of the ruling party's most powerful union ally. Mokwena was allegedly doing much more than he revealed to the SAPS. Apparently unbeknownst to the police, Mokwena was a deep cover agent on behalf of the state intelligence services. A court case brought by Thebe Maswabi against President Zuma and other government ministers and officials for R120 million in 2016 exposed Mokwena as founder of a company that was behind an attempt to start a new union to oppose AMCU in 2014. The domestic intelligence register of agents show Mokwena received cash payments from 2004 until at least the end of 2012. Furthermore, the out-of-pocket Maswabi claimed that Zuma personally instructed him to start the new union to oppose AMCU, which was decimating the ANC-aligned NUM. It should be an interesting court case.[3]

The fourth point of concurrence was that Julius Malema or any other 'jick-and-jiff' political opportunist be prevented from taking advantage of the situation to further their careers. Mbombo related that Lonmin shareholder and non-executive director Cyril Ramaphosa had been pressurising the minister of police, Nathi Mthethwa, to characterise the strikers as criminals, and act accordingly. National police commissioner Riah Phiyega had asked Mbombo during a telephone conversation who the Lonmin shareholders were that she kept hearing about. When Mbombo replied that the minister had mentioned Ramaphosa, Phiyega then exclaimed, 'Now I got it!'

Phiyega's moment of enlightenment came from the fact that Ramaphosa had been the ANC leader who had led the disciplinary proceedings against the ANC Youth League president, Malema. Now that the popular Malema had been expelled, the ANC did not want him to profit politically from the strike. While still a member of the ANC, Malema had previously managed to defuse a volatile strike at the neighbouring Impala Platinum mine, or at least take credit for doing so. Were he to do the same now, it would give him a platform outside of the ruling party. Malema's populist views on nationalising the mines were also a consideration. The top police management and political leadership clearly were most concerned that the strike was damaging to the interests of the ruling party.

In a bizarre ending to the disturbing discussion, Mokwena expressed that he was particularly excited by the presence of STF snipers. Lonmin's

3 Pieter-Louis Myburgh, 'Opinion: SA deserves truth about govt spies and Marikana', News 24, 16 August 2016, http://www.fin24.com/Opinion/opinion-sa-deserves-truth-about-govt-spies-and-marikana-20160816; Pieter-Louis Myburgh, 'Lonmin boss was a "spy"', City Press, 2 May 2016, http://city-press.news24.com/News/lonmin-boss-was-a-spy-20160528-2.

attitude, on the face of it, was mystifying. Threats to force workers to end a strike had no history of success, either at Lonmin or at any of the nearby platinum mines. One would have expected the company to open talks to get the workers back to work quickly. Instead, it would appear that they were colluding with the police to act as strike-breakers at the risk of bloodshed, even as they pretended to be trying to facilitate talks between Lonmin and the workers.

The untimely forced absence of the forty-seven-year-old chief executive Ian Farmer, who while in London had been rushed to hospital the day before with kidney failure and was later diagnosed as having bone marrow cancer,[4] saw other top Lonmin men step in to direct company strategy. Mokwena worked with three other directors: chairman Roger Phillimore; non-executive director Mohamed Seedat, who had until recently been the Lonmin chief executive; and Simon Scott, who was also the chief financial officer. Others closely involved were Albert Jamieson, the chief commercial officer; Mark Munroe, executive vice president of mining operations; and Frank Russo-Bello, vice president of mining.

At the koppie early that afternoon, three men were confronted on suspicion of being spies, or *impimpi*. One was an older miner and NUM shop steward named Isaiah Twala, who, earlier that morning, had decided to go to the meeting on the mountain with a friend. After some time, they were ready to return home. As they were leaving, they were stopped by two men wearing blankets and armed with sticks and spears who ordered them to return to the meeting.

Once back at the koppie, they were taken to a clearing and ringed by a dozen men, with several of the strike leaders (allegedly including 'Anele', 'Bayi', 'Rasta' and Mambush) among them. There was already a man, a NUM official, seated on the ground, and they were forced to sit next to him. The men were questioned, and when miners among the group making up the kangaroo court spoke up for them, two of the men were allowed to leave, but not Twala.

Despite the sangoma's ban on mobile phones at Thaba, Twala had a cellphone on him. Dressed in neatly pressed khaki trousers, a plaid shirt and brown jacket, and highly polished brown shoes, Twala was fearfully answering his interrogators when Xolani Nzuza arrived and sat next to

4 'Ian Farmer: Apologies for Marikana and hope for SA', *BDLive*, 11 October 2013, http://www.bdlive.co.za/opinion/bdalpha/2013/10/11/ian-farmer-apologies-for-marikana -and-hope-for-sa (last accessed September 2015).

Mambush. Nzuza was given the cellphone and he scrolled through it, finding the phone numbers of several NUM officials as well as those of management. Twala responded that as a shop steward he had to be in contact with them from time to time. In addition to defying the taboo, the cellphone had what the strikers described as an excessive amount of airtime on it. The buying of airtime for someone is often used as an informal and immediate method of payment and thus, to their minds, it confirmed that Twala was receiving compensation for betraying them to Lonmin.

Twala, desperate to have someone vouch for him, addressed Nzuza, saying, 'The person who knows me is this one, this boy sitting here. He knows where I work.' Nzuza replied, 'No, old man, don't say you know me. I only met you once.' Nzuza narrated that Twala, as a supervisor underground, had once told him to don his safety goggles or he would have him fired. Nzuza went on to say that Twala was a bad man who had precipitated the firing of many men. After relating this story, Nzuza says he left the gathering and went in search of a cold drink. Other witnesses tell a different version of what happened next. They say that Twala was searched once more, leading to a silver pistol being found. A group of three to four of the leadership is said to have then led Twala away, to the south of the koppie and out of sight of the gathered miners.

Miners say they heard Twala cry out; others reported hearing one or two gunshots before the leadership group returned, without Twala. Twala's body was discovered by police behind the koppie later that afternoon. He had been shot and stabbed thirteen times. Someone had placed the skull of a cow on his chest.

13

Cyril Ramaphosa: Saint or Sinner?

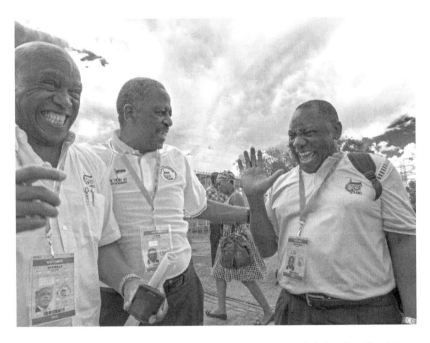

From left, Tokyo Sexwale, Mathews Phosa and Cyril Ramaphosa shortly before the tally of the votes to determine the leadership of the ANC at its 53rd congress at Mangaung, 18 December 2012. Jacob Zuma was re-elected president and Cyril Ramaphosa was voted in as his deputy.

'Apartheid was baked hard in the mining industry, because that's where it originated.'
— Cyril Ramaphosa[1]

What is less spoken about in South Africa's 'miracle' transition are the deals that were struck in corporate backrooms as the country moved from a racist authoritarian state to a non-racial democratic state. The key ANC negotiators were scions of the liberation struggle Thabo Mbeki and NUM's secretary general Cyril Ramaphosa. Both of these men were moderate African nationalists who appeased white fears and ensured there was not a large-scale right-wing revolt. While the political aspects of the negotiations taking place between the main political parties occupied centre stage, a seduction was occurring behind the scenes. The hugely wealthy capitalist dynasties were revealing the pleasures of a champagne-and-private-jet lifestyle to a select few representatives of the black majority.

In 1994, ANC supporters and, more importantly, ANC voters believed that the transfer of political power and access to economic power would benefit them materially. But as the brief Mandela presidency was followed by the Mbeki years, there was a move away from the more progressive, pro-poor policies to a series of neoliberal economic initiatives which cynically promised that wealth would also trickle down to the poor, soothing their desperation with capitalist mantras like 'A rising tide lifts all boats'. Mbeki's presidency organised golf days so that the rich could mingle and network with ministers and the politically connected to their mutual benefit. It set the tone, and methodology, for the spectacularly corrupt Zuma years that would precipitate deep anger and disillusionment among South Africans.

1 Quoted in Bill Keller, 'Could Cyril Ramaphosa be the best leader South Africa has not yet had?' *New York Times*, 23 January 2013, http://www.nytimes.com/2013/01/27/magazine/could-cyril-ramaphosa-be-the-best-leader-south-africa-has-not-yet-had.html?_r=0 (last accessed September 2015).

The formalistic policy of black economic empowerment, a tool to reverse hundreds of years of black dispossession and legislative racism, became the way for politically connected black South Africans to rapidly rise to millionaire, and even billionaire, status. From within the ANC, a few select individuals were 'deployed' to the belly of the capitalist beast to make money for the party. They were also free to enrich themselves. A small circle of these businessmen seemed to be involved in every major deal as nervous white business scrambled to be associated with them. It is unclear whether the party initially foresaw just how wealthy some of those deployed cadres would become. This coterie became known as 'the usual suspects', and their ostentatious rise to immense wealth further exasperated the massive numbers of poor Africans who realised that they would never access even the crumbs of the feast.

As a student, Matamela Cyril Ramaphosa was detained for eleven months under the Terrorism Act, a blunt law used against political activists. In 1976, while a candidate attorney, he was again arrested under the same law and spent six months in the dreaded John Vorster Square. He went on to become a passionate and principled young lawyer within the trade union movement. When he was just thirty years old, he was instrumental in founding the National Union of Mineworkers in 1982, organising the very cohort of black men on whose backs the majority of white South Africa's wealth had been built. Ramaphosa was a prominent member of the Mass Democratic Movement (MDM), a broad coalition of left-wing, church and progressive organisations including both the United Democratic Front and the union federation COSATU. The MDM essentially represented the banned ANC inside South Africa, even though it arose from a broader spectrum of leftists.

The fruit of the fight against apartheid was the first non-racial polls. The 1994 election was an emotional and powerful moment for which generations had fought and died. Anthony Butler's biography relates an anecdote in which Ramaphosa went to cast his vote, appropriately in a mining community. 'I was stopped by one old miner ... who said: "We are pleased you are here ... I can now go and retire because what we fought for all these years, and what you also came and fought for ... you belong to us miners."'[2]

Mandela encouraged Ramaphosa to believe that he was Mandela's choice to be the ANC's first deputy president ahead of the 1994 election, and

2 Quoted in Anthony Butler, *Cyril Ramaphosa* (Johannesburg: Jacana, 2013).

when the party elders gave Mbeki the nod instead, Ramaphosa was devastated.[3] He was one of the ANC's young princes, but unlike the majority of the liberation movement's elite, he was neither an exile nor did he serve time as a political prisoner on Robben Island. He was also from a small and marginalised ethnic group, the Venda. Chagrined by his defeat, he apparently refused the post of foreign minister in a huff, and did not attend Mandela's historic inauguration. Ramaphosa withdrew from the forefront of politics, spending his time, not insubstantially, helping write the new South African constitution. Crucially, he kept his hand in, remaining on the ANC's influential NEC. Then Ramaphosa set out to become rich.

His political credentials and connections made him much sought after as a business partner and a rainmaker. His marriage to Dr Tshepo Motsepe, the sister of South Africa's only black dollar-billionaire Patrice Motsepe, did not hurt either. Ramaphosa joined New Africa Investments Limited (NAIL), a major black investment vehicle led by Dr Nthato Motlana, Mandela's physician from Soweto. Within a few months, Ramaphosa was named as the deputy chair of NAIL. By November 1996, newspapers were already reporting that he was a millionaire.

Ramaphosa must have seemed like a natural ally for ambitious global businesses; some would call him an asset. Years later, a Glencore executive told business partners, 'I don't want to be crude, but we made him', and claimed Ramaphosa's Shanduka Coal was a front for Glencore.[4] Glencore was the successor to rogue commodity-dealer Marc Rich's company, Marc Rich & Co. AG. Rich made immense profits circumventing the oil embargo on Iran in the 1970s. The current CEO of Glencore, Ivan Glasenberg, is South African–born and was a Rich protégé. Glasenberg ran the South African coal office during the eighties. The South African office was the 'most important and most profitable part'[5] of Rich's business, making an estimated

3 Keller, 'Could Cyril Ramaphosa be the best leader South Africa has not yet had?'
4 Interview with author, 2013. Interviewee prefers to remain anonymous. From Glencore: 'Glencore is not aware of these allegations. In any event, these allegations are completely baseless. The relationship between Glencore and Mr Ramaphosa was limited to his and Shanduka Resources' participation as a BEE partner in certain Glencore group coal mining companies. These comprised just a few of the investments held by Mr Ramaphosa and Shanduka Resources. Mr Ramaphosa has disposed of all of his mining interests and no longer has any relationship with any Glencore group entities.'
5 Murray Hunter, 'Marc Rich, apartheid's oil man: His "most important and most profitable" business', Daily Maverick, 19 July 2013, http://www.dailymaverick.co.za/article/2013-07-19-marc-rich-apartheids-oil-man-his-most-important-and-most-profitable-business/#.VfhCJJ1Viko (last accessed September 2015).

$2 billion busting oil sanctions for the apartheid regime. Glasenberg and Rich's top management eventually forced Rich out after a disastrous adventure in trying to corner the world zinc market. Thus was Glencore founded.

Like its antecedent, Glencore made a name for itself by going into resource-rich, politically unstable countries and forming partnerships with often unsavoury governments to access commodities. They then shipped those minerals with a fleet larger than the British Navy and stored them, waiting for the perfect time to sell. Glencore sometimes precipitated those perfect moments through their control of these commodities, everything from oil and coal to wheat. The friendship between the anti-apartheid unionist and the profits-first Glasenberg-led company seems unlikely, yet for many, business is just business and idealism is best set aside. Of course, Ramaphosa is an exceptionally smart, complicated and independent individual, who had already made himself into a national and international figure before he entered business, and so just who was using whom is debatable. For Ramaphosa, it was a rapid ride to unimagined wealth. He was listed as owning or having equity in many of South Africa's top companies, from SAB Miller, Standard Bank, Bidvest and MTN to the South African McDonald's franchise.

A snapshot of how one of these deals worked reveals just how favourable some were to Ramaphosa. Shanduka was brought in as the BEE partner of the manganese mining giant Assore for $27 million in 2005; these shares were sold in 2011 for $260 million. Additionally, Ramaphosa disclosed that he personally owned five million Assore shares, worth $168 million by 2013. That was the year that Ramaphosa was named South Africa's nineteenth-richest person. In that year, the number of South African millionaires increased at a remarkable rate of 14 per cent. Most of those millionaires were black, but there was still a sizeable addition to the number of white South African millionaires. The combined wealth of these 48 700 millionaires equated to a third of the country's individually held wealth. In a country of over 50 million people, that means that less than 0.01 per cent of the population controls 33 per cent of its wealth. Economist Moeletsi Mbeki, Thabo's brother, commented: 'It's crony capitalism. It's an anti-competitive system.'[6]

The ANC government set up a system of ensuring that a portion of mine ownership would be held by previously disadvantaged South Africans. All

6 Moeletsi Mbeki, quoted in Sipho Hlongwane, 'South Africa's only black billionaire donates half his fortune to charity', *Guardian*, 31 January 2013, http://www.theguardian.com/world/2013/jan/31/south-african-billionaire (last accessed September 2015).

existing mining licences had to be converted to 'new order rights' wherein mining companies would adhere to black empowerment equity requirements and also formulate plans to uplift the communities that surrounded the mining areas.

Lonmin's own empowerment deal was launched with great fanfare. Incwala Resources was made up of a mix of black beneficiaries, including Lonmin employees. The idea was that this stake would enable previously disadvantaged people to benefit after decades of exploitation. On the back of all the hype, Incwala's value increased 328 per cent in the first two years. Yet by 2009, demand for platinum had plunged and Lonmin miscued badly on an ill-advised mechanisation programme. How Lonmin ever came to make that decision is baffling, as the Merensky and UG2 reefs that they mine are never more than a metre thick. Even now there is no mechanical means to extract the basket of precious metals without also mining many more tons of useless rock. The key to economical mining is to extract as little as possible of the useless rock that sandwiches the ore. By the time Lonmin reversed the decision to go mechanical, they had burnt through a lot of cash. They had also demonstrated to the rock drillers, who stooped and crawled in pursuit of the ore, that they wanted to be rid of as many of them as possible.

The problem with the empowerment deal, and many others like it, was that the state administrators of mining's empowerment deals who were negotiating with the massive international companies were outgunned. The Department of Mineral Resources drew upon smart but inexperienced young lawyers who simply did not understand what those deals meant in real life. They were, and are, functionally illiterate in the language of high finance. The mines, however, drew on experts from JP Morgan and the Rothschild Group, among others. Lonmin's cultural heritage was moulded by founder Tiny Rowland – one of the most deceptive and corrupt dealmakers in international business.[7]

Once the platinum price slumped during the recession of 2008, Lonmin's three main BEE shareholders began to struggle. Like many BEE deals, the beneficiaries bought their shares mostly through loans from commercial banks. They were reliant on dividends from Lonmin to service those debts. Lonmin, who had guaranteed the outside debts, needed to step in and bail them out because without black shareholders they would lose their mining licence. But Lonmin did not want to go the broad-based route again, which saw them give away shares to players with little or no political clout. They

7 Bower, *Tiny Rowland: A Rebel Tycoon.*

were done with small fry, and wanted a heavy-hitting partner who could deliver more than just a black face to fulfil their BEE requirements.

Ramaphosa was perfect. He was already a successful black businessman involved in mining and was in favour among Zuma's clique. But Ramaphosa also needed a loan from Lonmin to buy into Incwala – to the sum of $304 million. His Shanduka itself put up just R300 million (about 10 per cent of the sum needed). As a result, Lonmin diluted their shares, infuriating shareholders who had to dig into their pockets to bail out the initial badly conceived empowerment deal.

Ramaphosa stood to make truckloads of money should it work out. If it did not, he could walk away from the deal, albeit losing the R300 million of Shanduka's investment, and Lonmin would have to start looking for other BEE partners to maintain the 18 per cent empowerment stake or forfeit their mining licence.[8]

One of the remaining original shareholders, the Bapo ba Mogale people, on whose land Lonmin mined and who had the right to first refusal, wanted to buy more shares. Lonmin brushed them off, saying they preferred a partner who could add value; and the poverty-stricken local community were sidelined. The workers were paid out for their Lonmin shares in 2011. Ramaphosa was chosen as the face of the 'previously disadvantaged under apartheid'. The industry that invented the colonial precursor to apartheid was tone-deaf to the irony.

As it turned out, the Bapo ba Mogale were perhaps fortunate to have been shunned. Ramaphosa's investment rapidly depreciated. By the time the miners went on strike in August 2012, the share price was around £7. Ramaphosa's investment was looking like a bad bet – to break even, the share price had to be above £14. Put another way, in 2010, when Ramaphosa bought in, Incwala was worth approximately $600 million. By September 2012, Incwala's value had dropped to $398 million.[9]

As the strike took hold, the former unionist and champion of the working man was now in a position where his financial interests were being threatened by the demands of the miners he once represented. But Ramaphosa was more than just a shareholder; he was a non-executive director tasked with 'looking into all the transformation activities of the

8 By December 2014, Lonmin increased their BEE shareholding to 24 per cent, as per the requirement.

9 Lisa Steyn, 'Lonmin unlucky in BEE love', *Mail & Guardian*, 7 December 2012, http://mg.co .za/article/2012-12-07-00-lonmin-unlucky-in-bee-love (last accessed September 2015).

company to see the extent to which the company could transform issues of housing, the employment equity and taking care of the mining labour plan filed with the Department of Minerals and Resources', according to Lonmin's website. He had a responsibility to look out for the workers' interests.

A series of phone calls and a flurry of emails with Ramaphosa at the centre showed just how profoundly the former unionist and socialist had come around to the thinking of big capital, and how much influence he wielded with government ministers and the president.

On Tuesday 14 August, minister for mineral resources Susan Shabangu was on the East Rand and made her first public statement on radio about the strike, describing it as a labour dispute and calling on all parties to sit down and sort it out. Lonmin executives deemed this incorrect. They called upon Ramaphosa to persuade her to say that what was happening was a criminal matter and not a labour issue, and to get the state to intervene much more robustly in the strike. Much later that day, after midnight, Ramaphosa sent an email to the chairman, Roger Phillimore, stating that he had indeed had discussions with, among others, Minister Shabangu. The email says that he told her that her silence was bad for her and the government. Ramaphosa claimed she said she would issue a statement. He further wrote that he would be meeting Shabangu in Cape Town later that day to 'have a discussion and see what she needs to do'.

Lonmin representatives were pleased, yet despite the intervention Shabangu told a national radio station later that morning that the Marikana situation was a labour dispute that had to be solved by the parties coming together to sort it out. That provoked an incensed email from Lonmin chief commercial officer Albert Jamieson to Ramaphosa, asking him to call the minister and influence her to change the way the government identified the strike.

Ramaphosa immediately responded, saying he would have a discussion with the minister. 'I thank you for the consistent manner in which you are characterising the current difficulties we are going through,' he added. 'The terrible events that have unfolded cannot be portrayed as a labour dispute. They are plainly dastardly criminal and must be characterised as such. In line with this characterisation, there needs to be concomitant action to address the situation.'[10]

10 Marikana Commission of Inquiry.

By this time, Ramaphosa had also put in calls to Nathi Mthethwa, the police minister and a fellow NEC member. In a follow-up email sent at midday on 15 August, Ramaphosa told Lonmin's Phillimore, 'You are absolutely correct in insisting that the Minister and indeed all government officials need to understand that we are dealing with a criminal act. I have said as much to the Minister of safety and security.'[11]

Mining minister Shabangu had previously been the deputy minister of police, at one stage also known as the ministry of safety and security. In a speech in 2008 she told police that 'you must kill the bastards if they threaten you or the community. You must not worry about the regulations. I want no warning shots. You have one shot and it must be a kill shot. I want to assure the police station commissioners and policemen and women from these areas that they have permission to kill these criminals. I will not tolerate any pathetic excuses for you not being able to deal with crime. You have been given guns; now use them. If criminals dare to threaten the police or the livelihood of lives of innocent men, women and children, then they must be killed.'[12] Shabangu's infamous speech was reiterated in various forms by various police officials and ministers over the years, and indeed by Jacob Zuma, before he became president.

Lonmin and Ramaphosa's efforts were not at all directed at finding a peaceable end to an industrial dispute, however violent it was. Instead they strove to have all the strikers labelled as criminals and called upon the police to act. This was a police force that had been instructed to 'shoot to kill' anyone they judged to be a criminal, a police force Ramaphosa knew well. It had brutalised him and he had seen on many an occasion how savagely police dealt with striking miners while he led NUM and COSATU. If the strikers were 'criminals', then, the logic went, they could be shot without compunction.

Later, under cross-examination at the Marikana Commission, Ramaphosa insisted he had held that the killings and intimidation were the criminal acts, not the strike itself. This is not at all clear in his or Lonmin's emails, where the unprotected strike itself seems to be labelled criminal.

During this period, NUM called for the army or the paramilitary Special Task Force to be called in, a couple of days before the STF were indeed deployed at Marikana. This campaign did not fall on deaf ears. It

11 Mthethwa was appointed minister of safety and security on 25 September 2008, soon after which, on 10 May 2009, the name of the position changed to minister of police. He continued in that role until 24 May 2014.
12 Marikana Commission of Inquiry.

is clear from the discussions between the police commissioners Phiyega and Mbombo, and Mbombo and Lonmin's Mokwena, that Ramaphosa's desires were to be heeded.

A more reasonable side of Ramaphosa emerges in other communications during the strike. In emails between him and Thandeka Ncube, Shanduka's representative on Lonmin's executive management committee, Ramaphosa seems to side with the aggrieved miners, and reinforces his reputation as a fair man: 'The problem with the situation is that we know the cause of it; the real cause is the huge differential between the wages paid to the rock drill operators in other companies and what we pay them. I really did not know that the differential was so huge.'[13]

But he should have known. As the chair of the transformation committee from 2010, he was meant to hold management accountable for the social conditions of the workers and the communities around the mine. According to journalist Bill Keller, 'it still offended him to visit mine operations, now as a shareholder, and see electric lines running high past the villages and shantytowns to power the mine, which glows "like an island of light, all the villages around it dark". It irks him to see the pipes that carry water from dam to ore-washing, past villages with no sanitation. But as a minority shareholder, he insisted, all he can do is raise a voice for reform, and the companies are slow to respond.'[14]

It was Ramaphosa who counted as one of his great victories the end to the dehumanising hostel system for which the mining industry was notorious – the concrete shelf-like sleeping bunks where humans were packed like chattel. Ramaphosa had negotiated the live-out wage that saw miners move out to the burgeoning shantytowns, often without decent water or sanitation. He knew what wages a miner needed. As a man famous for negotiating the white supremacists out of the Union Buildings, and a former union leader, Ramaphosa should have insisted that at the very least Lonmin speak to their striking employees. He did not. Ramaphosa, it would seem, acted to protect his own financial interests, to protect NUM from the workers' ire, and to enable the ANC's legislated patronage to continue unhindered.

13 Ibid.
14 Keller, 'Could Cyril Ramaphosa be the best leader South Africa has not yet had?'

14

Day 6:
Wednesday 15 August

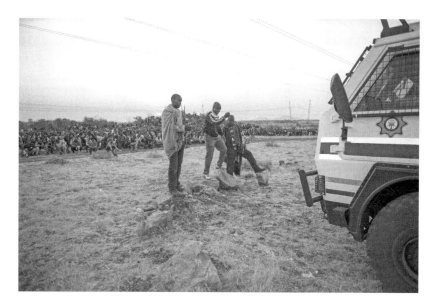

Xolani Nzuza (centre) gestures for the police Nyala with police negotiator Lieutenant Colonel Stephen McIntosh and AMCU president Joseph Mathunjwa inside to come closer so they can speak through the front gun port after the police refuse to allow the unionist to leave their vehicle to address the strikers in the late afternoon at Thaba, 15 August 2012. To Nzuza's right is Mambush Noki.

'Looking back, being unable to afford an education for their children was the resonant cry of all we spoke to. But at that moment, blinded by fear for my own safety, all I could see was angry and distrustful faces.'
— Kwanele Sosibo, journalist with the *Mail & Guardian*

E arly on Wednesday morning, by the light of a single paraffin lamp, Shadrack Mtshamba rolled his first cigarette of the day, careful not to spill any tobacco. There was domestic cheer in the hiss of the small paraffin stove on which a kettle of water for tea had just boiled. The sluggish, oily smell of the paraffin was so familiar he barely noticed it after a night in the shack. The word from other workers was that the leadership of the two unions would be addressing them at Thaba. Mtshamba tipped some of the steaming water into a blue plastic basin that he had already half-filled with cold water. He stripped down and stepped into the basin, methodically washing himself with a bar of carbolic soap and a washcloth. By the time he was dressed, his tea had steeped to a satisfyingly deep black.

A larger crowd than before had gathered at the koppie. All were eager to hear what the union presidents had to say. Mtshamba hoped for news of progress – his financial situation could ill afford any more time off work, and the unpaid strike days were adding up. The morning slipped by with no sign of the unionists and Mtshamba went to buy himself food before returning. The atmosphere was peaceful, most likely because of a combination of the growing police presence and the strikers' belief that Lonmin would soon talk to them.

At Lonmin's Marikana offices, Barnard Mokwena and Major General William Mpembe engaged in lengthy discussions with the NUM and AMCU presidents, Senzeni Zokwana and Joseph Mathunjwa. Mokwena made it clear that Lonmin was offering nothing to solve the stand-off – there would be talks, but no negotiations on wages. Mpembe was insistent that the union representatives tell the workers to disarm, disperse and return to work. Mpembe emphasised that the miners were dangerous, that the

unionists would only be allowed to approach the koppie in Nyalas, and that they had to address the men from within the armoured vehicles.

While Thaba remained the centre of attention, behind the scenes Lonmin executives were kicking their influence machine into high gear. Roger Phillimore, the Lonmin chairman, contacted the ruling party's secretary general, Gwede Mantashe. At first glance, it seems curious that the chairman of an arch-capitalist extractive company would call on the most influential leftist in South Africa, an avowed communist and a former NUM leader, to assist in breaking a strike in which workers were demanding a living wage. Mantashe epitomised the disconcerting cohabitation of big business and socialist rhetoric in post-apartheid South Africa. He was the first unionist to be appointed to the board of a major mining and energy company.[1] Mantashe, we recall, also had an acrimonious history with AMCU's Mathunjwa, having forced Mathunjwa out of NUM. Three days before, Lonmin's chief commercial officer Albert Jamieson had written to mining minister Susan Shabangu, asking that she 'bring the full might of the state to bear on the situation' and reminding her of how important Lonmin was to the economy and of the possibly dire consequences for all of them if the usual order of business was not quickly resumed.[2]

But the most powerful arrow in Lonmin's quiver of political influence seems to have been Cyril Ramaphosa, who feverishly lobbied his comrades in government. In response to an email from Jamieson,[3] Ramaphosa sought to discourage Shabangu from supporting negotiations. Ramaphosa wrote Jamieson that he had flown to Cape Town and had just had a discussion with Shabangu.

1. She agrees that what we are going through is not a labour dispute but a criminal act. She will correct her characterisation of what we are experiencing.
2. She is going into Cabinet and will brief the President as well and get the Minister of Police Nathi Mthethwa to act in a more pointed way.
3. She will be in Johannesburg by 5pm and would be able to speak to Roger. Let us keep the pressure on them to act correctly.

1 Samancor, from 1995 to the present.
2 Correspondence given in evidence at the Marikana Commission of Inquiry.
3 'We are grateful the police now have c 800 on site. Our next challenge is sustaining this and ensuring that they remain and take appropriate action so we can get people back to work.' Email from Jamieson to Ramaphosa at 09:43, 15 August 2012.

Back at the koppie, Mtshamba and the other miners waited as the afternoon passed with no progress other than ever-increasing police activity.

By mid-afternoon, the miners' leadership took the decision to speak to the media for the first time. Apprehensive journalists, who had previously been kept at a distance by the miners, were invited to be addressed by the strikers, but only if they removed hats and caps, wristwatches and any jewellery. Mobile phones had to be switched off. Female journalists were not welcome. These strictures were in line with the sangoma's extensive list of taboos. Five miners were selected to speak to the journalists. One of them was Bhele Dlunga, who explained that the men on the koppie were all Lonmin employees, and that no union represented them.[4] The strikers were clearly neither 'faceless' nor without leaders willing to speak in public. The miners appeared to have filtered into two groups. Those on the main outcrop were relaxed and spoke to journalists, explaining that they believed the R12 500 to be a starting point in their negotiations. The other half of the strikers had congregated around the collection of boulders just off the foot of Thaba, and with hisses and whistles they discouraged any journalists from approaching them. All the while, a small cohort of heavily armed strikers danced and sang in isiXhosa on the grassy clearing in front of the koppie; many appeared to be hamming it up for the cameras, holding blades to their own throats or licking spear tips.

It was only as the sun dropped through the dusty haze to the horizon that the NUM president was brought to the koppie in a Nyala. Mambush Noki, Xolani Nzuza and a third miner came forward. Zokwana addressed them through the armoured vehicle's public address system, telling them simply that they should return to work. The miners asked that Zokwana disembark from the armoured vehicle to talk to them. He refused and the miners booed Zokwana, who then departed.[5] Then it was Mathunjwa's turn to be brought forward. Nzuza and Noki again asked that he get out of the vehicle to speak with them and he replied that the police would not let him do so. The police also refused to shut off the diesel motor, which was making effective communication very difficult. Nzuza persuaded the police to edge the Nyala up to some rocks where the trio of strikers were perched, enabling them to speak through the gun port in the front windscreen. Noki eventually climbed onto the Nyala's bull bar and put his face right to

4 Kwanele Sosibo, *Mail & Guardian.*
5 Zokwana became minister of agriculture, forestry and fisheries under Zuma's government in May 2014.

the opening. It was a ridiculous situation for parties engaged in delicate discussions. Despite the circumstances, the miners received Mathunjwa warmly. They asked him to request their employer to come to Thaba and engage with them.

Soon thereafter, Mtshamba and most of the thousands of miners left the koppie for their homes, leaving behind just a couple of hundred stalwarts to continue their cold and uncomfortable vigil at Thaba. Mathunjwa reported back to Major General Mpembe and Lonmin's Mokwena that he was confident that he could get the miners to lay down their weapons the next morning if he could assure them that their employer would talk to them.

At the same time, a secret police meeting was being held at the Protea Hotel Midrand, 130 kilometres away. This was a scheduled National Management Forum (NMF) meeting of the police's upper management, dealing mostly with in-house and administrative matters. As the regular meeting drew to a close, national commissioner Riah Phiyega asked the financial and administrative people to leave, as well as the minute taker, Major Gugu Lethoko. Phiyega wished to discuss Marikana and she did not want there to be any record of the conversation. We know of this meeting only because of a secret source from among the police's top hierarchy present that night who did not want to go down in history as one of those who approved the Marikana operation.[6] That anonymous source, who the commission's evidence leaders dubbed 'Deep Throat', sent messages to the commission through a still-undisclosed third party that gradually revealed the full story. It was at that extraordinary meeting that the decision was taken to go in and 'disperse, disarm and arrest' the miners. It was also then that the use of 'tactical options' was approved, without the involvement of the operational commanders on the ground. Perhaps saying that a decision was taken during that meeting is not quite right; it is far more likely that a directive was given. It was a political determination.

What we do know is that Phiyega and North West provincial commissioner Mirriam Mbombo briefed the gathering on the situation. By ten that night, the most powerful police generals in the land had agreed on what was to happen at Marikana. Mbombo called her spokesman, Captain Dennis Adriao, to set up a media briefing for the following morning. She also called major generals Mpembe, Annandale and Naidoo back in Marikana. Her

6 Also present were Lieutenant General Elias Mawela and General Sehlahle Masemola of 'operational services', as well as Major General Chris Ngcobo, the head of intelligence. Gauteng commissioner Mzwandile Petros also spoke; he would be present during the operation, despite being from a different province.

message was essentially the same one she delivered to the media the next morning: 'Today, we end this matter.' She also called Lonmin's security chief, Graeme Sinclair, to ensure that Lonmin delivered the ultimatum to the striking workers late enough that they could not actually get to work. For a company desperate to get the men back underground, they apparently preferred to keep the miners at the koppie to allow the police to deal with them. As planned, by dawn on Thursday morning Mark Munroe, vice president of Lonmin,[7] told his executive managers to issue the ultimatum.

Afterwards, the police did their best to bury any evidence of the Midrand meeting. While Phiyega had thought to dismiss the secretary taking minutes, she had failed to account for the routine audio recording of all NMF meetings. In a messy arrangement, an outside company is contracted to do the recording and at the end of each meeting one of the SAPS technical staff copies the audio files onto a memory stick before ensuring that the original is deleted. Phiyega, as a neophyte just two months into the job, was probably not aware that the meeting was being recorded, or perhaps believed the recorder had been switched off at the end of the ordinary session. The meeting, to her mind, was off the record and fell under the Protection of Information Act, which rendered it secret. With the minute taker dismissed from the meeting, Phiyega thought that the only physical record of what was discussed was her own. Phiyega is a compulsive note taker, forever writing entries in one of the notebooks she totes around in her handbag.[8] Those notebooks were never referred to in the commission's inquiry, despite Phiyega's monotonous answers during cross-examination that she could not recall almost all details of substance.

Unknown to Phiyega, the memory stick with the recording was given to Brigadier Ledile Sheile Malahlela,[9] who was meant to give it to Major Lethoko to write up the minutes. In this case, Brigadier Malahlela took the memory stick home, contravening the Protection of Information Act. It was only on Friday the 17th, two days after the meeting, while Lethoko was writing up her minutes, that she realised she needed the audio to fill in some of the omissions in her minute-taking and emailed her superior for the memory stick. By now, of course, the massacre had taken place and there was no doubt a desperate effort under way by Phiyega and the top police brass to hide their fingerprints. Malahlela responded only by midday

7 Graeme Sinclair reported to Mark Munroe.
8 Personal correspondence with Cees de Rover.
9 Head of the Executive Secretariat Risk and Information Management section.

on Sunday, saying that her secretary would bring it to the office on Monday. The stick did not show up on Monday and Lethoko asked the secretary to go and collect it from the brigadier's home. Eventually the audio recording was delivered to Lethoko on Tuesday afternoon. When she listened to it, she found that the recording of the extraordinary session was absent. It is clear that Malahlela had brazenly disregarded the strict protocols pertaining to 'top secret' information. It is also obvious that, during the time the stick was apparently in Malahlela's home, someone had deleted the part of the meeting when Marikana was discussed. A decision had been made to excise this critical discussion from history.

The minutes based on the recording were written up by Lethoko and forwarded to Malahlela, who in turn sent them on to Phiyega. The police commissioner then wrote her own version of what happened in the extraordinary meeting, making sure that it was everyone's decision to go in and disarm the miners on the 16th, including the people who had been dismissed after the normal meeting. Phiyega then instructed Malahlela to append this fictitious recounting as Item 7.[10] When these draft minutes were circulated at the next NMF for approval, in October 2012, not one of the people asked to leave at the end of the ordinary meeting was willing to sign it. Item 7 was then removed from the minutes of the NMF. The smaller group from the extraordinary meeting was meant to reconvene to confirm the last portion, but they never did. Questionnaires that the Marikana Commission of Inquiry later sent to the attending generals were answered in insultingly vague and nonsensical ways, obscuring the truth of what they discussed and concealing the probability that there had been political 'guidance' from above.[11] Every single one of the nation's top cops felt their duty was to thwart justice.

10 Item 7: 'The National Commissioner opened the meeting and requested the Provincial Commissioner North West, Lieutenant Mbombo to brief the attendees on the issue of the labour unrest in Lonmin mine in Marikana, North West. After deliberations the meeting endorsed the proposal to disarm the protesting masses and further indicated that additional resources must be made available upon need identification by the Prov Comm, North West.'

11 When the commission tried to find out more about what happened in the meeting, they were blocked at every turn. Malahlela was booked off sick with stress for months and did not appear to testify. Phiyega did her usual bureaucratic stonewalling. The commission sent out a questionnaire to those high-ranking officers who were present. The results were disappointing, to put it mildly. The senior evidence leader, Advocate Geoff Budlender, called the responses a disgrace. 'Chair, if one analyses these statements one is left, to be absolutely blunt, with a feeling of absolute despair. These are the most senior people in the South African Police Service. They're asked some very important questions by a Commission which is investigating, as Mr Chaskalson put it, the greatest catastrophe since we achieved democracy, and the answers are evasive and they are non-responsive.'

Phiyega, a businesswoman with a background in social work and zero experience in policing, had been on the job for just two months. Her appointment was typical of many made by President Jacob Zuma, who has repeatedly demonstrated a proclivity to install underqualified people into key positions – those most likely to demonstrate their loyalty and obedience to him. Phiyega would have deferred any major move to her political bosses in cabinet. The decision to go in and break the strike was made far higher up the food chain than her, with police minister Nathi Mthethwa most likely leading the process. What is less sure is which other cabinet members, including the president, had any direct input, given the political weight being thrown around and the ANC's evident fear of Malema.

Mbombo and the head of the police's specialised operational units, Lieutenant General Elias Mawela, begged Phiyega for more time to plan and mount the operation, but she insisted it had to happen the next day.[12] Whatever the policemen on the ground thought about it, they knew that there would not be a peaceful outcome.

Brigadier Calitz, or Lieutenant Colonel Merafe[13] perhaps on Calitz's instructions, ordered an extra 4 000 rounds of R5 ammunition to be delivered to Marikana. The state mortuary was also asked to send four mortuary vans. In a conversation between Major General Mpembe and NUM president Senzeni Zokwana the evening before the operation, Mpembe told Zokwana that 'me going there to the mountain, disarming people, it going to be bloodshed. It is going to be bloodshed. That one I assure you ... How do I disarm somebody with an axe when I have a firearm? It will never work.'[14] Yet Mpembe, who had watched in horror as two of his policemen were hacked to death by miners just three days prior, had a clear course of action: 'We are not going to lose any more officers. We are also not prepared to use less bullets ... here it is that the police are shooting, are killing people and we do not want to go that route but at the same time we are also not prepared that our members should die.'[15]

12 Meeting between the commission and lieutenant generals Mbombo and Mawela, October 2012.
13 Their evidence is contradictory.
14 Marikana Commission of Inquiry.
15 Ibid.

15

Day 7:
Thursday 16 August –
Scene 1, a Kraal near Thaba

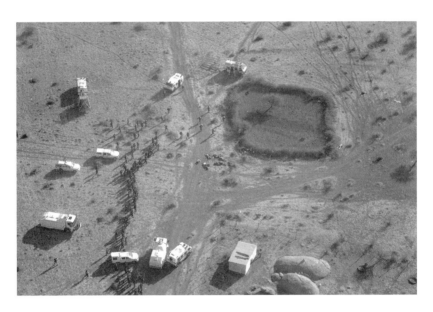

Aerial photograph by Lieutenant Colonel Vermaak taken on 16 August 2012 at 15:58:32, shortly after the police line (right) opened fire on Noki and his lead group of miners. The dead and wounded can be seen across the track and next to the kraal. The armoured vehicles that formed the funnel had already moved off to what would become Scene 2.

'Comrade, the life of a black person in Africa is so cheap ...
They will kill us, they will finish us and then they will replace us
and continue to pay wages that cannot change black people's lives.'
— Joseph Mathunjwa speaking to the miners less than
two hours before the massacre, 16 August 2012

Lieutenant Colonel Scott arrived at the six o'clock commanders' meeting at the Lonmin security office on Thursday morning to discover that he had urgently to devise a new plan. He was to discard the early-morning koppie encirclement plan he had been fine-tuning just the evening before and pull together a plan that would roust the strikers off the koppie that same day. Instructions were that the strike had to be broken then. By 08:30 Scott had cobbled together a new plan. In his haste, he used the same Google Earth document from the original plan and carried over remnants of that deployment plan to later versions. Scott knew that the new plan was far from perfect and he hoped that the AMCU leader would talk the strikers off the mountain and that it would not have to be implemented.

By mid-morning, thousands of miners were gathered at Thaba. Rumour had it that Lonmin would finally address their demands, even that CEO Ian Farmer would come. The strike leaders were less naive; they had received word from one of the strikers who had recognised a policeman from his area of Pondoland in the back of one of the Nyalas. The 'homeboy' policeman had told the miner that they had been given permission to kill the strikers, a paper had been signed and today was D-Day. That information corresponded with their intuition that the murders, and especially those of the two policemen, would dictate how the wage struggle played out. From their vantage point, they could see many of the more than 700 policemen preparing their equipment. Nyalas pulling trailers loaded with rolls of razor wire positioned themselves to the east, between the koppie and Nkaneng. Water cannons and men in combat fatigues aboard two camouflaged armoured vehicles rolled into place. The miners were unaware that while they waited for word about talks, provincial commissioner Mirriam Mbombo

was holding a press conference telling the world that the police would end the strike that day, no matter what.

There were still peaceful options open to all parties. AMCU president Joseph Mathunjwa arrived at Lonmin's local headquarters hoping to find common ground, only to discover that his organisation had not been invited to the police press conference, even though NUM had. He spent the morning trying to get Lonmin's Barnard Mokwena to agree to send someone to the koppie. While cooling his heels, he bumped into Mohamed Seedat, a man he knew when they had both worked at coal miner BHP Billiton. Seedat, previously Lonmin's chief operating officer, had been let go in 2008 but continued to work as a consultant to the company. With Ian Farmer off ill, he was brought in to find a way through the crisis. Mathunjwa told Seedat that if space could be made at the bargaining table for AMCU, he would persuade the miners to disarm. The unionist, while genuinely trying to broker peace for the miners, no doubt recognised that the situation provided a golden opportunity. Seedat said he would see what he could do and disappeared. Eventually Mokwena came back with a response: the company refused to meet their employees unless they reported for work.

Mathunjwa went to the koppie to tell the miners there was no progress. Mathunjwa was also angry with Lonmin, as his speech over a loudspeaker held by one of the union officials shows: 'Africa's economy is in white men's hands, who arrived here by boats. They are the ones who control our lives even today, on how to live. *Amandla!*' (Power!) The workers responded with '*Ngawethu!*' (It is ours!)

The AMCU president continued: 'They take our brothers and give them top positions. That is called rent-a-black in English. They rent people who are said to be educated; they are from universities to come and oppress us. They work for the employers. They are the investors. *Amandla!*'[1]

The miners were in a defiant mood, responding lustily to his militant calls. Mathunjwa asked them to let him try again, to avoid what he saw as the intention of the police and Lonmin to shed the strikers' blood: 'Comrade, the life of a black person in Africa is so cheap ... They will kill us, they will finish us and then they will replace us and continue to pay wages that cannot change black people's lives. That would mean, we were

1 From a transcript of Joseph Mathunjwa's first address to striking miners at the koppie, 16 August 2012.

defeated, but capitalists will be the ones who win.'

The AMCU president wanted to get a mandate to carry the message that the miners were willing to climb down from the R12 500 demand. Dropping to his knees before the koppie, he implored: 'I am kneeling down, coming to you, as nothing. I say, let us stop this blood that NUM allowed this employer to let flow. We do not want bloodshed, but we want your problems to be solved and get your salaries, comrade. You should benefit from this platinum. I appeal to you, not to give NUM this opportunity to run and say, AMCU made people to be killed in the mountain. I appeal to you, I am going to take it back to the leaders to take it further, then we will see where we take it. I do not have the last say, comrade, but all of us, united, we will be able to move forward and bury this enemy that is the employer and the enemy who is the oppressor. *Amandla!*'

The miners agreed that Mathunjwa could try to speak on their behalf, and he left at around one o'clock that afternoon, just as the next envoy arrived. Anglican bishop Johannes Seoka, known for his stand on issues of justice, had come to mediate. While Seoka spoke with Noki and the strikers, Mathunjwa tried in vain to get Mokwena's team to reconsider meeting with the strikers as the latter had softened their position.

It was after two o'clock when Bishop Seoka entered Lonmin's administrative block and approached Mokwena with the miners' request that they meet to resolve the stand-off. Mokwena's deputy, Abey Kgotle, responded, saying that Lonmin would not meet with criminals and murderers. He angrily directed the bishop's gaze to a woman dressed in black with a traditional mourning shawl over her shoulders. This was Mokwena's assistant. The strikers had murdered a close relative of hers.

Lonmin had rejected another opportunity to find a peaceful resolution. The bishop, rebuffed, went in search of the police commissioner in an attempt to slow a situation that seemed to be hurtling towards a violent confrontation.

When Mbombo finally emerged to meet Seoka, she was irritable and distracted, and rudely interrupted the bishop's pleasantries to press him on what he sought from her. Seoka could see he was failing to hold her attention. Abruptly, she asked to be excused as she had not yet eaten and lunch was almost over. She left without giving the astonished bishop a chance to respond. Within minutes, there was a flurry of police activity, with helicopters landing and taking off. Mokwena appeared again, asking the bishop to tell the miners that if they laid down their weapons and

returned to work the next day, Lonmin would talk with them about their demands. Seoka and his group were walking to the car park when someone approached Mokwena and whispered into his ear. Mokwena then hurried after the bishop and told him that the churchman could not return to the koppie as it had been declared a security zone by the police. While the bishop was digesting this, a police chaplain approached and informed him that police chaplains had been put on standby. The bishop had approached the police to parlay for peace just as Operation Platinum was kicking off. With a heavy heart, Seoka decided to leave Marikana.

Mathunjwa, meanwhile, had decided to return to the miners once more even though the police were refusing to escort him. He was no longer thinking about recruiting members or trying to manipulate the situation to benefit the union; he simply wanted to avoid a bloodbath. The union leader addressed the miners at three o'clock, telling them that he had failed to make any headway and that the miners should leave or the police would kill them. To retreat today would not be a defeat, he counselled, but strategic. The strike leaders told Mathunjwa that they were ready to die, but by now they displayed resignation instead of their earlier bravado.

The men thanked him for his efforts and said he should leave. Various miners addressed the crowd and all were adamant that they were prepared to stay and die. But for all the talk, it was clear that the police's show of force had dampened their swagger and many began to drift off. The remaining miners began singing the liberation-era dirge 'Senzeni Na?' (What have we done?). The majority of the approximately 3 000 miners on the koppie were nowhere near as militant as the group of about 300 men that had coalesced around Noki. Most were deadly afraid of the police. There were dozens of police vehicles, many of them armoured, and police and military helicopters whirred overhead. Arrayed against the strikers were 200 public order policing members, 165 Tactical Response Team members, 110 from the National Intervention Unit and 22 men from the elite Special Task Force in their distinctive camouflage uniforms. Most of the miners thought that the latter were soldiers, referring to them by the historic isiXhosa term 'amaJohnny'.[2]

The operation began a couple of minutes after Mathunjwa left the strikers at 15:40, with the police having no idea if the AMCU president had

2 *The Frontier War Journal of Major John Crealock 1878*, Van Riebeeck Society, Second Series, No. 19, p. 77. Available at http://tinyurl.com/qhdmugl (last accessed September 2015).

been successful or not. Six police Nyalas with razor-wire trailers had been parked at exact intervals earlier in the day to allow for a sort of wire laager to be created as the first trailed a coil of razor wire up to the second, the second to the third, and so on. This pre-positioning also enabled the miners to see exactly where the barrier was to be deployed. As the southernmost Nyala set off, stretching out shiny coils of wire behind it, the majority of miners began to disperse off the koppie.

The lead group under Noki's command did not display any sense of urgency. It was when the second wire-trailing Nyala set off that they began to walk slowly north-east towards Nkaneng. Noki told them to walk and not run as they had done nothing wrong. By the time Noki's group was alongside the still-stationary fifth wire-trailing Nyala, only three coils had been laid out. Had Noki's core group intended harm to the police, this would have been the time to get behind the 'protection line' before the wire coils were in place and to attack the lightly armed policemen there. They did not. At this stage many of the strikers who had left the koppie early had taken the well-worn track past a small cattle kraal and into Nkaneng. No attempt was made by police to stop them as they walked past, and they did not show any aggression towards the officers. A crowd of miners walked past an isolated Nyala along the path without displaying any belligerence.

As Noki approached the kraal, the police operation moved into higher gear. Xolani Nzuza was still up on Thaba. From that elevation he watched as the fourth wire-trailing Nyala accelerated ahead of the miners to the small kraal, its razor wire cutting the miners off from their intended path. His route blocked, Noki circled around the left-hand side of the kraal, while other miners either followed him or dispersed north into the open veld. The time was 15:52. In the minute it took Noki's group to skirt the kraal, two Casspirs and nine Nyalas raced up on the far side of the kraal. Nzuza could see that the line of armoured vehicles made up the far side of a funnel, with the small kraal's impregnable thorny wall forming the near side. He watched eighty-seven policemen with rifles[3] run towards the exit of the funnel just as the lead miners were headed for its entrance. Nzuza called Noki's phone to warn him, but it went unanswered.

If Noki wanted to get back onto the path leading to Nkaneng, he would have to go into the funnel. Most miners veered away north to the veld and

3 Tallied from Lieutenant Colonel Vermaak's aerial photograph taken seconds after the shooting.

barren winter fields of a farm. Heading north and then east was a possible route, but for hundreds of metres entry into the settlement was impaired by a barbed-wire fence that ran along that side of Nkaneng. Noki led a rapidly decreasing band of miners into the channel. For the first time, Noki and the others could see the wall of armoured vehicles, the gaps between filled with public order policemen pointing shotguns at them. The miners were moving rapidly, keeping to the right-hand side of the funnel, along the kraal wall.

At 15:53:30, police fired the first stun grenade. It exploded with its distinctive double bang a third of the way from the front of Noki's group. It had the effect of splitting the group, sending the thirty-seven men in front of the explosion rushing forward and away from it, and causing those behind it to stop and turn. Then the public order policemen in between the armoured vehicles to their left and rear opened fire with rubber bullets, forcing Noki and his group further down the funnel. Another stun grenade exploded above the heads of the miners and one of them lifted a pistol and fired a single shot towards the armoured vehicles.

Hidden out of sight behind the last Nyala, Papa 19, which had pulled across the neck of the funnel, were the feared amaBerete from the TRT with their distinctive dark-blue berets interspersed with some members wearing helmets. They lined up on the far side of the dirt track the miners were trying to reach. A policeman stretched out his open hand to the side for the men to form a 'basic line' and then clenched his fist in front of him, the signal for them to hold the line. This line shut down the miners' only escape route. The policemen cocked their R5 rifles.

The thirty-seven men were now moving in a crouch and covering their heads with their thick wool blankets and jackets for protection from the shotgun blasts. They accelerated as tear-gas canisters landed behind them. Police water cannons shot jets of water from the rear, reinforcing the effect of pushing the miners further into the funnel. Confused and disoriented by the stun grenades, blinded by the tear gas and stung by the rubber rounds, many of them had their heads hidden under their blankets as they ran, and could only see the ground a few feet in front of them. Some of the miners finally looked up and saw the line of tactical police ahead of them for the first time, and pressed ever closer to the thorn enclosure on their right-hand side as they followed its curve. If they could get to the kraal entrance, they might run inside and escape the withering shotgun fire that continued to blast at them. Then, from their left, some among the policemen in one

of the last two armoured vehicles began to fire live rounds at them. Five men in that kraal-wall group were shot by birdshot pellets, one of them, Bonginkosi Yona, fatally. All of these pellet wounds were on the men's left sides, showing that none had been a danger to the policemen firing the shotguns. Despite the outlawing of live shotgun rounds such as birdshot or buckshot, some of the public order policemen in or around the armoured vehicles used this lethal ammunition at close range within the funnel.

A dozen metres ahead, Noki and the twelve men left with him made a headlong dash down the funnel, perhaps believing that once they cleared the last armoured vehicle they would have gained the road and escaped into Nkaneng. Suddenly the Nyala, Papa 19, lurched out of the neck of the funnel, revealing the blue line of tactical policemen. It was also the first time that the police in the basic line could see the miners, who were running full tilt towards them. From the policemen's point of view, they were unsure of how many strikers were behind the lead men. The heavily armed men instinctively, nervously, took a step back and braced themselves, lifting their rifles.

Some of them had been involved in Monday's clash, and the reckless bravery and savagery of the miners' attack and murder of two policemen had unnerved them. Some of the police undoubtedly also held traditional beliefs and would have at least entertained the thought that the miners' intelezi had true power. Others among the police line were itching to avenge their fallen comrades. Then Brigadier Calitz's voice crackled over the two-way radio – 'Engage, engage, engage!' – and the policemen opened fire, four of them with their R5s on full automatic mode, the rest firing sporadically. Others were shooting with their pistols. Some of the policemen fired at the ground before pointing directly at the miners, perhaps as warning shots, but others immediately began firing at head and torso height.

The first R5 was fired at 15:53:50 and, within three seconds, eight men were down, including Noki. After four seconds, a cloud of dust kicked up by the bullets veiled the scene, and by then all but three of the front group had been gunned down. The din of gunfire continued unabated. Those among the rear group alongside the kraal wall who had survived the shotgun fusillade were hit by dozens of R5 rounds. One and then several police officers began to call for their colleagues to cease fire, but the fusillade continued for another eight seconds. Sporadic rifle and pistol fire continued for up to a minute. Apart from the unknown policeman/men who fired the illegal shotgun rounds, forty-five policemen fired 328 live

rounds, fatally shooting seventeen men. All but one of the dead men was shot in the head or the upper body.[4] Noki was hit by at least eight R5 bullets. He died instantly, his brain lacerated. The distinctive green blanket was still wrapped around his neck and shoulders as his corpse lay face down in the dirt, blood pooling from his head and neck wounds. Six other miners lay dead around him; the others were severely wounded.

Once the shots had finally died away and the dust began to settle, policemen pumped up with adrenaline edged forward in a semicircle, their weapons trained on the dead and wounded. They used their rifle barrels or boots to search under miners for guns or other weapons. One policeman gingerly pulled a pistol out from under a lifeless body with his thumb and forefinger, careful not to obliterate fingerprints. Despite several of the wounded men being in terrible pain, none of the policemen offered even rudimentary first aid or comfort. When the gravely injured and obviously incapacitated Mongezeleli Ntenetya struggled to sit up, a policeman used his boot to shove him back down. It would be over an hour before the paramedics who had been on standby would attend to the wounded. Had Ntenetya received assistance earlier, doctors estimate he would likely have survived.

Four men were killed much further away, all shot with R5 rounds. Three of them died at the far side of the small kraal, between fifty and a hundred metres away from the shooters. The fourth person shot at distance was twenty-seven-year-old Thembinkosi Gwelani. Gwelani was not even a miner, much less a striker. He had come to Marikana to seek work and had been taking food to his cousin who was at the koppie. He was 250 metres away from the police line when he was shot through the head.

The mass killing of these seventeen miners was witnessed and recorded by dozens of local and international journalists. Social media and radio were the first to report on the shooting, though the number of dead was underestimated. The horror of what had taken place was apparent only when footage of policemen gunning down striking miners was shown later that evening. Viewers in living rooms around the country gasped and many began sobbing at the terrible visuals and sounds of a multitude of automatic rifles firing simultaneously as men dropped to the ground and were almost immediately shrouded in dust. That video was captured by Reuters

4 Bongani Mdze bled to death from R5 wounds in his arm and leg. He had non-fatal pellet wounds in his head.

cameraman John 'Dinky' Mkhize, a veteran who had come of age covering the violent end of apartheid. The nation was transfixed by Mkhize's footage; it evoked traumatic memories of a history of brutal policing, punctuated by massacres of civilians by state forces and different warring groups.

Brigadier Adriaan Calitz, the operational commander, was in one of those Nyalas and he would later describe the early part of the operation – the funnelling – as 'the perfect block'. Surviving miners bitterly referred to it as the 'trap gap'.

Bishop Seoka's car, driven by his colleague, had just taken the onramp to the highway heading away from Marikana. His cellphone rang, and he answered it. He could hear the sound of helicopters, guns firing, people screaming and a man shouting at him, 'Where are you? We are being killed here!' and then the phone went dead. Seoka tried calling back, but the phone rang and rang unanswered. The bishop thought the call was from the man in the green blanket, whose name he did not then know. The bishop would have sleepless nights, haunted by the thought that he had heard Noki's last words before he was gunned down. It was not Noki, of course; he was already dead by that time. The call was from Nzuza, who was running for his life, pursued, he believed, by police in a helicopter who had recognised him. A miner running alongside him told him to take off his jacket and offered him his own, hoping it would throw the police off his tracks.

16

Day 7:
Thursday 16 August –
Scene 2, Small Koppie

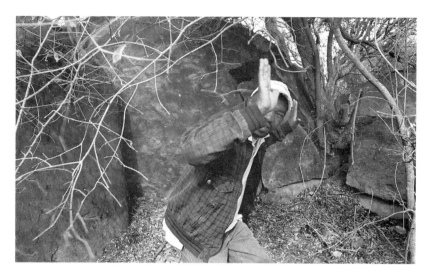

Survivor Shadrack Mtshamba relives the afternoon of 16 August 2012 at Small Koppie (still frame from video).

*'I was so afraid. It was the first time I am hearing the sound of a lot of
bullets like that. Other splinters were coming on my head. As the cops
approached through the bush I said to myself, I am going to die now.'*
 – Shadrack Mtshamba on his experience at
 Small Koppie on the afternoon of 16 August 2012

Shadrack Mtshamba clambered down the granite at a leisurely pace,
slowed by the steep terrain of the koppie. He could see the glittering
rolls of razor wire being laid out in the afternoon sun, but did not feel he
was in any particular danger. He dawdled at the smaller outcrop, waiting on
an older striker who was hand-rolling a cigarette for him. When he heard
the explosions and initial gunfire a couple of hundred metres away in the
vicinity of the small kraal, he was neither surprised nor alarmed. He and
many of the others with him believed it was probably police firing rubber
bullets and tear-gas canisters. This was confirmed when he saw white clouds
of tear gas billowing over the miners. He relaxed and savoured the cigarette.
Within a minute, though, the sound of a multitude of guns being fired rolled
across the veld. It went on a long time and was unlike anything he had ever
heard before. Like many of the laggards, he now began to move off, away
from the sound. He still had no idea that the police were using live rounds,
or that colleagues had been killed.

As Mtshamba began to move, so did the police Nyalas and Casspirs
that formed the funnel, as well as the water cannons and the intimidatingly
camouflaged war wagons of the Special Task Force. They all pushed west-
ward in a line, like beaters raising game birds on a hunt. The combined
effect was that the couple of thousand miners began to flee in the only
directions open to them: north across the open veld or west towards a
broken-down koppie known as Thaba Nyana, Small Koppie.

Working his way west, Mtshamba paused now and then to draw deeply
on his cigarette and to use the glowing tip to set the dry, brittle grass alight.
Dozens of miners were doing the same, hoping to disperse the harsh pepper
gas and also perhaps to provide a smokescreen to escape behind. A police

water cannon was spraying blueish jets of water towards them as it advanced, as much to extinguish the grass fires as to drive the men towards waiting lines of policemen further west. Mtshamba gradually came to realise that the police were not simply trying to disperse them, but were pursuing them. He began to run across the broken terrain, trying to stay ahead of the police. Mtshamba's sense of what was happening was abstract and dreamlike, his disorientation intensified by adrenaline. He watched a police Casspir zigzag through, scattering miners. Like other survivors, he believed that the armoured vehicle's huge wheels ran over a miner, flattening his body. In the days after the killings, people spoke of having seen a photo of the flattened man on a miner's cellphone; they spoke of the courage of the man who took the image. This image has never surfaced publicly. Despite the conviction of many of these men, none of the wounded or dead displayed injuries that correlated with being run over. One of the miners most likely took an image of a miner shot in the head with an R5 round. The terrible damage caused could well look as if the victim had been run over.

In video footage shot by Dinky Mkhize in the immediate aftermath of the killings at the small kraal, a couple of dozen blue-clad policemen can be seen lining up, facing north and firing at miners, who are visible as specks running towards the horizon. Police video footage shot inside the police helicopter that pursued the miners heading west beyond Small Koppie shows Sergeant Adrianna Venter throwing stun grenades at the strikers below. In a Felliniesque moment during take-off, Venter reaches back and rests her hand with perfectly painted fingernails on Brigadier Johann Fritz's thigh. The bizarre juxtaposition underscores to what extent the strikers were objectified and dehumanised by a pair of police officers who showed more interest in flirting than responsible policing.

There is a period of nineteen minutes between the gunning down of the miners next to the kraal at Scene 1 and the first death of a miner at Small Koppie, Scene 2. It was during this period that any of the commanders in the control room, or Calitz in his Nyala, could have assessed what had happened at Scene 1. There was time for everyone to calm down and take stock. It was not a helter-skelter pursuit across the veld: for nine long minutes, the line of police vehicles, including Calitz's, paused. One of the great mysteries is just what was discussed in this period.

Mtshamba managed to reach Small Koppie, where he and hundreds of other men hid among the many boulders and thickets. He had hoped to

make his way through it, and eventually on to his home in Marikana itself, but he soon realised that police were closing in on the jumble of rocks from all sides. The police had foreseen Small Koppie as a possible place to which the miners might run once the operation entered the 'tactical phase'. The miners had not contemplated Small Koppie as a refuge because they had not imagined that they would need one. And even if they had, the miners viewed the area as a place of dirt, to be avoided unless they had to vacate their bowels. For many of the shack dwellers whose pit latrines were full, or for those who had no latrines at all, Small Koppie was where they went to relieve themselves with a modicum of privacy. The inner areas were dotted with white wads of toilet paper and reeked of human shit.

The miners chose the neighbouring Thaba with its dramatic shape and striking colour as a place suitable for both the sacred and the heroic. In the end, no victory was seized there, no blood shed on the iconic orange rock itself. Instead, it was the nondescript Small Koppie – Thaba Nyana – that would become their unreliable redoubt, a reeking altar on which many lives were sacrificed.

Mtshamba found shelter in a cleft where a large triangular piece of rock had sheared off a massive blue-black boulder. At first, he was one of just a couple of dozen men, but as the police encirclement tightened and the gunshots drew ever nearer, more and more men pushed their way in. He assisted one miner who had been shot in the arm to staunch the blood by tying his jersey tightly around the wound. The man also complained of a wound on his back; Mtshamba looked and realised it was serious and beyond his ability to help and so he told the man it was just a small injury, nothing to worry about. Bullets were now coming from all directions, some ricocheting off the granite, others cracking overhead, clipping the branches. The sound of the gunfire was like nothing Mtshamba had ever heard before. Continuing bursts of automatic fire were punctuated by the whining crack of high-velocity rounds passing just above his head. The men were all trying to burrow deeper into the mass of people. Eventually, only Mtshamba's head was free of the tangle of miners. At one stage, a jet of icy water drenched them, even as the gunfire continued. Mtshamba trembled, both from the cold and from the fear of imminent death.

One of the miners, an older man at the front of the scrum of men, called on the strikers to surrender to the police. He stood up straight, with his hands raised above his head, and was immediately shot in the hand or arm. He dropped to the ground, but then he raised himself again, calling

on the others to join him, and he was shot again, this time in the chest, and he collapsed to his knees. He tried to stand up a third time but was shot again in his side, before falling for the last time. Another miner stood with his arms raised and he was swiftly struck in the head, collapsing next to the first miner. No one else dared to present themselves. Then three heavily armed policemen wearing bullet-proof vests appeared before them and one of them gave a hand signal that finally caused the guns to fall silent. The policemen yelled at the miners to move out.

Mtshamba and the others scrambled to comply, treading on prone comrades, not knowing if they were dead or alive. The policemen instructed them to lie down; anyone who dared lift his head was beaten with rifle butts or confiscated knobkierries. The miners were then told to crawl on their bellies to a clearing. Mtshamba used his elbows to pull himself through the open-air toilet, becoming smeared with shit. By now, the sun was casting long, deep shadows. The cold, wet men were told to discard their jackets and blankets to be searched. The abuse continued – one policeman with a knobkierrie beat the prone men, yelling that they were cop killers and that their muti had failed them. An old man was especially targeted for a savage kicking because he was said to have set a bad example for the younger men. One warrant officer told the men that were this Zimbabwe they would just pour petrol on them and burn them alive. As Mtshamba lay on the ground, he could hear occasional gunfire continuing around the koppie. At that stage, he had no idea how many people had died either at the kraal or at Small Koppie. Even as they beat them, some of the cops jeered at the miners about their belief in the magic potion that would transform police bullets into water. Others bragged in Sesotho about shooting the miners, like it was a competition. 'I wanted to take him from my angle with my 9 mm, but you already took him down with your R4.'[1]

It would be days before Mtshamba and the other survivors detained in various police stations would find out that seventeen men died at Small Koppie and another seventeen at the small kraal near Thaba. Seventy-six were wounded.

The massacre of Noki and the others at the kraal (Scene 1) was captured by dozens of journalists, but what happened at Small Koppie (Scene 2) was witnessed only by survivors and policemen. Even the ubiquitous Lonmin security cameras did not penetrate its mysteries. But one miner's

1 Author interview; and, for the record, no R4 rifles were used, but rather the very similar R5s.

fate irrevocably reveals the intentions of at least some of the policemen that day.

Henry Mvuyisi Pato, aged thirty-four, worked at Lonmin's Hossy shaft. He and his brother had left their home village in the Eastern Cape's Pondoland to seek work on the platinum mines. While his brother was taken on as a rock driller, Henry Pato had a much slighter build, without the muscular legs and buttocks needed for that gruelling work. He was grateful to get a job as a general production worker, tasked with supporting the rock-face crews. As the strike dragged on, his brother decided to take advantage of the enforced break and return home, but Henry chose to stay in support of the strike.

Henry Pato was one of the hundreds of men who sought refuge at Small Koppie. He was not among the mass of men with Mtshamba, but found shelter twenty-five metres away in a hidden spot where low boulders protected him from almost every side. On the one side where granite did not shield him, a tree trunk offered protection and visual cover. The narrow entrance to the miniature defile was concealed by a tangle of thorny branches. The spot Pato chose was so difficult to get to that it was one of the few places at Small Koppie that had not been used as a toilet. Had he remained crouching, he would have been invisible to the policemen as they entered the terrain, firing at strikers hiding in the undergrowth. But he most likely panicked when he saw the group of policemen with Major General Ganasen Naidoo cresting a shoulder between the largest remnants of the koppie, a pair of twenty-five-feet-high boulders.

Despite the complete protection offered by the rocks, Pato decided to stand up, probably with his hands raised. Did Pato call out that he was surrendering, believing that the police would not shoot him?

His blue shirt stood out clearly enough for the approaching policemen to easily pick him out. Pato will never be able to tell us what he saw in those last moments that made him turn away from the approaching policemen, with his hands still raised but now behind his head, because it was then that a police bullet tore through his left hand and ripped into the back of his neck and out of his throat.

Pato's body bore mute testimony that only forensic pathologists like Dr Steve Naidoo could decipher. Naidoo is globally acknowledged as an expert in forensic pathology, having worked in the Croatian, Bosnian and Kosovar wars, as well as with South Africa's own Truth and Reconciliation Commission. Naidoo's suspicions were aroused when he was examining

Pato at a state morgue several days after the massacre. Pato was killed by a high-velocity round to the base of his neck, with the bullet exiting low on his throat. The entry wound showed that the bullet was unstable when it hit, most likely caused by hitting something soft, like foliage or human tissue. The wound on Pato's left palm seemed to indicate that the bullet had passed through that before slamming into the back of his neck. Try to visualise how that could occur. Perhaps stand up and try putting your left hand in such a position that a bullet would penetrate the palm and then enter your neck, just above your shoulders, through your vertebrae and out just below your Adam's apple. To Naidoo, the wound suggested an execution from the back, with a hand or hands raised for protection or surrender.

The neck injury would have immediately incapacitated Pato and it would have taken a second or two before the blood began to gush out. Time enough for Pato to put his uninjured right hand to his throat in reaction to the pain. The pattern of the blood flow on Pato's body shows that he would have been upright for a few seconds before he collapsed onto his back. Death came in less than a minute of being shot, leaving him stretched backwards, his legs folded impossibly beneath him and his head thrown back, exposing the gaping exit wound on his throat.

Pato's autopsy in a government mortuary at Phokeng was just part of the piecing together of what happened to him. An examination of the site and of the crime-scene photographs taken of Pato's body was crucial. The first police crime-scene image shows a man in a long-sleeved blue polo shirt and blue tracksuit trousers lying on his back, close up against a large boulder. His legs are folded underneath him like those of a rag doll. His blood stains the roughly textured rock and soaks into the compost-rich soil at its base. The low sun lights up parts of the boulder, yet his body is in deep shade. Police crime-scene experts would soon enumerate the dead man by spray-painting the letter N onto the boulder alongside him. This was an error: Pato was actually body M; the real body N was 100 metres distant.

Those images taken by the first policeman reveal no weapons, yet later images taken by a different policeman show a panga under his hand. Pato's swift death would have ensured that no policemen would have had to remove weapons from him to ensure their own safety once the shooting was over. The panga, also photographed among a pile of weapons dozens of metres away from where Pato died, was clearly planted to support the police's claim that they shot the miners in self-defence.

Scientific evidence speaks on behalf of the silenced Pato – he was murdered by a policeman. The question remains, which policeman? The nature of high-velocity rounds, especially unstable ones like the R5, ensures almost all bullets disintegrate on impact with a human body. The sudden dissipation of the kinetic energy carried by that small piece of speeding metal usually means the bullet breaks up into tiny fragments, ruining any chance of tracing it to a specific weapon. Yet there are other clues left for experts like Cobus Steyl, the private ballistics expert hired alongside Dr Naidoo. Steyl judges that the bullet that killed Pato was most likely fired from where several spent rifle cartridges were found atop the highest part of Small Koppie, twenty to forty metres away. That was where several others witnessed General Naidoo leading a handful of policemen, firing at miners as they went.

The geography and other marks left in the aftermath of the killings raised chilling suspicions about the circumstances of several of the other deaths. The spray-painted letters J and H marked where two miners, Fezile David Samphendu (J) and Mafolisi Mabiya (H), died, one lying across the other in the narrow cleft where Mtshamba had sought refuge and survived. They too had no route of escape from where they hid. A bloody handprint where someone tried to support himself stained a rock surface next to their bodies.

For other dead men, suspicions were raised once the autopsies had been done and the crime-scene photographs examined during the commission. Anele Mdizeni (body A) and Nkosinathi Xalabile (body O) were both handcuffed after they were shot, and their autopsies show that they died while still cuffed, with the plastic restraints only cut before the police took crime-scene photographs. Mdizeni died on the other side of the high point from which Pato was shot, but several minutes before, prior to Pato's murderer reaching and climbing the rounded boulders. The pathologists indicated that Mdizeni's hands were shackled behind his back for some time before he died. It is likely that he would have survived had he received medical attention. Xalabile would likely have died sooner from his chest wound, especially without swift medical care. In both cases, the police chose to manacle fatally wounded men instead of administering first aid. The position forced on the men by cuffing their hands behind their backs hastened death by restricting their breathing, and denied them the chance to find a comfortable position in their last moments.

The police found only two pistols at Scene 2. All the recovered spent

nine-millimetre cartridges were linked to policemen's weapons. No miner fired a single bullet at Thaba Nyana.

In the case of Mdizeni and the body nearest him, that of Thabiso Johannes Thelejane (body B), both displayed R5 bullet wounds penetrating from their right sides to their left. The position of their bodies on the eastern side of the koppie corresponded to the police's report that members of the National Intervention Unit were involved in one of the first shooting incidents at Small Koppie at 16:12. In this report, the NIU alleged that they opened fire at a group of miners charging at them. The wounds that killed Thelejane and Mdizeni tell quite another story. From a reconstruction of the scene by ballistics experts, these men were shot from a distance of forty-five metres away, and from the side. It is clear that they were not charging, but trying to flee.

Mtshamba and the other eyewitnesses who survived the killings at Small Koppie were arrested and held incommunicado in various police stations. Mtshamba's friend Jackson Mjiki also tried to seek refuge at Small Koppie, but before he got there, the arrival of policemen forced him to hide in dense thorn bushes. From there he says he heard policemen calling out to the miners that they were now going to kill them. When Mjiki finally made it home, he asked Mtshamba's girlfriend if his friend had made it back yet. Jackson feared the worst and asked to be woken when Mtshamba returned. He tumbled onto his bed, falling into a deep, exhausted sleep.

17

What Really Happened?

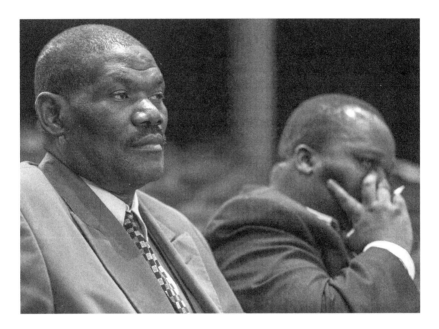

North West Deputy Police Commissioner William Mpembe watches his boss, Police Commissioner Riah Phiyega testify at the Farlam Commission into the Marikana Massacre sitting in Rustenburg, North West Province, 5 April 2013. Mpembe was one of 72 police officers recommended to be charged by the Independent Police Investigative Directorate, IPID, in March of 2017, five years after the massacre. The charges range from murder and assault to defeating the ends of justice and perjury.

'From the early days of apartheid, right from Sharpeville,
senior officers manage to be away from the killings in order to have
the defence that "I'm not responsible, those who shot are responsible;
we as leaders are not responsible" ... All the senior officers,
including you, managed somehow or other to be both blind and
deaf to what was happening whilst the people were being killed.'
— George Bizos to Lieutenant General Mirriam Mbombo
during the Marikana Commission of Inquiry

I t would take a week before it became clear that there were two massacre sites, and even longer before suspicion of executions began to emerge. But the clues were there: at the first press conference on the next day, Lieutenant Colonel Duncan Scott explained that there were two separate sites where miners died. None among the dozens of journalists picked up on this, even those who had witnessed the shooting at Scene 1. That was the last time the police mentioned both scenes; from then on every press conference or statement would try to fudge the truth, and put all the deaths down to the police being charged at by miners.

It is crucial to understand why thirty-four men were murdered by policemen on the 16th. Were the coupled massacres the result of an undertrained, habitually brutal police force that lost its way in an unprecedented situation, or were they revenge for slain colleagues? In a more sinister interpretation, was the police force being used as a tool by a kleptocratic political elite at the behest of big capital? Despite strenuous efforts by the police to fabricate a benevolent narrative, the Marikana Commission of Inquiry led by retired judge Ian Farlam, as well as investigative work by journalists, lawyers and human rights organisations, showed that the double massacre at Marikana was no accidental 'tragedy'. Layer upon layer of the truth was revealed over the two-and-a-half years the commission sat, as the discovery of each piece of the puzzle led to the next.

The police have repeated time and again that their plan to surround, disarm and arrest the miners was 'disrupted' by the miners attacking *them*. It is still the primary government line even though it was an argument that was thoroughly discredited during the commission. Scrutinising the behaviour of certain policemen can help to penetrate the haze of obfuscation, perjury and lies.

It is clear that high-ranking police did not expect the operation to end peacefully. The state mortuary was asked to put four of their mortuary vans on standby, enough to convey sixteen bodies. An additional 4 000 rounds of R5 ammunition were ordered from police stores, though never issued.

A police briefing was held at dawn to inform the various commanders that the miners had to be cleared off the koppie that day. Lieutenant Colonel Scott was asked to come up with a plan at short notice. Intelligence reports indicated that the miners would not acquiesce to being disarmed, reinforcing General William Mpembe's caution of two nights before that there would likely be bloodshed should the operation go ahead. At 09:30, the provincial commissioner told reporters that 'today we are ending this matter'. The commanders were told at a 13:30 briefing that the operation would proceed, and Scott offered up a vague overall plan which was accepted without further input. Scott was a member of the Special Task Force, with no public order policing experience. There were no details as to exactly how his plan was to be implemented. An hour later, Scott gathered the twenty unit commanders around the side of a Mercedes-Benz Vito van and showed them a Google Earth image of the area with various icons to indicate where the units and resources should be positioned. The commanders had to squint to make out the screen. There were no handouts of the map. The briefing took thirty minutes and then the commanders dispersed to instruct the members within their units. They had twenty minutes to do so and no visual aids or maps to assist them. It is little wonder many of them were confused.

If the plan was indeed to disarm, arrest and disperse over 3 000 'murderous' miners, then the array of policemen that was chosen to implement that plan could only have led to a disaster. There were over 700 police officers deployed that day, but just 200 were public order policemen. These were the only cops trained and armed in a way that would enable them to subdue the miners without having to resort to lethal force. The real police plan for that day was a half-cocked shambles, because it had to be developed in just a couple of hours once Phiyega set the 16th as D-Day. A reverse-engineered plan was offered to the commission to show that the police plan was 'disrupted' by the miners. The disruption theory is difficult to follow, as what played out seems to be precisely what experienced officers would expect from the deployment of the police forces that day. If the real plan was to funnel the strike leaders into an area where they could be arrested or shot while 'resisting', then the police strategy worked perfectly.

At no time before the police action began that afternoon were the

strikers asked to disarm or submit to being searched. They were given no instructions or warnings at all. The only warning given by the police that afternoon was to tell journalists to 'get away' during the roll-out of the razor wire and the deployment of the armoured vehicles. Up until the razor wire and the wall of armoured vehicles closed off the road to Nkaneng, miners were allowed free passage, with or without their spears, sticks and pangas. The corralling of the miners ensured that those, like Noki, who wanted to take the shortest route to Nkaneng would have to come into the funnel formed by the police armoured vehicles and the small kraal. Brigadier Calitz would later describe this as a 'perfect block'. Once Noki's group were at the mouth of the funnel, none of the police's non-lethal weaponry was used to prevent them entering into that channel.

Non-lethal ordinance was used only once Noki and the leading band were inside the funnel, and served to further propel the miners towards what they thought was an escape route. The heavily armed presence at the end of the funnel was meant to persuade the miners to surrender, but if they indeed refused then the Tactical Response Team would respond 'proportionately'. Security forces characteristically use bland euphemisms to avoid words that leave no room for misinterpretation. What would men trained for high-risk policing situations like heists and hostage-taking consider a 'proportionate' response when they were armed only with military rifles, pistols and live rounds? The R5's 5.56-millimetre NATO round exits the muzzle at very high velocity. The high kinetic energy of the bullet ensures it disintegrates on impact and inflicts a horrific wound of up to twenty centimetres across. Should the bullet hit a human being anywhere on the body within 100 metres, it will most likely be a kill shot. The lead group of miners was shot at a distance of between twelve and thirty metres.

There are a couple of key questions around the deployment of the TRT. Why did Calitz order them right up to the funnel exit before the miners had even entered the mouth? Why were they commanded to cock their weapons long before the miners entered the funnel, unless their commander somehow knew that the miners would indeed emerge from there, that the public order policemen's orders were to drive the strikers towards the waiting rifles?

Even if the shooting was not premeditated, then given the close quarters forced on the officers by the implementation of the plan, should the miners emerge from the funnel at a run there would have been scant seconds for the presence of the heavily armed police to act as a deterrent. There was

neither enough space for the policemen to determine whether the miners posed a real danger, nor sufficient time for the miners to respond to police instructions or warning shots. As one of the severely wounded survivors of the lead group, Mzoxolo Magidiwana, said, 'We never even reached the road. If the police then had shot us after in fact we had crossed, or passed that road, then I would say they are telling the truth.'

The Marikana Commission of Inquiry erred in failing to call any of the policemen who fired their weapons at Scene 1. Many of their first statements were contradicted by later statements. In one untested statement, Constable Nyamisile Majombozi wrote: 'They continue to come to us to keep shooting to us. I never hesitate to shoot ... My first shot was on the ground between their legs to scare them about four shoot [shots]. Then I shoot 6 straight to them.'

The statements from two other constables in the basic line among the dozens who opened fire are chillingly laconic. Constable Thabang Molatowagae recalled, 'As they were running upon their attack about 20 I then heard two gunshots from that group but I didn't know who was shooting at us because they were bangled and on that situation they were running towards us so I see that my life is in danger then that situation lead me to discharge the rounds. I discharged 24 rounds with my R5 rifle.'

His colleague Constable Vuisile Khuma[1] wrote: 'The miners started to move from the mountain towards us and they were having dangerous weapons such as spears, pangas and knobkierries in their hands. POPS member tried to stop them by altering a security fence to block them but they go through it. Whereby they force to use the rubber bullets to shoot them with it but still the crowd came towards them. Then the POPS member ran into the nyalas for cover. The water cannon were called to assist to disperse the crowd and also didn't help miners were attacking police with those dangerous weapons. One of the miners whom I saw wearing a brown jacket was holding a long stick and a panga covered with a white cloth in his left hand and a firearm on his right hand. He fired to us whereby we were commanded to engage. I fired to the African male who was firing at us for self-defence. That is all I can state.'

No shots were fired towards the TRT line.

An interrogation of the actions of the highest-ranking police officers

1 It is likely that the spelling of Constable Khuma's name is Vuyisile, but this is how it was spelt on his statement.

involved in the operation at Marikana is helpful in understanding how the massacres happened. It also hints at why.

National police commissioner Riah Phiyega chose the launch of the operation to pay a hospital visit to Lieutenant Baloyi, who had been severely wounded in the Monday clash with miners. She switched off her cellphone and turned it back on only at 16:32, when she received a call from provincial commissioner Mirriam Mbombo alerting her to the shootings. It remains unclear why she did not give her phone to an assistant or her driver when such a massive and unprecedented operation was to take place.[2] Her subsequent testimony before the commission would be a masterclass in obfuscation, denial and lies.

Next in the chain of command was Lieutenant General Mbombo, who claims that once the operation began, at 15:40, she stepped out of the command centre. All she could hear was the jabber of several people and radios from inside, combining into unintelligible babble. She claims to have been told that there were fatalities only after the operation ended. Yet inexplicably, just a few minutes after the killing of Noki and the others at Scene 1, she made several attempts to get hold of Phiyega, whose phone was switched off. There is also the matter of an SMS she sent Phiyega at 16:02. Mbombo claims she does not recall what that text was about.

Mbombo's first deputy commissioner and the official operational commander of the operation was Major General William Mpembe. Mpembe claims that he commandeered a private security company's helicopter and was in the air at the time of the shooting, and was thus unaware of what had happened at Scene 1 until later. This is patently false, as video shows the helicopter still on the ground two minutes after the shooting at Scene 1 had occurred. Mpembe claims that he had left the control room prior to the shooting, but he admits that he did hear Lieutenant Colonel Vermaak, who was in the police helicopter already airborne, say over his hand-held radio that the strikers were moving towards the TRT line.[3] Yet Mpembe says he somehow did not hear the thunder of the police fusillade a few seconds later, also distinctly audible on the police radio system. It is more likely that Mpembe had decided to use the helicopter to see what was happening, and did not let the shootings dissuade him. One could take a

2 AMCU leader Joseph Mathunjwa claims Major General William Mpembe told him that Phiyega was at a police torch-lighting ceremony before Operation Platinum began, and thus unavailable. Phiyega denied this.
3 Marikana Commission of Inquiry, p. 11475.

far more negative reading of his actions. While Mpembe was in the air, looking down at the operation, a video recording from inside the helicopter captured him saying, 'They are firing. They are firing in the direction of the dogs.' This was at 16:12, nineteen minutes after the shooting at Scene 1, and coincides with the start of the shootings at Scene 2.

Major General Charl Annandale, the Pretoria-based national head of specialised operations, was deployed to Marikana by the head of the specialised tactical units, Lieutenant General Elias Mawela. Despite Annandale's claims to have simply been the 'chair' for police meetings and that he did not hold any operational or command role on the day, he had in fact taken over as operational commander from Mpembe. He had overall command of the operation and was in the control room throughout, fully aware of what was happening, as his initial statement said that both Brigadier Adriaan Calitz and Lieutenant Colonel Vermaak gave continual updates. Yet he claims he was unaware of the deaths.

Also inside the control room, the policeman who planned the operation, Lieutenant Colonel Scott of the STF, listened to his plan unfolding over the radio. In his statement he did not mention hearing the fusillade of gunfire at Scene 1.

Dirk Botes, a senior Lonmin security official also in the control room, heard the gunfire over the same radio channel all the police commanders were listening to, as did Captain Wayne Peter Kidd, who was commanding a line of policemen two kilometres to the west.

Brigadier Suzette Pretorius was the operational control room coordinator. At 16:03 she sent a text message to the Independent Police Investigative Directorate (IPID), alerting them to what had happened: 'Having operation at wonderkop. Bad. Bodies. Please prepare your members as going to be bad.' Pretorius would certainly have first cleared sending that text with Annandale, who was in the room with her.

It is clear that most if not all high-ranking police officers knew that there had been multiple casualties by four o'clock. Any of these officers could have been the voice of restraint, yet none spoke up.

There were two police helicopters in the sky that afternoon, one carrying Vermaak and the other Brigadier Fritz. Vermaak was taking pictures with his BlackBerry and sending them to Pretorius in the control room in real time. Vermaak and Fritz could see what was going on and either one of these men could have advised the operational or overall commanders that the operation should be halted after the shooting at Scene 1.

Out in the field, Calitz was in charge. His background was primarily in public order policing. He is a fairly tall, pallid, overweight man with the start of heavy jowls he attempts to disguise with a thin, pyramidal moustache. He gave the orders for the formation of the funnel as well as the movement of the line of TRT members who would do the killings at Scene 1. He was in the mobile command-post Nyala fitted with a radio base set to ensure better transmission and reception. That Nyala was at the furthermost point of the funnel at the small kraal, but even then was only sixty metres from the kill zone. Calitz claimed to be unaware that the TRT had opened fire, even though he gave the 'engage' order. He said he was also unaware that people had been killed at the kraal.

Calitz ordered the police vehicles to move forward from Scene 1 in pursuit of the fleeing miners. As his Nyala made its way from Scene 1 to what would become Scene 2 at Small Koppie, Calitz could have used either his cellphone or the radio to find out just what the radio traffic about 'bodies down' meant, unless, of course, he already knew. There are other radio transmissions in those twenty minutes that indicate people had been shot, and that there was a danger of more fatalities. Unknown cops are heard calling out 'Stop shooting. Cease fire!' and 'They are coming. They surrender but they never throw their pangas and their ... they want to come out.' Calitz even gave radio orders to his men at Scene 2: 'No lethal firearms now unless the target engage you. No need to shoot while they are running unless the target engages you.'

Just as Calitz's Nyala was a little way off the kill zone at Scene 1, so too did he park 150 metres north of Small Koppie while the killings were going on there. Calitz admits to getting out of his Nyala on several occasions as he coordinated arrests, but implausibly says he did not hear the 295 shots fired. Furthermore, he displayed neither surprise nor distress at what had happened. There was another Nyala alongside Calitz at this time, Papa 11, and the commander of that armoured vehicle was Warrant Officer Masebole Mamabolo. All the policemen in that Nyala heard the gunfire that Calitz claims not to have heard, and Mamabolo took his men off to investigate.

The highest-ranking officer involved on the ground was Major General Ganasen Naidoo. His original role in the planning of the operation was, ostensibly, to escort paramedics to assist any injured strikers or policemen. His day job was deputy to provincial commissioner Mbombo. Naidoo was not the kind of man one expected to get his hands dirty; he was essentially a bureaucrat. In the days leading up to the 16th, Naidoo was entrusted only

with less-than-exciting tasks. The bookish cop was agitating to get into the action and to prove to his colleagues that he was more than a pen-pusher. At 15:50, Naidoo made a call from his mobile phone to Calitz. Considering that a very dodgy operation was just about to kick off, the two-minute call must have been tiresome to Calitz, or perhaps not. The call ended only ninety seconds before the shooting at Scene 1 began. Just as the conversation with Calitz ended at 15:52:23, Naidoo led his convoy of canine policemen, public order policemen and medics from the holding area towards what would shortly become Scene 2 at Small Koppie. These movements were tracked by the GPS unit in his vehicle.

While on this drive, the shooting at Scene 1 took place. It is clear that there were many wounded or killed and that there was a call for medics. Naidoo ignored this and kept driving towards Small Koppie.

Before taking a look at what Naidoo actually did, it is instructive to spell out his version of events, which was demonstrably false. He claims to have set off with a column of paramedics, canine unit members and public order policemen after receiving the call for medics to go to Scene 1. (False: he was already en route.) Despite having spent the previous two days in the Marikana area and being assigned a senior officer from the local police station as his guide and driver, Naidoo declined to use any of several dirt tracks which would have brought swift medical help to the wounded miners, saving the lives of at least one, perhaps more. (Bongani Mdze slowly bled to death from wounds to his arms and legs at Scene 1 for want of simple medical care.) As a result, Naidoo says he and the driver got lost and eventually chose a long, circular route that brought them near to Small Koppie, where police were in the process of chasing down hundreds of fleeing miners. Oddly, I had met the general the day before at the four-way stop near Rowland shaft, on my first day in the Marikana area. I had no idea where the miners' koppie was and asked a policeman. He told me to ask 'the general', to whom I then repeated my request for directions. He had no trouble pointing me in the right direction of what would be Scene 1 the next day. Naidoo says that he decided to abandon his escort of the medics to Scene 1 when he heard heavy gunfire near Small Koppie. He claims that he believed there were policemen in need of help, and thus additionally armed himself with stun grenades and took to the field on foot. This is also false, as the tracker unit shows that his bakkie had almost reached Scene 2 by this time, indicating that he had already decided to abandon taking the medics to assist the wounded at Scene 1. His contingent formed a basic line

and moved up from the south. Quickly, though, Naidoo left the men he was meant to be commanding and joined up with the paramilitary NIU policemen under Lieutenant Colonel Kaizer Tlou Modiba, who were moving in from the east. Perhaps he found the tactical policemen more attractive company than his own canine unit members.

At the same time, other police units were closing in on Small Koppie from all directions. POP members were moving in from the north and a large contingent of ninety TRT men under Captain Kidd was sweeping in from the west, despite Sergeant Venter in a helicopter above telling him to move north, away from Small Koppie. It was Captain Kidd's men who were the first to reach the koppie, and were either the first or second unit to open fire and kill there. Their victim was twenty-nine-year-old Makhosandile Mkhonjwa (body N), who was shot at approximately 16:09.

By then, Small Koppie was entirely surrounded by hundreds of policemen. A police reaction team in an Oryx helicopter hovering low overhead would have seen that the miners were trapped. Anyone with a police radio knew this, because Vermaak announced that the miners at the koppie were encircled. There were more than enough armoured vehicles to allow police to approach the miners safely. Instead, the police behaved like soldiers trying to finish off a defeated enemy. They surrounded the miners and concentrated fire onto the koppie from several directions. Many of the police officers thus came to believe that they were under fire from the miners, not realising that it was 'blue on blue' fire.

Far from providing the calm-headed leadership needed to avert deaths, Naidoo appears to have led some policemen on a shooting spree. In his statements afterwards, as well as under oath at the commission, Naidoo clearly attempted to mislead. His version insists he came under fire from miners, this despite the two recovered miners' pistols showing no forensic signs of having been fired that day and the police not finding any spent cartridges from them. Naidoo's version of the incident that probably led to the shooting of Nkosinathi Xalabile (body O) is such that when he and some NIU members climbed to the crest of the highest boulder at Small Koppie, he saw a miner shooting at him from bushes to his left. The bullet hit the rock near his feet. He returned fire, but was unable to discern whether he hit anyone. The general's version stands in contrast to all the NIU members who came over the boulder with him, and is contradicted by the testimony of POP member Warrant Officer Mamabolo, who says that when he arrived in a Nyala on the flat ground at the base of the boulder he

could see Naidoo and other policemen firing from the top of it. He repeatedly called on them to cease fire, but they ignored him. Mamabolo said that once the shooting stopped, miners began to emerge from cover with their hands up, and suddenly one of them fell to the ground: 'I did not see any protestors shooting at the police using firearms or attacking the police with dangerous weapons.' A fellow occupant of Mamabolo's Nyala, Papa 11,[4] was Constable Thivhudzini Mathavha, who supported what Mamabolo saw, but added that he saw protesters in the bush with their hands raised in surrender while Naidoo's group kept shooting.

During the commission of inquiry, Naidoo would prove to be a spectacularly disingenuous witness, and he avoided handing in his pistol for ballistics matching until specifically requested to do so many months after the shootings. It is likely that one of the handful of NIU men alongside Naidoo was responsible for killing Henry Mvuyisi Pato with an R5.

Also under Naidoo's command was canine unit member Warrant Officer Hendrich Wouter Myburgh. Myburgh's role at the koppie came to light only months afterwards, when he appears to have grown fearful of being charged with one of the murders at Small Koppie. He related a strange tale to senior officers. Once the shooting had ceased at Small Koppie, he entered and found three wounded miners under police guard. As he turned away in search of other suspects, 'I suddenly heard a gunshot behind me as I turned I saw a NIU Constable who is unknown to me putting his side firearm in his leg holster while he was standing next to the injured I first met was having a jersey wrapped around his arm. I asked him the NIU Constable what is going on he replied by saying, "They deserve to die", and he moved away.'

By Myburgh's account, a constable of the NIU murdered a wounded miner. Even though he could not identify the man, it would have been a simple matter to narrow down which NIU constables discharged pistols at Scene 2 and link the bullet to the weapon. If Myburgh's version was true, the commission established that it could only have been one of two NIU members. It is clear that the police investigators did not believe Myburgh; but why were they so sure of that? After Myburgh came forward, Warrant Officer Jan Jacobus Swarts, a member of the TRT, submitted a second statement about his experiences at Small Koppie. His first statement had not mentioned the incident with Myburgh at all. In the supplementary

4 Papa 11 was also involved in the funnelling at Scene 1.

account, however, he suddenly remembered that a canine unit member (Myburgh) told him that he had just shot and possibly killed a miner in a rocky thicket. Swarts later told his commander, Captain Kidd, about it, who noted it in his pocketbook. Two days later, while smoking and waiting to give his statement to the police lawyers, Swarts recognised Myburgh and joked that Myburgh wasn't much of a shot, as the miner Myburgh thought he had killed had only been injured.

Given that Myburgh had been told that the man he is alleged to have shot did not die, why would he later concoct a story about an NIU man executing a wounded striker? If Myburgh's account is true, one of the bodies autopsied would have revealed a close-range nine-millimetre wound in more or less the place described. There is no such record. Perhaps this can be put down to slipshod crime-scene work and autopsies. If Myburgh was lying and Swarts was telling the truth, it would have been a simple enough matter for the police to track down the wounded miner, since they arrested all those who survived Scene 2.

Myburgh must have known that such an easily repudiated story would only draw attention; it did, and even the national commissioner became involved. His actions led to Swarts's second statement and a concerted and successful effort by police lawyers at the commission to discredit him. Whatever the truth of the matter, the cavalier attitudes by these two cops to the murder or attempted murder of a stricken miner are examples of just how little regard police officers had for a miner's life. Furthermore, their superiors had sent out a clear message that no policeman should break the code of silence should their conscience become burdensome. It is not a trivial matter that all police officers who attended the Roots conference in Potchefstroom from 27 August to 8 September 2012 were compelled to sign an oath of secrecy.[5]

Whatever happened, there seems to have been an orchestrated endeavour by the most senior officers on the day to distance themselves from the events at Marikana either physically or sensorily (by switching off mobile phones and radios) in order to be able to claim ignorance. At any stage, one of the senior officers could have halted the operation. That they didn't leads one to draw the conclusion that, far from being a 'tragedy', the massacres were quite possibly the result of a covert plan. Some analysts,

5 The Roots conference was attended by police top brass and all involved in the Marikana operation. SAPS claimed the conference was held to debrief and prepare for the commission of inquiry. However, SAPS failed to provide minutes of that meeting to the commission.

including lawyers who have been consumed with Marikana since the inception of the commission, believe this is highly unlikely, given the ineptitude of the police. One of those lawyers confided that the police could scarcely organise a piss-up in a brewery, far less a massacre, and then still manage to keep their planning a secret. It is difficult to conclude with any certainty that the killings were what the police, Lonmin and certain state players wanted, but equally it is impossible to discard the idea.

18

Aftermath

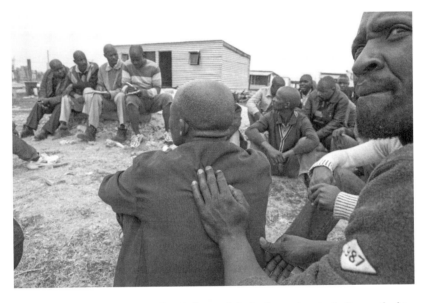

Strike committee members at the edge of Nkaneng help family members try to discover the fate of missing relatives, who are either dead, wounded or arrested, 27 August 2012.

'A dominant view is that states first arise when violent actors impose a monopoly of violence in order to extract taxes.'
— Raul Sanchez de la Sierra[1]

The day after the massacre, President Jacob Zuma went to Marikana and met with Lonmin executives and police officers, but snubbed the miners and the community. Zuma said that he would appoint a commission of inquiry. Even before that announcement, a systematic campaign of disinformation by the state began. On the very night of the massacre, minister of police Nathi Mthethwa stated: 'The police did their best in a volatile situation … Now what should police do in such situations when clearly what they are faced with are armed and hardcore criminals who murder police?'[2] Riah Phiyega read this statement on the 17th:

When the Police started deploying the barbed wire fencing, the group of protesters armed with dangerous weapons and firearms, hastily flanked the vehicles deploying the wire. They were met by members of the Police who tried to repost the advance with water-cannon, teargas as well as stun grenades. The attempt was unsuccessful and the Police members had to employ force to protect themselves from the charging group. The dispersion action had commenced at this time and the armed protesters were driven from their stronghold to a high bush ground in the close vicinity. The Police members encircled the area and attempted to force the protesters out by means of water cannons, rubber bullets and stun grenades.

1 'On the origins of states: Stationary bandits and taxation in eastern Congo', 3 December 2014, http://papers.ssrn.com/sol3/papers.cfm?abstract_id=2358701 (last accessed September 2015). Referencing Carneiro, 1970, and Tilly, 1985.
2 'What were we supposed to do, police ask', *fin24*, 16 August 2012, http://www.fin24.com/Companies/Mining/What-were-we-supposed-to-do-police-ask-20120816 (last accessed November 2015).

The militant group stormed towards the Police firing shots and wielding dangerous weapons. Police retreated systematically and were forced to utilise maximum force to defend themselves. The total death toll of the protesters currently stands at 34 with more than 78 injured.[3]

That afternoon, Phiyega spoke at a police parade, telling the cops who had been involved at Marikana that 'whatever happened represents the best of responsible policing'. Following on her speech, Minister Mthethwa said:

On behalf of the Government, the Executive as a whole, on behalf of the President of the Republic, Commander in Chief of all the armed forces in this country, we are all behind you. We know what we have gone through this period, this week and we would want you to continue ensuring that lives are saved, property is protected against anybody who would want to do bad things in this country ... We are not going to allow anybody to run amok in the country, to want to turn South Africa into a banana republic ... From the bottom of my heart as your Minister, I want to thank you on behalf of our government ... Continue to protect your country.[4]

It is startling that Mthethwa chose to back Phiyega in this way, unless he was himself so implicated in the chain of orders and decisions that this was his best option, as Phiyega might have a lot to say if she were sacrificed. Brigadier Calitz, after first ensuring there were no members of the press present, told a parade of policemen on the 18th:

At this stage we did nothing wrong. From the planning to the execution was 110%. Exactly how we plan it and it is not often that this happens in this large group. I have to congratulate you. Exactly how we planned it and we briefed the commanders, exactly we executed in that line. The force continuum, we did the water cannons, we did the stun grenades, we did the tear smoke, we did the push back, we tried. When it was ineffective the guys run back. Ne. On the media they say police were running away. Yes, it is true, but we call it, tactical retreat, we don't call it running away. Ne? Ja. We tactically retreat with a speed, why,

3 Marikana Commission of Inquiry.
4 Ibid.

because your head and your neck cannot take the blow for a panga or a spear – alright? I am not joking when I am saying. That is the words that we are using. We tactically retreat, and you have to face the Nyala in order to get in there. So it is right, your actions was completely right. By retreating and going back to your safe haven. Therefore we got over to the second phase. And that is where the TRT line and the NIU line was formed. And when they become under attack, that is where the command was given by their commanders as well as some of them act in self-defence. Alright? So on that, nothing, nothing, nothing was wrong. Okay? You acted. It was justified.[5]

Various arms of the state, the ruling party and their allies supported the police force with a series of statements intended to vilify the miners. The miners were ruthless murderers who mutilated their victims for backward and satanic rituals in their attempts to wrest money out of their employer. Many journalists portrayed the miners as radical – their salary demands would bankrupt Lonmin, resulting in the loss of 28 000 jobs. The government information website carried this statement from the day of the Marikana massacre:

Following extensive and unsuccessful negotiations by SAPS members to disarm and disperse a heavily armed group of illegal gatherers at a hilltop close to Lonmin Mine, near Rustenburg in the North West Province, the South African Police Service was viciously attacked by the group, using a variety of weapons, including firearms. The Police, in order to protect their own lives and in self-defence, were forced to engage the group with force. This resulted in several individuals being fatally wounded, and others injured.

The nation was in a state of disbelief. Parts of civil society, which had been so courageous in condemning apartheid atrocities and post-apartheid inequities, were initially struck mute. The communities clustered around Lonmin's Marikana holdings were fearful and angry. While some were intimidated, the majority of strikers were spurred to keep going. The miners chose a new place to meet – a nondescript piece of veld just beyond the northernmost shacks of Nkaneng. Lists of the dead and injured were

5 Ibid.

drawn up as relatives came in search of missing loved ones. Many of those missing were being detained by the police. From the back of bakkies, miners addressed the crowd, relating their experiences, calling for solidarity and fortitude.

It was on this dusty field that the ANC's worst fears came to life. At the time, Julius Malema was facing seemingly insurmountable problems. In addition to being forced out of the ruling party in which he had grown up, the revenue service was claiming millions in unpaid taxes and preparing to confiscate his luxury house in Sandton. In his home province of Limpopo he was facing charges of tender fraud and corruption. Malema was defiant and Marikana was a perfect situation to exploit. It even starred his nemesis in the ANC, Cyril Ramaphosa, as the arch-villain and betrayer of miners. Malema was rapturously received by the miners and the community.

The ruling party's fear of Malema taking advantage of the strike pushed them to act more rashly than they might otherwise have done. Party elders recognised that Malema was the perfect enemy: he spoke the language of the township and was able to present himself flawlessly as the voice of the people even as he led a millionaire's lifestyle. He had come of age as a convincingly radical voice for the poor just as the ANC appeared increasingly out of touch with the majority of South Africans.

At his first appearance, on 18 August, Malema affected a common touch by wearing a tracksuit and running shoes, with one trouser leg pulled to mid-calf as a concession to the midday heat, in 'kasie (township) style. Xolani Nzuza gave an impassioned rendition of how he had so narrowly escaped his police pursuers while his comrades were slaughtered. Tears streamed down Nzuza's face and eventually he collapsed at Malema's feet. For long minutes Malema and his deputy, Floyd Shivambu, ignored the stricken man. Eventually Shivambu and other strikers helped to revive him, but Malema refused to look down at the miner. When Malema stood on an oversized loudspeaker that served as a rudimentary podium, he transformed into an animated fighter for justice, calling for the removal of Zuma and Mthethwa. Three days later, he would lead survivors and family members to lay charges of murder and attempted murder against the police. Even while he was engrossed in that, he was receiving messages on his phone from hawkers in Pretoria begging for his help after police destroyed or confiscated their goods. Malema was on a mission to prove there was indeed life after the ANC.

On the same day that Malema was ensuring charges were laid at the

Marikana police station, a delegation of government ministers and party worthies, treading gingerly in their shiny handmade loafers, followed in his wake. The lifestyle gap between the gaunt, economically clothed miners and the well-fed parliamentary team[6] could not have been greater. They came to ameliorate the political damage, both locally and nationally, but failed. Defence minister Nosiviwe Mapisa-Nqakula was tongue-lashed by strike leaders. Zuma came the following day. He had made a strategic mistake by failing to meet the miners on his first Marikana visit. Shielded from the sun by an umbrella held by a bodyguard, Zuma told miners sitting on the ground that he wanted to hear from them what had really happened and that the inter-ministerial group would investigate their allegations that government colluded with the mine to kill the strikers. In the next breath, Zuma, the master of plausible deniability, said, 'We did not say people must be killed; I want to know the position of the employer.'

There was also an attempt to steer attention away from the fact that there was a second killing site – Scene 2. Police hoped that the traumatic video footage from Scene 1 would eclipse the indefensible murders at Small Koppie. To a large extent, it initially worked. Even the left-of-centre *Mail & Guardian* initially bought into the police tale of the miners as superstitious savages:

> Police footage and documents, including aerial shots documenting events, argue persuasively that the group of miners were indeed militant and armed, and concertedly attacking. That is born[e] out by the fact that the protesters were, apparently, not necessarily acting in a fully rational manner; the SAPS seemed to confirm swirling rumours that protesters had, under the ministration of a sangoma, come to believe that they were bullet-proof.[7]

The tone had been set very clearly – the police had acted honourably under almost impossible circumstances. At the end of August, the police convened a retreat at the Roots wedding and conference centre in the town of Potchefstroom. 'Roots', as the nine-day event came to be known, was where

6 Led by Collins Chabane, the large team included former state security minister Siyabonga Cwele, health minister Aaron Motsoaledi, defence minister Nosiviwe Mapisa-Nqakula, former minister Richard Baloyi, and Thandi Modise, then North West premier, now chair of the National Council of Provinces.

7 Phillip de Wet, 'Zuma announces inquiry into Marikana shooting', *Mail & Guardian*, 17 August 2012, http://mg.co.za/article/2012-08-17-police-go-with-bravado-on-marikana (last accessed September 2015).

the police fashioned a mixture of truth, lies and misdirects into a narrative. Policemen were coached into making statements that supported a case of self-defence. Evidence of unlawful police actions, especially at Scene 2, was suppressed. False evidence was introduced to show the miners as the aggressors. Incriminating images were deleted, and entire sets of images renamed to try to cover up the deletions. The secret meeting held by the police leadership on the eve of the massacre was struck from the record, and the recording of the meeting, as well as any minutes of it, was destroyed. Even the official minutes of the Roots conference were rewritten to hide the cover-up. Every police commander, except Brigadier Calitz, refrained from writing their statement of what they had witnessed until after Roots.

Falsifying the evidence and ensuring that individual policemen's statements did not incriminate one another were not the only measures taken by police. On the night of the massacre, the 276 miners who were arrested at Scene 2 were taken to Lonmin's Number One shaft. Shadrack Mtshamba says they were left locked in police Canter trucks until one in the morning. They were not given the opportunity to go to the bathroom, and several men relieved themselves inside the trucks. One by one they were taken to give statements before they were instructed to go outside and squat in lines for hours, until after dawn. It was a bitterly cold night for the men to endure, and many of them were in shock and traumatised. Mtshamba's treasured leather jacket had been taken from him at Small Koppie by the police and never returned. Once all the men were processed, they were taken to various police stations across the district. Mtshamba was taken to the village of Bethanie in the former homeland of Bophuthatswana. On arrival, he and others were forced to lift their shirts so that any animal-skin thongs or wool strings tied around their waists could be cut off. These traditional or Africanist religious paraphernalia are used in the same way that Catholics, Anglicans and Lutherans deploy the devotional scapular, as a fetish to ward off misfortune and evil. The police mistakenly saw all these spiritual objects as manifestations of witchcraft, linked to the intelezi applied by the sangoma. Any miner who dallied was struck with fist and boot. After that they were locked in crowded cells and only fed bread and tea by the evening of the 17th, their first meal since before the killings. Over the next days, their mistreatment and beatings continued. When they were brought to court, miners held at other police stations confirmed that they too had suffered beatings. It was while the witnesses to police murder were

being thus intimidated that IPID, the cops who are meant to police the cops, took statements from the arrested miners.

Worse was to follow. The miners, who had initially been arrested on charges of public violence, were then charged with the murders of their slain co-workers. Prosecutors used an antiquated law known as the common-purpose doctrine under which the miners were ultimately responsible for the murder of their comrades because they should have reasonably foreseen that the strike and their presence on the koppie would have resulted in those deaths.[8] The common-purpose doctrine had been abused by apartheid courts in the 1980s to convict members of a crowd of murder in such political cases as the Upington 26, in which fifteen people were sentenced to death,[9] as well as the Sharpeville Six. The Marikana murder charges would be provisionally withdrawn by early September. Mtshamba and the others were released after three weeks in jail.

Other processes were under way while the miners were in jail and the police were concocting their narrative at Roots. IPID asked Dr Reggie Perumal, the best-known forensic pathologist in the country, to be an independent observer at the autopsies. In his almost two-decades-long professional career in private practice, Perumal had investigated some of the highest-profile criminal cases in South Africa. Perumal, in turn, called on the renowned academic Dr Steve Naidoo to assist him. They would be working for the organisation that investigates police abuses, a body that had a mixed record on combatting police criminality. On the morning of 20 August, as Naidoo was on his way to the Durban airport to fly to the interior for the autopsies, his cellphone rang. It was Perumal with bad news – they had been taken off the case. Apparently the minister in the Presidency, Collins Chabane, had ordered IPID to use only state pathologists.

Naidoo was familiar with the standard of work done in state mortuaries and was certain that they would make a hash of it. The chances of justice being served if the autopsies were bungled, or purposefully sabotaged, were close to zero. He began to send out emails to his peers around the country, expressing his dismay at the state's meddling. Within hours, Naidoo received a call from Advocate George Bizos, the legendary human rights lawyer. The

8 George Devenish, 'Folly of common purpose', *Daily News*, 5 September 2012, http://www.iol .co.za/dailynews/opinion/folly-of-common-purpose-1.1376252#.VXmeP1xViko (last accessed September 2015).

9 SABC Truth Commission Special Report, 'Upington 26', sabctrc.saha.org.za/glossary/ upington_26.htm (last accessed September 2015).

soft-spoken eighty-four-year-old lawyer asked Naidoo if he would care to represent the Legal Resources Centre (LRC) as an independent observer at the autopsies. Naidoo of course agreed, asking if he could engage Perumal as his assistant. Yet they could not act just yet. To allow them to take part in the commission of inquiry, the LRC had to persuade at least one family of a deceased miner to agree to have the venerable human rights body represent them. Thus it was only on the morning of 22 August that the Durban-based pathologists got the go-ahead. As they were preparing to board their flight, Naidoo called Dr Kevin Schlesinger at the Ga-Rankuwa mortuary, asking him to hold off starting the autopsies until they arrived; he agreed. After landing at Lanseria airport, on the north-western rim of Johannesburg, Naidoo called Schlesinger again from their rental car, only to discover that the state pathologists had already begun cutting up the bodies. Naidoo was furious, accusing the North West province's chief pathologist of capitulating to political pressure. Perumal grimly pressed down on the accelerator.

At Ga-Rankuwa, they were met by a handful of top provincial health officials; even the director from neighbouring Gauteng province was there. It was unusual. Perhaps it would all be okay, Naidoo thought, as he and Perumal hurriedly donned protective gear.

The smell of freshly opened bodies assailed Perumal and Naidoo as they stepped into the cavernous main dissecting room at the mortuary. The scent of ferrous blood hinted at freshly spilt warmth, even though the bodies were by then a week old. A morgue, with its sour fermented stink of gastric contents and the hint of decomposition, smells nothing like the tame butcher's fridge. This is a smell you try to block from entering your body. The pathologists knew from experience that in ten minutes they would no longer notice it.

A dozen bodies were laid out on galvanised iron gurneys, side by side, with just enough space between them for a person to move alongside each corpse. The bodies were shrouded in silvery body bags, some closed, others open, revealing the faces of the dead and, in some cases, their wounds. Some of the bodies had had the very skin flayed off them by the doctors during the examination. One man's exposed ribs, the flaccid skin sliced away, looked sickeningly like a side of pork ribs. The Ga-Rankuwa mortuary itself was still a work in progress and piles of rubble and building material had to be stepped over or around. The grey concrete floor was cut through with sluice canals below industrial metal grids that ran to a central drain-

age point. Teams of pathologists, technicians and assistants, their faces all hidden behind medical masks, were busy on the corpses. Some had their shoes covered by cloth booties, while the more experienced, or fastidious, wore wellington boots. It took a few seconds for the pathologists to recognise their peers among the group.

Perumal, with his decades of experience in dealing with obstructive state employees, drew Naidoo aside and told him that they would have to work quick and smart. Perumal would work with the two state pathologists in the large room, while Naidoo would observe in the smaller dissecting rooms, where the other two doctors were at work. Under the best of conditions, it would be trying for them, but things would soon become more difficult. While the pathologists were helpful enough, discussing their findings as they went from body to body, the state technicians were actively obstructive.

Whenever Naidoo tried to look at the X-rays that are such an important part of the examination, the technician would rip them from his hand, and refuse to even let him get a glimpse of others. Naidoo was flabbergasted. The technician was, it turned out, a former policeman, and he was intent on frustrating the independent pathologists. What astonished Naidoo even more was that none of the doctors intervened.

Naidoo had only recently entered into private practice, and still retained much of his academic ways and manners – he was not used to the rough and tumble of the state protecting its own in a charnel house. Naidoo retained his professorial ways, even going so far as to gently nudge the less experienced state doctors towards evidence or conclusions they were about to overlook. This infuriated one of the police ballistics experts, who loudly expressed his irritation. It all added to the pressure as the bodies were examined with unseemly haste.

Naidoo and Perumal took a break for tea at about two in the afternoon. As is customary, the tea was served in the offices adjoining the morgue. It was here that Naidoo complained of the lack of cooperation and animosity that they were experiencing. As difficult as it was to observe effectively the fourteen bodies that were being autopsied in their presence, they still faced the impossible task of the twenty bodies that had been completed the day before. The mortuary officials were insisting that the bodies be loaded and taken to the funeral home, denying the independent doctors a chance to examine them. It was a crisis – without independent examination, the chance of prosecuting their killers was close to nil. Naidoo fully expected the

directors to rectify the situation immediately, but instead they simply gave silly grins and shrugged their shoulders helplessly.[10] Naidoo's chilly courtesy went unheeded. The more streetwise Perumal, his face a picture of calm, kept up a more diplomatic front, appearing not to be bothered by the obstructions they faced. As they left the office, Perumal whispered to Naidoo that there were ways to get these things done. 'Don't worry. I know the Phokeng mortuary guys who are helping, and have asked them for help,' he said.

The bodies had initially been taken to Phokeng mortuary, which is closest to Marikana, but it was too small to handle the number of dead, and so they were moved to Ga-Rankuwa. In between autopsies, Perumal had approached the workers and asked them for help, promising them 'something to make their day'. The Phokeng workers managed to delay the loading for long enough to allow the pathologists a chance to examine the crudely opened and resewn corpses as they lay in a row on the concrete floor as well as on utilitarian steel gurneys.

Naidoo and Perumal took ten bodies each. They had never had to do examinations in such a short time, and would be able to spend only a couple of minutes on each body, without any assistance or access to X-rays. Naidoo had a surgical glove on one hand, which he used to turn the bodies he examined. He used his other, ungloved hand to operate a digital camera. In his pocket, his recorder ran, capturing his observations and notes. He rushed through the line of bodies, sweat dripping off his face and onto the corpses. In the background he could hear the harsh, hectoring voice of the white X-ray technician, the former policeman, bullying the black workers to load the bodies 'now!' The old racial power dynamic continued to play a significant role, and the workers could no longer resist the order – they began to load the bodies. Perumal managed to complete a hurried examination of each of his ten corpses, but Naidoo viewed only eight of his ten. He was distraught that perhaps one of the miners he had failed to

10 One of the state pathologists later shared with Naidoo that they had been under intense pressure from the deputy director of health for the province to get the bodies done and out in two days. Troubled by this, as he estimated at least four days of work for six pathologists was needed, Naidoo called the head of the compensation board, Dr Barry Kistnasamy, to ensure they had the state's full cooperation. To Naidoo's surprise, the doctor passed the handset to the director general, Precious Matsoso, who was alongside Kistnasamy. Matsoso assured Naidoo that 'we will make every resource available to you; we will be helping you as much as possible'. Nine months after that assurance, the independent pathologists had not yet been able to view the X-rays of the deceased, and despite the Marikana Commission of Inquiry into the massacre, the police failed to share a great many photographs and video evidence from the day.

examine would have provided a vital clue to what had actually happened at Marikana.

As it turned out, one of the unexamined bodies had in fact been shown separately to Naidoo by one of the state pathologists who had wanted to discuss a matter of forensic interest. Thus, only one of the thirty-four bodies was not seen, even briefly, by the private pathologists.

One of the actual autopsies that Naidoo did manage to view was of case 577. As is usual, none of the bodies were named, the case number being the only identification. Case 577 was an extremely thin fellow, with a little moustache and a wisp of a goatee beard. Unknown to Naidoo then was that the dead miner's name was Henry Mvuyisi Pato, the thirty-four-year-old general worker employed at Lonmin's Hossy shaft. Pato's wounds were unusual enough to stand out in Naidoo's memory of the bodies he saw that day. Pato was the man whose body was found in an enclosed maze of boulders and trees at Small Koppie, or the Killing Koppie as it came to be known. Pato's body was erroneously designated N, as already discussed.

It was the location of N that most aroused suspicions as to what actually happened at Small Koppie. To the layman, it seemed as if Pato had been trapped while hiding among large boulders in a thick tangle of low trees. Even without access to Pato's autopsy, the geography of where body N was recovered strongly suggested that he had been cornered and executed, either at close range or from some distance.[11]

There were two bullet wounds. The first was a laceration to Pato's hand. The second was a high-velocity gunshot wound to the neck that entered at the rear of the neck, directly on the spine. The bullet exited at the front of the neck – from Pato's throat, just to the right of the midline. In Naidoo's experience, from the killing fields of Bosnia to South Africa's own police hit squads, this wound suggested an execution from the rear, with the victim using his hands to shield himself. There was no gunpowder residue on the back of Pato's neck, and none of the characteristic tattooing or pseudo-shrapnel of a bullet fired from less than a metre away. It was not a coup de grâce–style execution with a gun barrel placed almost against the victim, but a shot from less than 100 metres.[12]

11 Every combination of weapon and ammunition has its own definition of 'close range' and 'distance'. One metre to one hundred is 'close range' for an R5.

12 Greg Marinovich, 'The murder fields of Marikana. The cold murder fields of Marikana', *Daily Maverick*, 8 September 2012, http://www.dailymaverick.co.za/article/2012-08-30-the-murder-fields-of-marikana-the-cold-murder-fields-of-marikana#.VddN5NNViko (last accessed September 2015).

It is not just the physical wounds that add to the tale of how a person might have been killed. Ballistics expert Cobus Steyl's evidence of where cartridges were collected gives a short list of possible places from where Pato was shot. In a scene as complex as Scene 2, where there are multiple bodies and multiple shooters, all the forensic pathology and ballistics evidence has to be mapped and interpolated. While this cannot pinpoint the shooter, it can exclude some possibilities. Once testimony from the commission had been heard and cross-examined, it became clear that Pato was most likely shot from the large remnant boulders to the west, at a distance of between twenty and thirty metres away. This was where Major General Ganasen Naidoo had led the group of NIU members.

19

Mashonisa

Morning sunlight shines through plastic trash littering the veld between Nkaneng settlement and the Lonmin processing plant at Marikana, 18 August 2012.

'The truth is that this company has platinum because of us.
If we did not drill, they would not have it.
Why must we work like slaves for nothing? Sikhathele.'[1]

— Lonmin miner, 18 August 2012

The strike ended on 20 September, forty days after it began. An accelerated schedule with overtime and weekend shifts saw production swiftly rise. On a warm spring day, Shadrack Mtshamba was cautiously excited about his October salary, the first since the strike. In the aftermath of the massacre, Lonmin had retreated from their demand that striking workers return to work or face dismissal. They had reluctantly negotiated directly with the workers, AMCU and NUM. The outcome was not the R12 500 the miners had initially demanded, but much less. The increases ranged from 7 to 22 per cent, and included the increase that was part of the previous two-year wage agreement through NUM as well as the R750 allowance for Karee drillers working without an assistant that had been agreed on in July but not yet paid because of the strike. John Brand, a labour lawyer and mediator, estimated that the six-week strike and the loss of, in total, forty-four lives had gained the miners an increase of just 7.7 per cent to the lowest-paid workers. The drillers who led the strike received only a 3.3 per cent increase.

The shanties were awash with rumours and Mtshamba was prepared to be disappointed. The strikers had forfeited more than a month's salary, and Mtshamba was in desperate straits, having had to borrow from the *mashonisa*,[2] or moneylenders, to tide him over the unpaid strike. Even prior to the strike, he had been borrowing money. The previous year, he had encountered 'a problem', and had turned to one of the myriad moneylenders who abound on Marikana's main street. Mtshamba borrowed R3 500 in

1 *Sikhathele* is isiXhosa for 'We are tired'.
2 These are mostly informal lenders charging high interest rates. It is an isiZulu word meaning 'the people that take you down (or sink you)'.

November 2011, which he repaid at the end of the month, but then was left without money to get through the following month. Now he found himself in a cycle of debt from which he could not extricate himself. On his pre-strike rock-driller salary he was not coming out each month. He had to support his wife and children back in Klerksdorp, as well as pay his Marikana rent and buy sustenance for himself and his live-in girlfriend. Halfway through every month, he would be at the mashonisa, borrowing R3 500 to see him through until the next payday, when he would repay what he owed, which by then amounted to R4 100 with the short-term loan's astronomical interest rates. The six-week strike had pushed Mtshamba ever deeper into a financial pit.

The strikers' demand for R12 500 saw the mining houses, investors and business analysts throwing their hands up in horror. They claimed that there was no way to afford a doubling of minimum wages in an industry already burdened with labour costs as a high percentage of their overheads. And the Lonmin miners were, theoretically, part of an employed elite. Each had managed to get and keep one of the few full-time jobs, with benefits, available in South Africa. Out of a population estimated at fifty-four million, only seven million earn enough to pay taxes, and of these just over three million people pay approximately 99 per cent of all income tax.[3] Figures such as these are grist to the mill of those who say a small number of burdened taxpayers carry the rest of the country.[4] Another way to view it is that very few of those who are employed earn enough to pay taxes of consequence – they are underpaid. The top 10 per cent of employed black people earn an average of R10 300 a month. The top 10 per cent of white salaried workers earn R40 000 a month.[5] Mtshamba and his fellow rock drillers believed that Lonmin was obliged to pay them a 'living wage'.

Two days after the massacre, a Lonmin rock drill operator who asked to be identified only as Xolani shared the details of his July 2012 payslip. His basic salary was R4 365. In addition, there was a R1 850 housing allowance

3 Rene Vollgraaff, Michael Cohen and Robert Brand, 'S. Africa targets wealthy with first tax increase since 1995', *Bloomberg Business*, 25 February 2015, http://www.bloomberg.com/news/articles/2015-02-25/south-africa-targets-wealthy-with-first-tax-increases-since-1995 (last accessed September 2015).
4 Some 2.3 million pay 93 per cent and 1.5 million are responsible for 84 per cent of income tax. There were just over 15 million registered taxpayers in 2014.
5 John Brand presentation, crediting Statistics South Africa Labour Market Dynamics 2010/2011 as his source, which could not be traced, but the Statistics South Africa Monthly Earnings of South Africans 2010 is very close to this figure, showing slightly lower earnings.

and a bonus of R1 352 (this was a little above the bonus average for Lonmin of R1 057[6]). That month, his gross income was R8 124. After his union fees, unemployment insurance, other fund contributions and 18 per cent tax, his take-home pay was just over R5 600.

Xolani, who lived in a single-roomed corrugated-iron shack he had erected himself on land he rented in Nkaneng, said that his earnings enabled him to remit between two and three thousand rand to his family in the Eastern Cape. 'What am I left with? I have to eat with this money, buy clothes and everything. There's nothing left after that. I can't put money away. Even small improvements I want to make around the house are impossible. My mother, wife and child all know that I have a job in eGoli, but what do I have to show for it? It's a shame for me. You can work here for years and have nothing at the end.'

Xolani was aware of how much more his bosses were earning, saying CEO Ian Farmer took home hundreds of thousands a month. Farmer's earnings in 2011 were R15.3 million (£1 220 629), contrasted with Xolani's R64 800 (using Lonmin's stated bonus average). The CEO earned 236 times what his rock driller did.[7] Farmer also benefited from a three-year performance-based share scheme that offered him 205 849 shares should Lonmin do better than a basket of other platinum mining companies and also see an improvement in the share price. None of these incentives were on offer to Xolani. Had all of Farmer's targets been met, he would have received an additional one-off bonus of R25 million in 2012.[8] For both Farmer and Xolani, I am ignoring benefits, which were naturally much more generous for the CEO.

The answer to why so many miners have high levels of personal debt

6 Lisa Steyn, 'Miners earn a R7000 "pittance"', *Mail & Guardian*, 24 August 2012, http://mg.co
 .za/article/2012-08-24-miners-earn-a-r7000-pittance (last accessed September 2015).

7 According to the World Bank, South Africa from 2011 through 2015 had the world's worst
 Gini index rating at 65 per cent, occasionally slipping to second behind the Seychelles. The
 Gini index measures income inequality.

8 Just a few months before the strike, Farmer lost out on about R3 million because of poor
 performance, and probably another R7 million that would have been due at about the same
 time the strike was resolved, calculated on the 10 January 2012 share price. According to
 Lonmin's annual report for 2011, Farmer's total remuneration for the financial year
 amounted to £1 220 629 (around R25.3 million at current exchange rates), which consisted of
 £565 000 as a salary, £148 639 for benefits in kind, £203 400 for payment in lieu of pension,
 £283 065 as an annual bonus and £20 525 in dividend equivalents paid in cash on the vesting
 of share awards. See André Janse van Vuuren, 'Lonmin's pains hit CEO Farmer's pocket',
 miningm^x, 10 January 2012, http://www.miningmx.com/news/platinum_group_metals/
 Lonmin-pains-hit-CEO-Farmer-pocket.htm (last accessed September 2015).

requires an understanding of the living wage. According to NUM, their typical mineworker is a thirty-year-old man with eight dependants.[9] In 2012, that mineworker had to clear R4 850 each month to buy sufficient food for those eight dependants. This excluded schooling, clothing, transport, a cellphone and airtime, and possibly a refrigerator and a television or radio. What a wage earner needs to survive is dependent on several factors, including how many of his dependants might be receiving a government grant, or their access to arable land. That most miners are migrants adds to their cost burden, with many sustaining one family back home in the labour-sending area and another, or at the least a cohabiting girlfriend, in the area where they work. Throw in unexpected emergencies like a death or illness in the family and it is easy to see how Xolani felt exploited by his employer or why Mtshamba felt trapped.

Many black South Africans, and especially those from areas where seeking a job as a miner had historically been seen as prestigious, have no historic or generational wealth to draw upon. When a financial crisis hits, they have little or no safety net, and turn instead to the predatory money-lenders, whose interest rates are way above those for secured loans, even up to 80 per cent a year.

Yet miners have to look for unpalatable solutions when the pinch is on. With no other choices, the miners borrow money on terms that would make Lonmin's bankers blush. Once they have taken the money, the huge cost of those loans keeps them in a debt spiral they are rarely able to escape. Recall how Mtshamba's mid-month loan of R3 500 incurred R600 of interest and fees by month's end. The mashonisa, be it a single storefront business on Marikana's only commercial street or a national giant like Capitec or African Bank, lends very expensive money to the poor. One of those lenders told Bloomberg that their business model allowed for 55 per cent of their loans not to be repaid in full. Between 10 and 15 per cent of Lonmin workers had garnishee orders against their salaries, indicating that they had failed to fully repay a loan.[10]

Standing around outside one of those moneylenders is an enlightening experience. Mineworkers in their muddied white overalls and rubber boots

9 Reuters, 'How much is a living wage for miners?' *fin24*, 11 July 2013, http://www.fin24.com/Economy/How-much-is-a-living-wage-for-miners-20130711 (last accessed September 2015).
10 Franz Wild, Mike Cohen and Renee Bonorchis, 'Mineworker debt mounts as South African lending booms', *Bloomberg Business*, 10 January 2013, http://www.bloomberg.com/news/articles/2013-01-09/mineworkers-buried-in-debt-as-s-african-unsecured-lending-booms (last accessed September 2015).

gather outside. Some seem embarrassed and dart in and out, displeased to have an outsider witness their financial misfortune. Others view it more phlegmatically; a middle-aged miner laughingly revealed that he was borrowing just enough money to refuel his car. He was more indignant than ashamed.

Lonmin had benefited massively from the platinum boom, without any corresponding improvement in the salaries of the lower, poorer-paid workers. There were several subsequent sharp rises in the cost of living in South Africa, and hard-pressed miners demanded better wages. The strident calls for better wages began to build, ironically, after the platinum boom had passed. International trends that determine the demand for precious metals and the arcane ways of global capitalism are not subjects that the rock drill operators discuss, being as inscrutable to them as to the majority of us, but Lonmin was under pressure. Its payroll increased from $590 million in 2010 to $700 million in 2011.[11] The platinum industry in general had seen an annual increase in profit of 18 per cent for ten years from 2003 to 2013. Yet it still left the workers way short of what they needed.

The industry recognised that the salaries it paid were not sufficient, which was why it agreed to large-scale social-improvement schemes to benefit workers and the communities that surrounded the mines. The platinum belt was a magnet for people desperate for employment, or for entrepreneurs trying to dip their cup in the river of wealth and opportunity flowing to and from the mines. Neither the local municipalities nor the companies made any real attempt to provide for these tens of thousands of migrants. People had to lay their own water pipes from distant sources or buy water by the bucket; they also had to dig their own pit latrines. Every mining licence granted by government comes with specific social improvements and labour practice norms to be reached. Looking at Lonmin, one such goal was to renovate their decrepit and undignified hostels. Here between four and six men shared a room, their steel bed frames pressed tightly together. Lonmin agreed to convert each room into a family unit, and house the displaced workers in 5 500 small RDP-style houses by 2011. At the time of the strike in 2012, the company had built only three houses, and converted just over half of the 114 hostel blocks into family units. By 2015, more hostel blocks had been renovated but not one more house had been constructed.

11 Ibid.

With unnerving prescience, it was at the launch of the Bench Marks Foundation report on the lived experience on the platinum belt two days before the massacre that its chairman, Bishop Jo Seoka, said, 'The platinum mining companies appear on the surface to be socially responsible, respectful of communities and workers and contributing to host community development. Nothing can be further from the truth.'[12]

12 Press statement, Bench Marks Foundation, 14 August 2012, available at http://www.bench -marks.org.za/ (last accessed September 2015).

20

The Legend of Mambush

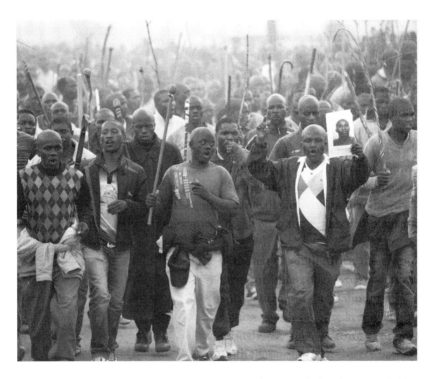

Thousands of striking Lonmin mineworkers march towards Karee 3 shaft. Xolani Nzuza holds a copy of a photograph of their slain leader Mgcineni 'Mambush' Noki, Marikana, 5 September 2012.

'We are all Marikana.'
— Campaign slogan of Tokolos Stencils, a graffiti
campaign to remind government that the
public has not forgotten the massacre[1]

I n the days after the massacre, the vast majority of the dead were anony-
mous. The exception was the charismatic young strike leader Mgcineni
'Mambush' Noki. Journalists, characteristically nuanced, had dubbed him
'the man in the green blanket'. The police and Lonmin had also noticed
him. Their informers would have told them that to break the strike, they
had to get rid of Noki.

On the morning of 16 August, Noki called his wife, Noluvuyo, to say that
he was going to the mountain again. With a sense of foreboding, Noluvuyo
begged him not to go, but he replied that he had to; he had a responsibility
to the men who had chosen him as their leader.[2] Noki told her that should
anything happen to him, she had to take care of everything and to be strong
for their baby.[3]

As much as thirty-year-old Mambush had been the miners' leader before
his death, so he became the strike's martyr afterwards. When thousands of
strikers marched on Karee 3 shaft three weeks after his death, they carried
photocopies of Noki's photograph with them. He became the face of their
struggle. As with many legendary figures, his story took on mythical aspects.
One of these was that he had not, in fact, died in the fusillade on the 16th,
but had merely been wounded and was murdered by police afterwards.
Several miners claimed that they saw him in the aftermath, and that he had
only been injured, in the upper leg. These purported eyewitnesses said that
when he was being loaded into an armoured vehicle by policemen, he had

1 The graffito is based on a photograph of Mgcineni 'Mambush' Noki by Leon Sadiki.
2 Kanya Ndleleni, Ayabonga Sakhanya, Manyanyo Swen, Sandiso Kohlombe and Asise
 Lekwetye, in testimony to the Marikana Commission of Inquiry.
3 Davies, 'Marikana massacre: The untold story of the strike leader who died for workers' rights'.

raised a clenched fist and, urging the workers to stay strong, called out, '*Qina, msebenzi, qina!*' (Be strong, worker, be strong!) One miner says that he saw Noki at the mine hospital on the Saturday after the shootings. Mambush, he claimed, had been injured at Scene 1, but had survived until police killed him by administering poisonous injections.

Objectively, this is incorrect. The footage and still images from the day show that Noki died at the scene, face down in the dust, surrounded by dead and dying comrades. Many months later, the results of his autopsy showed that he was struck by at least eight bullets from assault rifles and died instantaneously. The chief cause of Noki's death was a high-velocity gunshot wound to his face.[4]

But the miners chose to represent his death in the light of the efficacy of the intelezi. This was the narrative of Mambush in the weeks after the massacre, and when the striking miners marched, they would carry photocopies of a portrait of their slain hero, singing, 'How do we find peace when the police have killed Mambush?' Later, there would be T-shirts made bearing his likeness. At his funeral, other songs proclaimed, 'The lion has now come home'.[5]

The police knew who the broader leadership were – the strike committee met in tight huddles in front of the mass of miners on several occasions, and the police had informers among the miners and the community, as did Lonmin security. But they were not sure who the core leaders were. This fact is supported by how strike leaders were hunted and arrested in

4 Excerpt from Noki's autopsy: 'Mr Noki sustained the following wounds: A high-velocity distant gunshot entrance wound to the upper side of the left neck. The projectile fragments were lodged in the jaw. The direction of the shot was left to right and slightly upwards. A gutter wound on the left cheek. An entrance wound on the front of the left lower leg, which was 6 cm below the knee [there is no mention of corresponding exit wound]. An entrance wound on the front of the left leg, which was below the wound described above. An entrance wound on the front of left leg, which was 20 cm above the ankle. An atypical gunshot entrance wound on the front of the left thigh. The bullet was embedded in the thigh muscle close to the groin. A fracture of the left lower leg. An entrance wound on the left forearm. A tangential wound of the elbow joint. An exit wound on the back of arm and above the elbow. An entrance wound on the right buttock. An exit wound on the right buttock. A lacerated (gutter-type), indirect gunshot wound on the back of the right thigh. An entrance wound on the back of the right calf. An irregular exit wound on the right calf above the above-mentioned entry wound. An exit wound on the back of the left calf. A lacerated gunshot wound on the left lower leg. An atypical gunshot wound on the back of the left leg, which was 29 cm above the ground. A lacerated, indirect gunshot wound on the inner side of the right thigh. A laceration on the front of the right knee. A laceration just below the right knee.'

5 Poloko Tau, '"Man in the green blanket" mourned', *IOL*, 10 September 2012, http://www.iol .co.za/news/crime-courts/man-in-the-green-blanket-mourned-1.1379101#.VZPDKBNViko (last accessed September 2015).

the aftermath of the strike. Many of the striking miners tortured during interrogation sessions claimed that police were most interested in identifying people in photographs and in tracking down the surviving leaders, sometimes called the *amadoda*.[6]

Even Deputy President Kgalema Motlanthe said that the miners had been in a muti-induced 'trance', believing themselves invincible, and thus were particularly brazen.[7] It is also evident that among the police at Marikana on the day of the massacre, many were anxious about the miners' use of intelezi.

The death of one of the miners at Small Koppie (Scene 2) illustrates the fear and uncertainty that played a part in the conduct of some policemen. When Thobile Mpumza fled from the killing ground of Small Koppie, his mind was filled with terror and hope. He must have been terrified of the heavily armed policemen who had shot so many of his comrades; and he might have hoped that he would escape once he cleared the initial ring of police. Perhaps he believed that the sangoma's intelezi or the delicate string circling his waist under his shirt was indeed protecting him from bullets. What he did not know was that he was being herded by policemen on foot and in an armoured vehicle towards where others lay in wait for him.

Suddenly, his path was blocked by a group of policemen wearing dark-blue uniforms and berets. They yelled at him to stop, to lie down. He faltered and slowed and eventually lay on his belly on the short dry grass, his fighting stick and long-handled spear or assegai still in his outstretched hands. Constable Edward Sebatjane, from the elite Tactical Response Team, cautiously approached him, his pistol stretched out before him. As a wide-eyed Mpumza watched the policeman approach, more gunfire crackled nearby. Sebatjane says that Mpumza scrambled to his feet and lunged towards him with the assegai, the blade just about at his throat. Sebatjane stumbled backwards, firing repeatedly at his attacker at point-blank range. When the constable's magazine was empty and the sound of gunfire faded, the men fell away from each other, one miraculously alive, the other dead.

A few dozen metres away, Captain Randall Ryland, lying alongside a rock, had been recording video on his mobile phone of Mpumza's attempted flight a minute earlier. In the footage, Ryland is heard to shout out, 'Wait,

6 *Amadoda* is isiZulu or isiXhosa for 'men' or 'fathers', and can be used as 'the elders'.
7 Carol Paton, 'Marikana strikers may have been "in muti-induced trance"', *BDLive*, 31 August 2012, http://www.bdlive.co.za/national/labour/2012/08/31/marikana-strikers-may-have-been -in-muti-induced-trance (last accessed September 2015).

there he running. Wait, don't shoot him, don't shoot him!' Ryland then runs towards Sebatjane, fearing that the prone policeman has been injured, or shot by friendly fire in the chaos of the exchange. One of the policemen closer to the scene calls out, 'Shot suspect, shot suspect' in a strangled voice. Ryland responds, 'Ja, no, it's alright.' Another cop's voice breaks over the jabber, 'Look what he did, he took him, he took him.'

As Ryland nears Sebatjane, he asks him if he is alright. Sebatjane responds, 'I'm alright, I'm alright. This motherfucker, I shot him at least ten times! He just kept coming, coming, coming. Yhoyhoyho.' Actually, Sebatjane's nine-millimetre bullets all missed Mpumza. It was other policemen nearby who shot the miner; Mpumza was hit thirteen times. In the cellphone footage, more policemen gather around Mpumza, who is lying on his back in the grass, red spots on his shirt slowly blossoming into crimson flowers, his eyes staring blindly at the darkening sky. A plainclothes policeman with a bullet-proof vest kneels over him, calling for gloves before trying to resuscitate him in a rather leisurely fashion. No one else shows much urgency or interest in the shot miner either; it is clear to them that he does not have long to live. The policeman, Lieutenant Colonel Stephen McIntosh, gives up, leaving Mpumza with his torso exposed. Ryland excitedly instructs the other policemen not to touch the body: 'Leave it, leave it, there's the muti shit there. All over the body.' He is referring to the string around Mpumza's waist, now exposed. A calm and cynical African-accented voice from an unseen policeman is heard to say, 'Doesn't help, heh, baba?'[8]

Despite the hesitancy displayed by some policemen towards the intelezi, the strikers arrested at Small Koppie recall the arresting officers berating them for their stupidity in trusting the sangoma's assertion that police bullets would turn to water.

Yet in the shocked and angry sense of powerlessness that followed the deaths, many miners clung to the idea that something in their worldview retained its potency. It was a communal state of suspended disbelief. In the face of their annihilation, they needed the myth of invincible heroes who could be thwarted only by low cunning. The stories of how other leaders managed to outwit the police's intentions on the day fed into the wish of

8 Not one of Sebatjane's bullets struck Mpumza. He was killed by R5 bullets. The story put forward by the police was that a fellow cop fired from behind Sebatjane, saving his life. The commission's evidence leaders believe otherwise: that Mpumza was being hunted down by that band of policemen and a Nyala, and that he was assassinated.

the strikers to somehow deny the overwhelming might of the state and their employer.

Another strike leader who was killed on the 16th was forty-two-year-old Andries Motlapula Ntsenyeho. The striking miners had chosen Ntsenyeho to be in charge of discipline. Police and other footage show that he carried no weapon, not even a stick. He died alongside the small kraal, a few metres behind where Noki fell at Scene 1. Despite images showing Ntsenyeho lying dead, a false notion about his death also established itself among the miners.

As a young man Ntsenyeho had moved from the eastern Free State township of Meqheleng to Sasolburg, an industrial town that converts coal to petrochemicals. In 1998, Ntsenyeho and his wife were among hundreds of people who occupied empty land on the outskirts of the town, building shacks and planting peach trees. Sasolburg's new shack settlements were a phenomenon created by people moving from backyard shacks in the overcrowded Zamdela township, as well as rural folk forced off farms by the introduction of minimum wages, increased mechanisation and the cessation of farm subsidies. Later, the state built RDP houses on the stands, formalising the occupiers' claims.

On an unseasonably hot afternoon on 1 September 2012, a pristine white hearse carrying the corpse of Ntsenyeho painstakingly followed a handful of men on foot who guided the vehicle around Thaba and then off the track onto a deeply worn footpath. Eventually, the hearse could go no further, and it negotiated a U-turn among the tussocks of rough grass. The rear door was opened, allowing the coffin to face towards Small Koppie a couple of hundred metres away.

The group of men then continued across the veld. They moved swiftly now, unburdened by the vehicle, sure of the way. One of the men was Tebogo Ntsenyeho, younger brother of Andries. He carried a flimsy plastic grocery bag which bore his identity book, proof of his familial bond to the slain man.

The group approached the eroded remnants of Small Koppie, and passed by a large patch of dried blood fenced off with a few branches crudely torn off nearby thorn trees. An open container of snuff lay in the centre – an offering to the ancestors by relatives who had come to retrieve the dead miner's spirit, joining it to his corporeal remains for the journey home. As the men reached the base of a massive granite boulder, they could see more blood pooled alongside discarded plastic police handcuffs which had

been severed. The scenes were unmarked by assigned crime-scene symbols, yet it was clearly where at least two men's lives had leaked away.[9]

Passing without breaking stride, the group of mourners swiftly climbed over the largest of the granite boulders. The upper reaches of the rock were marked with several spray-painted yellow dots, the meaning of which was then not certain, but denoted where police cartridges were found. Their route took them down off the rock again onto a narrow strip of earth and stubby grass. They stopped and searched the ground, perhaps for a sign or forensic paint or blood, and settled on a particular patch. Here, the earth showed no yellow-paint markings, no symbols to denote key evidence or bodies. One of the men gathered some of the soil and put it in a crumpled white plastic bag, and then the men encircled the spot, lowered their heads and prayed quietly. This was where they believed that the Lonmin rock drill operator Andries Ntsenyeho had been killed by the police.

Ntsenyeho did not die at this spot shown to his brother, but was shot and killed 500 metres away, at Scene 1. There is photographic and video evidence to prove it. This did not seem to interfere with the myth that had grown around his killing, however. His comrades related that on the 16th Ntsenyeho was to ensure that no one ran, that they stayed on the mountain no matter what the police did. But then 'all hell broke loose', according to one of the strikers known only as Mpho. In the chaos that followed the initial shooting at Scene 1, Mpho says the police identified Ntsenyeho as one of the leaders and were chasing him as he ran towards Small Koppie. When they finally caught him, they killed him by stabbing him with knives, as the intelezi had rendered their bullets useless.

The autopsy of Ntsenyeho shows that he sustained a high-velocity gunshot entrance wound to the front of the neck. The bullet travelled from left to right, downward and to the back. It lacerated the trachea, carotid artery and the jugular vein. This was the cause of death. The deceased's brother, Tebogo, had washed the body. He described seeing three wounds, one at the juncture of the neck and collarbone, and two in the upper thigh/groin area on the left leg. There was no sign of knife wounds.

The white hearse delivered Ntsenyeho's body to his widow and five children at house number 11356 on the outskirts of Sasolburg. Here an overnight vigil was held, the coffin behind a screen and women wrapped in blankets sitting on the floor with their legs demurely folded to one side,

9 This was where Anele Mdizeni (body A) and Thabiso Thelejane (body B) died.

pressed together in the tiny room that was lit by a single candle. Outside, in the backyard, a bitter wind whipped dust and ash into the eyes of women preparing large three-legged pots of food. Ntsenyeho's miner comrades gathered to speak of their dead friend under the stark branches of the peach tree that he had planted. It was slow to bud that year.

21

Torture

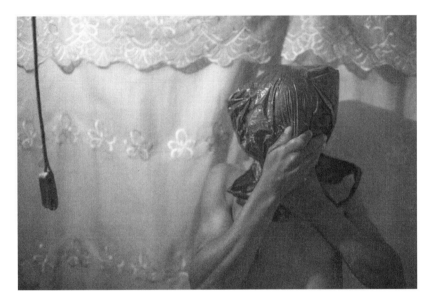

Tholakele 'Bhele' Dlunga demonstrates how he was tortured by police during his arrest and again while in custody as part of a systematic intimidation campaign against strike leaders and witnesses to the Marikana massacre, 1 November 2012.

'If there was something I did not know
they would beat me up and kick me.'
— Striking mineworker Bangile Mpotye

Tholakele 'Bhele' Dlunga is impassive as he pulls the plastic shopping bag over his head to show the torture he endured. His hands do not tremble as he mimics how police officers clamped their hands over his nose and mouth when they thought he was somehow managing to get enough air to breathe despite the black bag. That was just the start of the beatings and torture that would last for days.

The terror began when five plain-clothes policemen broke down the door to Bhele's one-room shack at dawn on 25 October 2012, a little more than a month after the strike ended. After suffocating and beating him, they found the pistol that he kept next to his television. Arrested on charges of possessing an unlicensed weapon, he was taken to Phokeng police station, where the assault continued throughout the day. He was then transferred to another police station, where he was again tortured.

In a voice raspy and constrained from being choked, Bhele claimed he had not used the pistol, but kept it with him as he feared for his safety in the dangerous mining settlement. The police's interest in the firearm, with its distinctive red-coloured slide on top, had been fuelled by their secret informer from among the strikers known only as Mr X. As his testimony would later show, Mr X worked with the police to fabricate evidence about many of the strike leaders, woven with incidents that he had perhaps witnessed or that police had gleaned and fed him from other sources. The police also had hours of video of the strikers shot by police cameramen and Lonmin security, as well as publicly available news material. In the aftermath of the massacre, and the launch of the Marikana Commission of Inquiry the month before, the police and the state were frantic to shift attention from their actions onto those of the miners.

The information that Bhele's tormentors sought was the whereabouts of other strike leaders, and those who had guns. The police, he says, had photographs of 'everyone'.

After relating his experiences, Bhele slips out of the shack and goes to a nearby Somali-owned grocery store. Recognising Bhele, the owner offers him the basic food items for free, as he has been doing for affected miners throughout and since the strike. Despite being, as he puts it, 'broke, broke, over-broke', Bhele refuses. He pays for the bread, tea and eggs with cash borrowed from moneylenders.

By the time he returns to his shack, one among more than a dozen ramshackle structures erected in the backyard of a Tswana homeowner in Wonderkop village, other miners are waiting outside. The group reflects key elements of Bhele's world – one is a fellow church member, another a man from his home region in the Eastern Cape, and two others fellow strikers. One of the strikers is a baby-faced man in his twenties who appears disoriented.

Bhele expertly prepares scrambled eggs on bread and a pot of tea for his guests, showing no hint of resentment at sharing the little he has. He then puts the kettle back on to heat his bath water. When it has boiled, Bhele strips off and steps into a plastic basin to wash. His small frame while clothed belies the musculature of his body, his powerful buttocks and thighs. It is the physique of a man who lives by the sweat of his brow, drilling at the rock face deep underground hour after hour. Still in pain from the beatings a week before, Bhele washes gingerly. The men, now finished with their breakfast, unabashedly watch him, now and then making a joke about his discomfort.

Drying off, he slips on boxer shorts and then mops the floor. While setting up his ironing board, he speaks gently to the young miner, encouraging him to tell the tale of his arrest. Anele Zonke, twenty-six, was arrested by plain-clothes cops two days before Bhele. The young man appears dazed, his face trembling from time to time. He is in obvious discomfort as he sits on a plastic chair that has lost its back, shifting to relieve unseen pain. He too was beaten and suffocated.

The other men keep their eyes on Bhele as he meticulously irons his grey wool trousers, even though their creases are already perfectly sharp. They are all, however, listening attentively to Zonke. The young man tries to gloss over some of the details of his torture, but Bhele gently prompts him from the ironing board. It was while being suffocated by a plastic bag that

Zonke lost control of his bowels and soiled his clothes. He was unable to
get other clothes, as police played hide-and-seek with the men, keeping
them away from their lawyers. He washed his reeking trousers in the basin
and waited, naked, for them to dry. He did not wash his underpants –
keeping them in the hope they could be used as evidence of his torture.
When Zonke finally appeared before a magistrate, he wore his still-stinking
trousers without underwear. The court ordered Zonke released, yet as he
emerged from the doors, he was rearrested by the same policemen. He
is unable to say exactly what he was charged with. Murder and a few other
crimes, he stammers uncertainly. He also can't specify whose murder he
was charged with.

Zonke is experiencing pain deep within his abdomen, and he says that
his bowels work constantly. He is just a husk of the energetic, bright young
man of two weeks before. The torture he suffered has left him ashamed.
Ashamed that he was rendered powerless, at the mercy of his tormentors;
ashamed that he undoubtedly gave the police many of the answers they
sought, and more besides.

It is a while after Zonke completes his story that Bhele is finally done
with ironing. He applies roll-on deodorant and then rubs cream into the
skin of his hands and throat as the men watch him patiently and not with-
out amusement at his fastidious preparations.

Bhele secures his shack with a padlock and chain, and leads the group
of men out of the yard to meet with other miners who were arrested and
tortured. As they pass a neighbouring house, a group of women undergo-
ing spiritual training in a combination of Christian and animist traditions
call out that they had prayed for Bhele every day of his arrest. They prayed
that he be released, if he was indeed innocent. The women's teacher says
that they regularly pray for those arrested by the police, believing many to
be innocent.

The months after the massacre were marked by a police campaign to
round up the strike leadership. Some had managed to evade or defer arrest
by going on the run, but they were hampered by having to go to work at
Lonmin every day once the strike ended. One of them went by a false name
and slept at a different girlfriend's home each night to throw the police off
his trail. He would evade capture for more than a year, until the campaign
ceased.

Another of the strike leaders was Thembele Sohadi, who was known
to everyone as Rasta because of his long dreadlocks. He had been readily

identifiable in the early days of the strike, and had been one of the first targets. When Rasta clocked in at the mine after the strike ended, his card alerted mine security, who had been asked by police to detain him. Mine security called him over, and Rasta saw the police waiting just outside the main entrance, off mine property, so he called on other workers to help him. The miners rallied swiftly, refusing to go underground unless Rasta was released.

By the end of the shift, Lonmin's miners had again downed tools, and returned to Thaba in an attempt to stop Lonmin from hunting down the strike leaders. It did little good, and the police picked up the leadership one by one. Rasta was finally detained and, he says, severely tortured – he affirms that his eardrums ruptured from being repeatedly slapped. Rasta previously exuded a militant, aggressive demeanour but is now a changed man; he is nervous and desperate to return to work. He has even shaved off his dreads. The number-two strike leader, Xolani Nzuza, was also arrested on two murder charges.[1] All of those arrested were released after a few days, the police having little evidence and instead trying to coerce confessions and statements that damned other strikers.

Outside of the leadership, the police cast what seemed like a wide net, which included arresting a politically nondescript mineworker, Bangile Mpotye, twice. Mpotye had been on the mountain the day of the massacre, and while he had been shot with rubber bullets and tear-gassed, he had escaped otherwise unharmed. In the middle of the night four days after the massacre, police burst into his shack, threw him to the floor and began assaulting him in front of his screaming wife. The police kicked and beat him, all the while demanding he give up a stolen police gun. Mpotye denied having a gun and, despite turning the room upside down, the police found nothing. He was accused of shooting policemen and was taken to Phokeng police station. Mpotye says his hands and feet were bound with cable ties from eight in the morning until ten at night for the first two days of his arrest. When he was beaten, he says, he was ordered not to cry. He was also forced into a municipal garbage bag and threatened with death should he not comply. After four days of torture, Mpotye gave in. 'They forced me to write a statement; because I was scared, I could not resist. I just wrote the statement because I was scared for my life. As I was signing the statement,

1 One in August and one in September, probably relating to the death of NUM branch secretary Daluvuyo Bongo.

my legs were tied up. I just wrote the statement to protect my life.' What is astonishing is that Mpotye claims the police transported him to Lonmin mine every day, and his beatings happened at Lonmin. 'They would close the curtain every time they assault[ed me]. They would close the door and curtains.' He says he never saw any Lonmin management or workers, just Lonmin security, who were at a distance and never intervened. When approached with these allegations, Lonmin's PR firm replied: 'Lonmin would never condone the torture of any individual under any circumstances. We recommend that the local SAPS representative be contacted for more information in this regard.' On his release, neighbours saw the marks and injuries from his beatings – his face was swollen, his ribs and abdomen were bruised. He was in pain and obviously terrified. He sent his wife back home to the Eastern Cape and went on the run. Eventually, he moved back to his rented room, one of twelve in a horseshoe-shaped compound of similar shacks. Two months after his initial arrest and weeks after he was interviewed by a British broadcaster,[2] Mpotye was arrested again. Police arrived at the compound and went straight to his room, dragging him to a police minibus by his shirt as neighbours watched, silent and fearful. When lawyers representing his union, AMCU, finally managed to track him down, they discovered that all he had been charged with was fraud relating to false paperwork he allegedly submitted to Lonmin when he was first employed there.[3]

Elite soldiers and spies are trained to survive torture, not resist it. No one resists torture; it's simply a matter of how long until you break under extreme duress. The miners were at the 'mercy' of men well practised in savagery. Many among the 270 strikers arrested on the day of the massacre were also assaulted and deprived of their rights. One of those who survived the killings at Scene 2 was Shadrack Mtshamba, who was held at Bethanie police station, where he, like the others, was subjected to fitful beatings. North West deputy police commissioner Major General William Mpembe, who was operational commander on the day of the massacre, was himself arrested on charges of assaulting the detainees at Bethanie police station five days after the massacre. Mpembe was, as of late 2015, the only police-man arrested or charged with anything related to Marikana. The general

2 Inigo Gilmore of Channel 4 News.
3 From their side, Lonmin have – through their press office – issued a statement that 'Lonmin did not lay any charges against this employee nor is the company aware of this particular case'. The police have never responded.

attested that he was not even at Bethanie at the time and laid a claim of R1 million against the police for wrongful arrest and infringement of his rights and dignity.[4] Neither he nor his spokesperson was willing to discuss either the claims against him or his civil claim against the police force.[5]

The behaviour of the police at Marikana confirmed fears that the force was once again being openly used as a tool of political oppression. Long before Marikana, residents of impoverished communities reported late-night raids by the 'Intervention Unit' (NIU) or the amaBerete (referring to the berets of the TRT) following street protests against corrupt local governments that fail to meet basic needs for water, sanitation and electricity. The raids are brutal, with alleged ringleaders beaten, tortured and, on occasion, killed.[6]

4 Shortly before the massacre, Mpembe was accused of being present when North West traffic officer Stephen Phoko was allegedly beaten up by Mpembe's bodyguard, who broke Phoko's leg and dislocated his shoulder, after a minor traffic incident. See Mzwandile Kabizokwakhe, '"Cops broke my bones as deputy chief watched"', *Sunday World*, 16 July 2012, http://www.sundayworld.co.za/news/2012/07/16/cops-broke-my-bones-as-deputy-chief-watched; Gcwalisile Khanyile, 'Top cop wants R1m for wrongful arrest', *IOL*, 16 September 2012, http://www.iol.co.za/news/crime-courts/top-cop-wants-r1m-for-wrongful-arrest-1.1383922#.UKyQoaUWw_s; and Glynnis Underhill, 'Top cop in Marikana brutality claim', *Mail & Guardian*, 7 September 2012, http://mg.co.za/article/2012-09-07-00-top-cop-in-marikana-brutality-claim (last accessed September 2015).
5 Author interview.
6 David Bruce, 'Police brutality in South Africa', http://www.csvr.org.za/wits/papers/papbruc5.htm; 'Addressing police brutality in SA', paper at the 5th ISS International Conference: National and International Perspectives on Crime Reduction and Criminal Justice, 15 August 2014, https://www.issafrica.org/uploads/5th-Crime-Conf-2014/019-D-Bruce.pdf.

22

Assassination

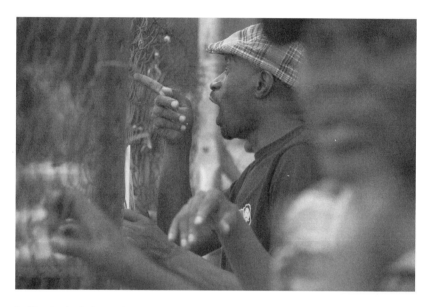

Striking Anglo Platinum miners protest at a COSATU/NUM rally at Olympia Stadium in Rustenburg, 27 October 2012.

'They want myself high and low. They went four times to my house.'
– Email from NUM branch secretary Daluvuyo Bongo
to Lonmin management, 12 August 2012

Everyone knew him simply as Steve. Joseph Steven Mawethu Khululekile was a cautious guy, some thought paranoid. When union business took him to hotels, he took his own *skaf'tin*, or lunchbox, as he feared being poisoned. Steve also preferred not to purchase a car, even though he could well afford to. 'Why should I buy my own coffin?' he would respond when people tried to persuade him to get a car.

The last time grassroots Marikana activist Chris Molebatsi saw Steve alive was in early May 2013. Chris climbed into a minibus taxi and saw Steve seated at the back. They exchanged a nod. When the taxi stopped at Ga-Pitse village in the Bleskop mining area outside Rustenburg, Steve made his way out, acknowledging Molebatsi with a 'Sharp, comrade'.

Steve preferred to drink at places where people he knew would watch his back. Billy's Tavern was one such place, a miners' bar where Steve felt secure. He walked in past the butchery and the buy-and-braai *shisanyama*. It was lunchtime on Saturday 12 May 2013, and the place was busy. Towards the bottom of the property was the tavern, a large rectangular building with two signs above the door informing patrons that no one under eighteen was welcome, and neither were firearms. Steve bought two lagers, which he put down on one of the large communal tables with a good view of the big television screen. He then went to put money on the side of the pool table to reserve a turn. Steve returned to his beer, and settled down to watch Kaizer Chiefs on the screen.

Witnesses say they saw a man dressed in a blue two-piece worker's over-all walk in. They noticed he was a stranger, but otherwise he did not raise their suspicions. He left. Shortly thereafter, another similarly dressed man entered briefly before also leaving. Steve had his back to the entrance and

did not notice them. Within minutes, the two men were back, accompanied by a third, who was also dressed in overalls. One of them swiftly approached Steve from the rear, pulled out a pistol and fired four shots into his back. The patrons either dived to the floor or ran for cover and the three men walked out of the bar and disappeared through a gate at the rear of the property.

Steve was dead.

Steve had once been a general worker at Lonmin's Karee mine, a malaisha, as his friends joked. He was elected as NUM shop steward and from there he rose in prominence in the early 2000s. From the first, he made his comrades at NUM uncomfortable. He was troublesome and belligerent, and did not care to hold to a united front with the rest of the elected NUM officials. He made it clear that he represented only the interests of the miners who had voted for him.

Steve was a guy with a big voice, and would often arrive at meetings unkempt, unwashed. He was, according to someone who worked with him, 'an arrogant bastard'. Neither this arrogance, nor his lack of personal hygiene, hindered Steve's meteoric rise. Soon he was hailed as the workers' de facto leader, not just at Karee mine where he was shop steward, but across all of Lonmin's Marikana mines. Even when other shop stewards representing the majority of the 28 000 workers across all of Lonmin's shafts agreed on a certain subject, if Steve disagreed, the motion would not fly. He was extremely powerful on the ground, a thorn in the side of NUM's regional leadership. The monolithic power of NUM in the mining sector was showing cracks as workers began to complain that most union officials and shop stewards were drifting ever further from the workers they represented. Steve was the one shaft steward they continued to trust unconditionally.

There is a lucrative career path associated with moving up the union ladder. Shop stewards mostly have access to a company vehicle and work in an air-conditioned office. There are hundreds of small and large contracts up for grabs at mines, and it is usually the union-connected people who get these. Unionists are encouraged by the company to further their qualifications and education on company time, which will help them get an above-ground job should they not be re-elected. Once a miner has escaped the bedlam underground, it is very unlikely that he will want to return. This system is part of how the mines work to keep the union officials tractable. The miners are well aware of, and resent, those who choose to protect their perks instead of the miners who elected them.

The Karee mine NUM branch elections set for early 2011 were a disaster.[1] Steve refused to allow elections as he claimed a popular mandate to keep serving the branch, fearing that NUM would find a technicality to push him out. He was suspended by NUM, and when the Karee workforce responded with a sympathy strike not approved by the union, all were fired. Only miners who were not among Steve's most ardent supporters were re-employed – this saw 1 400 men lose their jobs permanently.

It is unknown whether Steve had been talking to AMCU before his dismissal, but by the end of 2011 he was an AMCU representative. By early 2012, Karee was solidly AMCU turf. Steve's exact role during the lead-up to the strike of August 2012 is unclear, though many miners often deferred questions about union issues by saying, 'Ask Steve about that.'[2] Lonmin and NUM certainly believed him to be a key player behind the strike. In the aftermath of the massacre, Steve grew AMCU from their foothold in Karee to include 70 per cent of Lonmin's workforce, and a majority across the entire platinum belt. NUM had been routed.

Steve's foes did not forget him, and Joseph Mathunjwa claimed that Steve was receiving anonymous death threats prior to his assassination. Most miners believed that Steve was assassinated by NUM: 'They are tackling us top to bottom.' As word spread that he had been killed, hundreds of miners made their way from across the platinum belt to the bar, Billy's Tavern, as a form of pilgrimage. There was anger, as well as fear.

That same night, strangers entered the compound where strike leader and driller Bhele Dlunga lived. They circled his shack and tried the door, but Bhele was not there, having decided to spend the night at a neighbour's shack. In the morning, the compound residents scoured the yard, finding distinctive sneaker-sole imprints around the shack that they did not recognise as belonging to any of the denizens. Those imprints were also found near the entrance to the yard, as well as cigarette stubs, pointing to the conclusion that assassin(s) had waited to kill Bhele on the same day that Steve was murdered. It is worth mentioning that Bhele went on to be an AMCU union representative at Lonmin's Rowland shaft.

One of the Marikana 2012 strike leaders who visited the scene of Steve's death said, 'Without Steve, we are done, he was our only hope.' AMCU members in Marikana believed that Steve's death was linked to public speeches

1 See also Chapters 3 and 7.
2 Author interviews.

on May Day, less than two weeks before, in which ANC leaders like Blade Nzimande[3] and Cyril Ramaphosa declared that there should be just one union in any industry, and called for a 'fight back'.

Steve also had less obvious enemies. Just as he had been at NUM, Steve was a divisive force within his new union. He told confidants that he wanted to contest the position of deputy president at AMCU, a post held by Mathunjwa's right-hand man, Jimmy Gama. Mathunjwa denied this possibility, stating that as an official in the union Steve was not eligible to stand for any elected office-bearer position, not even that of shop steward.

Steve was neither the first nor the last unionist to be assassinated at Marikana. As Lonmin descended into the violent strike of August 2012, there were other dynamics at play under the surface. The struggle for the NUM leadership at Western Platinum, one of the three Lonmin mining operations at Marikana, was intertwined with the larger workers' battle at Lonmin. In the years leading up to the 2012 strike, there were three rather subtle power centres within NUM at Western. The dominant one was that of the branch chairman, Chris Nongomazi. His deputy, Ntate Moloi, was also the deputy chair of the entire Rustenburg region branch. In the 2007 elections, Nongomazi was ousted by an ambitious alliance between Daluvuyo Bongo and Malesela 'Brown' Setelele. It was Bongo and Setelele who led a group of NUM loyalists to try to break the will of the striking miners on the first night of the strike, 9 August 2012. They used the Toyota minivan supplied to the union by Lonmin to escort workers to shafts as well as to harry those trying to enforce the stay-away. Bongo was in constant contact with Lonmin security managers, and his emails reveal a man striving to prove his loyalty, and worth, to the company.

It is worth examining what was at stake for Bongo and Setelele. When Bongo contested the elections as secretary, he was an engineering assistant. His salary was R7 500. After he was elected, Lonmin boosted his salary to R14 000, even before all the perks like the minivan and free cellphone usage and the fact that he no longer had to sweat underground. If Bongo were to lose in any of the elections that followed, his salary would drop back to his original, and he would be back at the rock face. It was a similar deal for Setelele, who had worked his way up from a general worker to team supervisor before his election to the union chairman position. There is no

3 Bonginkosi 'Blade' Nzimande has been general secretary of the South African Communist Party since 1998, and is the minister for higher education and training in Zuma's cabinet.

way these men could return to those jobs underground, where their lives would be at risk from the miners they had alienated. Accidents happen. That was the kind of motivation that ensured Bongo and Setelele were willing to kill to hold onto their positions.

When Bongo and Setelele were alerted by Lonmin that a large group of miners were marching on the NUM office at Wonderkop on the morning of 11 August, they swiftly organised a defence, and successfully drove off the strikers, shooting and seriously wounding at least two of them. Bongo and Setelele were triumphant, but within a day the growing militancy of the strikers would turn the tide. The union officials believed the strikers had drawn up a hit list of the top five NUM men.[4] After hearing that two Lonmin security guards had been murdered by the strikers who were again marching on the NUM office, the shop stewards fled their homes for the veld. They called Setelele for help and he spent much of Sunday picking up the unionists from various hiding places dotted across the scrublands and taking them to a safe place in 'the bush', before finally checking them all into a Rustenburg hotel.

The union officials were safe, but not all was well among the leadership. The alliance between Bongo and Setelele, which had successfully unseated Chris Nongomazi's faction in the 2007 and 2010 elections, was unravelling. The powerful Nongomazi had tried staging a comeback a few months after his 2010 loss and some believed he could achieve it as there was unhappiness with the current leadership. Yet Nongomazi confided to a Lonmin manager that he believed Setelele and Bongo were bewitching him. Three days later, Nongomazi collapsed and died.[5]

With the demise of the external threat to their positions, the chairman and the secretary turned openly against each other, each with their own supporters. One of the alleged fault lines between the camps was ethnicity – Bongo was Xhosa and Setelele a Pedi. The disruption of the strike provided perfect cover for the camps to settle the power struggle. After the strike ended and the miners returned to work, Bongo moved back to where he had previously lived at Lonmin's Wonderkop hostel. On 5 October 2012, he was shot six times and died. A little less than a year later, Brown Setelele was shot and killed in Marikana.[6] While both deaths

4 Marikana Commission of Inquiry and author interviews.
5 Author interviews.
6 Several more NUM men would be murdered, including Dumisani Mthinti, Mbulelo Nqetho, Nobongile Nora Madodo and Percy Richard Letanang.

were publicly laid at the door of AMCU, insiders believe they were killed by opposing factions within NUM vying for the top union positions at Lonmin. A different camp wanted a chance to eat.

23

The Women of Marikana

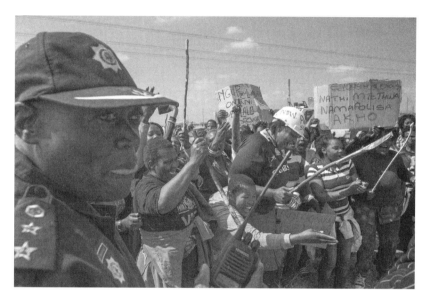

Women from Nkaneng shantytown, led by ANC PR councillor Paulina Masuhlo (centre, in white helmet) and Primrose Sonti (first woman on the left), protest against the police two days after thirty-four mineworkers were killed.

'I know I am nothing but I will do good in Parliament.
Even without an education, I know what people on the
ground go through every day. I went through that all my life.'
 – Nokulunga Primrose Sonti, Economic Freedom Fighters
 parliamentarian and former Marikana shack dweller and activist

T he strike of 2012, like mining itself, was the realm of men. The tradi-
 tional healer hired by the miners prohibited women from joining them
at Thaba as it would diminish the power of his magic potion. Despite this,
women played a critical part in supporting the strike. Some were miners'
wives or girlfriends, while others had migrated to the mining camp on their
own, in search of work or entrepreneurial opportunities.

Mandisa Yuma, the daughter of a migrant mineworker, dreamed of get-
ting out of her village in the Sterkspruit area of the Eastern Cape. Yuma
longed to leave the routine of poverty at home for a place with decent
jobs, but still wanted to be close to family. Her mother's sister had moved
to Marikana several years before. She had built a house and was making
a living renting out rooms to miners. When migrants came back during
holidays, they always brought stories of the glitzy gambling and entertain-
ment centre of Sun City, and of watching football matches in the same
superb stadium where six World Cup matches had been played. The tribe
on whose land the oldest platinum mines were situated, the Bafokeng,
was popularly known as Africa's richest tribe. It seemed to Yuma like the
kind of place where her intelligence and tenacity would be rewarded. Yuma
recalls her expectations when she arrived at her aunt's home just outside
Marikana in 2011: 'When people come back home from Rustenburg, you
see them wearing nice clothes. When I first came here, I thought I would see
a *place*, where people are living the life. Damn, this is not a place for people.'[1]

She was shocked to discover that her aunt lived in a rough shack, iden-
tical to the ones she rented out to other migrants: 'I thought my auntie had

1 Author interview, 2013.

237

a house built with bricks, not a makhukhu [shack]. I never knew this place is full of makhukhu.'[2] Yuma was surprised that her aunt used paraffin for cooking and lighting, that there was no toilet and that she had to relieve herself in the adjoining veld. Yuma called her father in tears. He persuaded her to stay on, go back to school in nearby Rustenburg and see where it led her. She obtained a qualification as a computer technician, but by 2013 was still only able to get a job as a cashier at the local Chinese-owned super-market, earning R1 000 a month.

Yuma has adapted to life in a mining camp. She has grown accustomed to buying twenty-five litres of clean water for R3, enough for one day. If she wants to do laundry, she buys a drum of water for R24. Every day, the younger children of her neighbourhood race the empty containers on wheelbarrows to be first in line for the water truck. Yuma shrugs off her aunt's deception, now aware that almost everyone lies to their families back home about their circumstances, few being willing to admit to the shame of living in a shack.

An older woman who came to find her fortune in Marikana in 1995 was Nokulunga Primrose Sonti. She found a job and endured a short marriage, the details of which she avoids talking about. Sonti was a fervent ANC supporter, and became steadily more involved in politics. She befriended a female ANC councillor in the local municipality, Paulina Masuhlo.[3] They made an incongruous pair – Masuhlo was a younger, broad-shouldered woman standing well over six feet tall with straightened hair, while Sonti, at fifty-two years old, was considerably shorter and preferred to keep her hair natural. They worked at the Nkaneng informal community centre, a roughly finished corrugated-iron structure with a hard-packed dirt floor, helping people solve problems. The pair was always out campaigning for the ruling party at election time. Sonti herself eventually ran as a coun-cillor and was elected, but began receiving anonymous death threats. She decided not to take up the position, but continued to be politically active at the community centre. During the strike, the centre became increasingly important for the miners and their families.

On 16 August 2012, Sonti watched on the television at her home in Nkaneng as the police rolled out the razor wire to encircle the strikers. She ran outside and began to repeatedly blow on the whistle that hung on a

2 Ibid.
3 Alternately spelt as Musohlo.

string around her neck. Many women came in response to her emergency call, and they decided to march on Lonmin's headquarters to ask why the men were being trapped in this way. As the women prepared to leave, Sonti received a call on her mobile phone from someone telling her that 'the people are dying here in the mountain!' Sonti and the women then changed direction and began walking to the koppie, but before they could reach it, men fleeing in the opposite direction told them not to continue. 'Please, Mama, please, please, please, don't go, it's bad there.' The women were crying and screaming in anguish; it was *their* husbands, lovers, brothers, sons and neighbours who were being killed. The distressed women stood in the street and, as strikers ran past them, they began to pray, tears streaming down their faces. They prayed and prayed.

The next morning, Sonti and Masuhlo led a group of women in an angry protest. Some women carried signs offering a R500 reward for the killing of policemen 'From Musina to Cape Town'. As the ANC continued to exhibit little concern over the killings or the squalid living conditions in Nkaneng in the days and weeks after the massacre, Sonti grew increasingly radicalised, turning against the party she had supported all her life. Masuhlo shared the same anger at the police, but retained her faith in the party. When the ministerial delegation led by Collins Chabane came to Nkaneng two days after the massacre, it was Masuhlo, dressed in a skirt and brocade jacket, who walked them to where a large crowd waited on the outskirts. She was excited to be hosting some of the ANC's most powerful leaders but also nervous about the possible reaction from the alienated community.

On 15 September, a cloudy day almost a month after the government visit, police mounted a large-scale operation into Nkaneng to look for guns and arrest strike leaders. For those not familiar with public order policing actions in South Africa, these are not disciplined, humane affairs. People living in the more impoverished communities know that random shooting and arbitrary arrests usually accompany police raids. Barricades of rocks and burning tyres were erected to obstruct the rugged police Nyalas as helicopters hovered overhead, and the acrid scent of tear gas prevailed as riot policemen fired haphazardly from armoured-vehicle gun ports.

Sonti and Masuhlo were standing with a group of women who had gathered on the bleak patch of clayey earth and wiry grass known as Nkaneng Square. They were to meet with human rights lawyers from Johannesburg in the community centre. The women's attempts to obtain permission for a march were being blocked by the municipality, and the lawyers were to

assist them in overcoming the local government's obduracy. One of the white and blue armoured vehicles raced towards the women, the policemen inside firing their shotguns at them from the portholes set in the windows. Most of the women scattered and began to run, trying to duck into the narrow alleys between the shacks. Sonti and Masuhlo did not. Sonti pulled the hood of her sweater over her head, folded her arms and turned her back to the police, waiting for a projectile to strike her. The sound of gunfire grew closer and closer, rubber bullets rattling off the shack walls. Sonti braced herself, expecting to be hit at any moment. Then the Nyala was gone, as suddenly as it had appeared. Masuhlo called out, 'They shoot me, Primrose!' Sonti turned to her friend and saw the blood running down her leg. Other women had also been shot, and the air was filled with the crying and screaming of hurt women. Two rubber bullets had hit Masuhlo, one grazing her abdomen and the other embedding itself in her knee. Eventually she was taken to Rustenburg hospital, a forty-five-minute drive away.[4] The remaining women gathered in the square, praying fiercely and singing the traditional struggle lament 'Senzeni Na?'

Sonti visited Masuhlo the next day. Her friend was in good cheer, chatting and laughing. The graze across her abdomen was not serious, but the doctors were to remove the bullet embedded in her knee the following day. Sonti did not hear from her on the day of the operation, but Masuhlo called her Monday, begging her to visit as she missed her and was bored. Sonti could not make it, but promised to come as soon as she could. By now the miners had been on strike for six weeks and Sonti was the community representative in the negotiations with Lonmin. Sonti was consumed by the talks as they accelerated to a resolution and believed that Masuhlo was already back home.[5] But even as the deal to end the strike was reached, a woman came to see Sonti with the news that Paulina Masuhlo had never been released from hospital, that her best friend had died there. Sonti began to weep with shock and grief. She was mystified; it had just been a wound to her knee.

In the aftermath, Sonti continued to face police harassment. 'They asked

4 Interview with Primrose Sonti by filmmaker Aliki Saragas, April 2013.
5 Greg Marinovich, 'Marikana aftermath: As the commission plays on, there's still no equality before the law', *Daily Maverick*, 4 March 2013, http://www.dailymaverick.co.za/article/2013-03-04-marikana-aftermath-as-the-commission-plays-on-theres-still-no-equality-before-the-law/#.VeWNKdNViko (last accessed September 2015); *City Press*, 'Newsmaker – Primrose Sonti: A journey to Parliament', 18 May 2014, http://www.news24.com/Archives/City-Press/Newsmaker-Primrose-Sonti-A-journey-to-Parliament-20150429 (last accessed September 2015).

me why we were supporting the strikers. I said, our brothers and husbands are dead, so we are supposed to support them.' The police asked, 'Where is that bladdy shit Julius Malema? How much money did Julius Malema donate to Wonderkop?' and 'What church do you attend? Anglican, ah, that is why you are so ...' And on her answer to where in the Eastern Cape she hailed from, they responded, 'Tsolo, aha, that is why, the killers come from Tsolo.'[6]

Sonti says the police threatened to beat and jail her, but she remained unmoved. 'These police know that they themselves are guilty, but they want to blame the miners and the community for causing the death of these people, that is why they go everywhere, arresting us. But we know it is the police.' She was charged with intimidation in a messy case of 'he said, she said' that was most likely used by the state to coerce Sonti into silence.[7] Sonti's anger at the police and disillusionment with the ruling party grew until she no longer wanted anything to do with the ANC. 'The government doesn't care about us, never, more especially the ANC. I am angry with the ANC,' she said in 2012.[8]

The ANC's expelled *enfant terrible*, Julius Malema, took full advantage of the anger over Marikana to forge a new political career and launch his own party, the Economic Freedom Fighters (EFF). EFF members took to calling one another 'fighter' in contrast to the ANC's more conventional socialist salutation of 'comrade', and the party offered a heady mix of nationalism and anti-establishment one-liners. Soon the characteristic red T-shirts and red berets, initially worn a little like truncated chef's hats, were as common on the streets of Nkaneng as were the green AMCU tops. When the EFF announced it was officially launching, Sonti, watching on television, jumped up and began yelling, 'Happy, happy, happy!' She immediately began organising and recruiting for the EFF. Her efforts were rewarded when she was put on the EFF's list of candidates in the general election of 2014. The fledgling party won 6.35 per cent of the vote, capturing twenty-five seats in Parliament. They won one ward in the Northern Cape and three in and around Marikana. MaPrimrose Sonti was on her

6 A much-maligned district of the Eastern Cape.
7 The charge was provisionally withdrawn in late 2015, after Sonti's lawyers at the Socio-Economic Rights Institute of South Africa (SERI) challenged the constitutionality of the Intimidation Act. A judgment was to be made by November 2015. See http://www.seri-sa.org/images/Sonti_Heads_final.pdf (last accessed October 2015).
8 Author interview, 2012.

way to Parliament in Cape Town. Her relief at leaving her two-room home in the dangerous and filthy shantytown was evident in interviews. In a moving rough cut of the film *Mama Marikana*,[9] Sonti is seen wishing the women of her group strength to continue. The transformation of a woman who never finished school and was almost crushed by poverty and political repression into a member of Parliament is startling. In the film she invites several of her women's group, Sikhala Sonke (We Cry Together), from Marikana to visit her at her official residence in Cape Town. They marvel, slightly enviously, at her modest luxuries of electricity and plumbing. In one scene the women brave the icy shallows of the Atlantic in mid-winter, thrilling at their first experience of the ocean.

9 Working title of a film by Aliki Saragas. See http://www.mamamarikanafilm.com.

24

Consequences

A tree at Scene 2 where a miner hanged himself in despair after losing his job and becoming burdened with debt, Small Koppie, Wonderkop, Marikana, 2013.

*'#SapsCommemoration Zuma: The callous murder of your
loved ones was not only an attack on them but on the state.'*[1]
– Tweet from eNCA reporter @Bongiwe_Khumalo quoting
Jacob Zuma addressing policemen at a ceremony to honour
police killed in the line of duty, 6 September 2015

A decade before Marikana, political scientist Achille Mbembe wrote of 'necropolitics', the 'subjugation of life to the power of death',[2] in part about the use of brutality through exemplars of savagery in postcolonial states to exert psychological control in otherwise neglected populations. In many African states, populations that do not feel the benefit of a strongly centralised government providing transparent economic systems, benign policing and accountable politics need, on occasion, to be reminded of their loyalty to the state through periodic massacres, committed by either agents of the state or tolerated militias. In their turn, the subjugated are willing to risk, even court, death to escape their bondage.

Patrick Walter takes this theme further and applies it to the Marikana massacre.[3] He sees the photographic documentation and widespread distribution of the first part of the Marikana massacre as a reinforcement of the ultimate sovereignty of the distant state over its most marginalised citizens. Indeed, the very images and footage of the deaths and mutilated bodies ensure that those rebellious miners continue to labour for the state and its allies. After death, their bodies are evidence of the state's ultimate authority: to intimidate and horrify those who might wish to challenge the status quo. Walter says:

The question of whether or not it is desirable for the state to want this violence to become visible is crucial. From one perspective, I think

1 Khumalo further tweeted the president as saying, 'We urge you 2 defend yourselves with everything at your disposal to defend yourselves within the confines of the law.'
2 Achille Mbembe, 'Necropolitics', *Public Culture*, 15(1), 2003: 11–40. Available at http://www .dartmouth.edu/~lhc/docs/achillembembe.pdf (last accessed September 2015).
3 Patrick Walter, 'Spectral alphabets: Photography, necropolitics and the Marikana massacre', *Cultural Critique*, due to be published in late 2016 by the University of Minnesota Press.

you are absolutely correct that the spectacular violence on display at Marikana functions as a warning and thus its visibility buttresses state authority. On the other hand, this visibility tends to undermine certain principles of democracy and humanitarianism espoused by state actors. Of course, the modern nation state, particularly the postcolonial state, tends to exist in a kind of perpetual instability, and sometimes this instability serves certain corporate interests. So the visibility of the Marikana Massacre might have been a blemish on the Zuma administration, but it may have served the mining companies' interests just fine. One thing seems certain, though. Global capitalism seems to foster such situations of massacre and radical abandonment of life.[4]

Few outside of academia might consciously grasp quite what Mbembe and Walter see, but most instinctively understand. A group of shack dwellers, the epitome of 'outsiders', named a new shantytown outside of Cape Town 'Marikana' in recognition of what the miners' 'uprising' and deaths meant. Graffiti activists paint stencils that remind citizens that 'We are all Marikana', while others feature an image of Mambush Noki, the Man in the Green Blanket, and exhort us to 'Remember Marikana'. Post-apartheid, it is reasonable to regard Marikana as South Africa's 9/11; it has changed the political landscape irrevocably.[5]

At Marikana, shack dwellers collided head-on with big capital in an alliance with the state and the ruling party syndicate. The police force's role was to reinforce the power disparity.

The aftermath saw the traumatised survivors of the killings brutalised and criminalised. The charges they faced included murder, under the doctrine of common purpose. The origins of this law lie in England in 1846, when a man was struck and killed by one of two horse carts racing each other. It was never proved which cart struck the pedestrian, but since both riders were egging each other on, they were held jointly responsible. In the South African context, this inherited colonial law was used against 'the mob' in protests that took the lives of black apartheid officials, seen as stooges.[6] In those cases, the convicted people were among the crowd that

4 Personal email communication to the author.
5 Jean Comaroff, in conversation with the author, 2015.
6 Most infamously in the case of the Upington 26, for the 1985 killing of a municipal policeman, and the Sharpeville Six, for the 1984 incident in which the deputy mayor was killed. See Pierre de Vos, 'Marikana: No common purpose to commit suicide', *Constitutionally Speaking*, 30 August 2012, http://constitutionallyspeaking.co.za/marikana-no-common -purpose-to-commit-suicide/ (last accessed September 2015).

took part in the killings, bringing some rationale to the charges, but at Marikana the approximately 270 men were charged for the murder of their own comrades at the hands of the police. National Prosecuting Authority (NPA) spokesman Frank Lesenyego incorrectly explained the legal reasoning: 'when people attack or confront and a shooting takes place which results in fatalities ... suspects arrested, irrespective of whether they shot police members or the police shot them, are charged with murder'.[7]

Many of those charged with murder had also been severely wounded by the police. Thus the victims of police shootings were transformed, through the abuse of the prosecuting authority and the nation's laws, into those responsible. It was a legal charade so Kafkaesque as to be laughable, but it served the purpose of forever criminalising those who dared stand up against the dual institutions of the state and big business. The law was a weapon against the poor.

Just as Julius Malema recognised the massacre as a watershed political moment, as well as his political lifeboat, so did Advocate Dali Mpofu understand the importance of the event. The controversial lawyer and political activist swiftly offered his services to the jailed survivors of the massacre. He joined the EFF soon after its launch, shedding thirty years of loyalty to the ANC, and would use both the Marikana Commission of Inquiry as well as his role in the EFF to discomfort his old party. Mpofu had first made news as Winnie Mandela's lover after her angry and hurt love letters to him were made public when Nelson Mandela announced he was divorcing her in 1992. A complex character, Mpofu does not appear to have been unduly damaged by this indiscretion, and he moved through a series of high-paying positions, reaching his zenith as head of the South African state broadcaster in 2005. He was forced out of this highly political job by ANC factional battles, his departure sweetened with a multimillion-rand golden handshake. He reinvigorated his legal career by representing ANC discontents, and indeed appeared for Malema at his disciplinary hearing and appeals prior to Malema's expulsion in 2012. As one of the most spirited of the many lawyers representing the various interested parties at the Marikana Commission of Inquiry, Mpofu used sensational rhetoric that ensured he grabbed the most headlines and enlivened public interest. His guerrilla tactics and politicisation of the massacre annoyed Ian Farlam, the genteel retired judge who presided over the inquiry, and earned tight-lipped disapproval from lawyers representing opposing parties at the commission,

7 De Vos, 'Marikana: No common purpose to commit suicide'.

but he was extremely effective at raising the political issues that pervaded the hearings. Oddly, he was less effective at getting the story of the miners told. Two of the three witnesses he chose from among his 270 clients did not make a positive impression. Shadrack Mtshamba was his best witness, even though Mtshamba persisted in his belief that police armoured vehicles drove over prone miners. The credibility of twenty-four-year-old underground locomotive driver Mzoxolo Magidiwana, who was shot several times at Scene 1, was damaged by his insistence that he was shot several more times by policemen standing above him *after* the initial shooting. Dozens of journalists would have witnessed this if it were indeed true. The strikers' number-two leader, Xolani Nzuza, was an especially problematic witness, clearly obfuscating many key facts. That said, Mpofu was the most tenacious in insisting the killings be called a massacre as opposed to 'a tragic incident', as the police and even Farlam preferred.

The flakiness of Mpofu's witnesses was nothing compared to the testimony of the vast majority of police officers and commissioners called to testify. National police commissioner Riah Phiyega's seemingly never-ending time as a witness was a masterclass in evading the truth as she sought to defend police actions as unavoidable and reactive, while also ensuring that the dirt of Marikana did not stain her political superiors. The commission's decision not to start off with the testimonies of individual police shooters was, in retrospect, a mistake. It allowed the police to set an agenda that took years to undo. The carefully, if clumsily, composed police narrative of 'facts' to fit the fictitious narrative of police innocence had to be painstakingly discredited before the real evidence could be uncovered. The commander on the ground, Brigadier Calitz, gave a thoroughly unreliable version of events, as did generals Mbombo, Mpembe, Naidoo and Annandale.

For those unused to the formalistic ways of the courts and the dry though heavy-handed humour with which judges and counsel alleviate the tedium of legal protocol, not to mention the interminable tea breaks, the wheels of justice must have seemed to have ground to a halt for extensive periods.

Throughout the commission, the state repeatedly showed its bias against the miners, most clearly when Mpofu had to go to court to force the Legal Aid board to meet his team's legal fees, even though his clients could clearly not afford lawyers for the two-and-a-half years that the commission ran.

There were fourteen different parties represented by their attendant

teams of lawyers at the commission: Lonmin; the police; the minister of police; the minister of mineral resources; Lieutenant Baloyi and Warrant Officer Sello Lepaaku; the family of Warrant Officer Tsietsi Monene; the families of Frans Mabelane, Thapelo Mabebe and Julius Langa; the arrested miners; the families of the dead miners; NUM; AMCU; the Legal Resources Centre (led by George Bizos and representing the Bench Marks Foundation and one family); the Bapo ba Mogale community; and the South African Human Rights Commission. Perhaps the most effective was the team from Wits University's Centre for Applied Legal Studies (CALS)[8] representing the Human Rights Commission and the 'evidence leaders' – the commission's own legal team.

As resourceful, smart and principled as many of the lawyers representing these various parties were, others seemed to be intent on confounding justice. Despite the best efforts of the few, the technical processes of the law were clearly afforded much more regard than justice, natural or otherwise. The commission was consistent in ensuring that family members of the deceased could attend and also be heard, but throughout the process the surviving miners were convinced that they would not have a fair hearing. This was a conviction inflamed by the police continuing to harry, arrest and torture strike leaders and community members throughout the commission. When the commission's recommendations were finally released in June 2015, most were disappointed. There were individual policemen that Farlam recommended be investigated for murder and attempted murder, but this simply handed off the responsibility to other agencies to reinvestigate and perhaps finally come to a decision about charging those who needed to be charged. At least in the case of Major General Ganasen Naidoo, the commission unequivocally found he 'participated in a chaotic free-for-all which cost sixteen people their lives, without exercising any command and control and without taking any steps to stop the shooting and isolate the problems'. In particular, Farlam agreed with the evidence leaders that 'firing from the K9 members under the command of Major General Naidoo and the NIU members from the east is most likely to have caused the death of those strikers killed in the area among the crevices and rocks'. Naidoo was also shown to be a liar.

Despite it being clear that there were concerted and consistent efforts

8 Kathleen Hardy, Toby Fisher and Advocate Michelle le Roux were the most noteworthy of the CALS team. The evidence leaders were spearheaded by the silks, Advocate Geoff Budlender and Advocate Matthew Chaskalson.

by the upper levels of police management to obliterate any footprints that might lead from the massacre back to the ministers or the president, Farlam's report weakly recommended that national commissioner Phiyega as well as provincial commissioner Mbombo merely be investigated on their fitness to hold office, as opposed to stating that they were clearly unfit. Zuma finally established a board to inquire into Phiyega's fitness on 22 September 2015, at least five months after he received the report, and by October she was suspended with full pay.[9] It would be laughable were the matter less serious. Farlam's findings did, however, excoriate Lonmin for their absolute failure to deliver on the social plan as they were required to in order to retain their mining licence – only a quarter of the lower-paid workers (grades 4–9) lived in decent housing. Three-quarters of the 23 000 workers still live in shacks or the equivalent.

It is clear that Lonmin's executives had no interest in finding common ground with their workers, whom they knew were underpaid. Management's only interests were company profits and the shareholders' financial well-being, and so they exposed many workers to danger during the strike, some fatally: 'Lonmin's reckless actions in urging employees to come to work in circumstances where they were aware of the potential dangers to them and in the full knowledge that they could not protect them, calls to be condemned in the strongest terms. Lonmin must, in the Commission's view, bear a measure of responsibility for the injuries and deaths of its employees and those of its sub-contractors.' Lonmin also endangered its security officers, resulting in the deaths of two of them, and, perhaps most tellingly, Lonmin did not use its 'best endeavours' to resolve the labour dispute. That Barnard Mokwena was allegedly a covert agent for the state while at Lonmin prompts further thought about his motivations at the time.

The commission also condemned some of the strikers for their readiness to resort to violence to enforce the strike, which resulted in the deaths of three men simply trying to report for work, as well as two security guards and two policemen.[10] A minority of the strikers were prepared to kill anyone whom they believed stood between them and a better wage. Depressingly,

9 Masego Rahlaga, 'Zuma launches inquiry into Phiyega's fitness for office', *EWN*, 22 September 2015, http://ewn.co.za/2015/09/22/Zuma-launches-inquiry-into-Phiyegas-fitness-to-hold -office (last accessed September 2015).

10 The other three of the ten killed leading up to the massacre were strikers shot by police on 13 August.

the Marikana strike was neither the first nor the last South African labour dispute to be stained with blood.

In the time that passed between the massacre and the end of the commission almost three years later, Cyril Ramaphosa put his billionaire businessman persona on ice to step back into full-time public politics. He was number two on Zuma's ANC election ticket that won easily against the inhibited and rather fatalistic campaign of Kgalema Motlanthe. It seemed an unlikely pairing between Zuma and Ramaphosa, but politics makes for strange bedfellows. In due course, as deputy president of the ruling party, Ramaphosa was inaugurated as deputy president of the country. This did not stop Mpofu calling for Ramaphosa to be charged with murder, corruption and perjury during the commission. This sentiment was not reflected in Farlam's report.

However bad the miners' working and living conditions, the sorry truth is that there is an oversupply of unskilled and semi-literate people prepared to face insurmountable odds to try to get jobs or create informal work for themselves. The desperation of those living the reality of South Africa's rural poverty pushes them to accept any kind of work. In this environment, sweating and risking death or disability thousands of metres underground is a desirable option compared to hawking sweets or offering your labour at a busy intersection from day to day. Yet once the thrill of getting a job wears off, the men begin to feel keenly the disappointment that even a proper job, with benefits, is insufficient to meet their unassuming needs. Even as the miners are dragged deeper and deeper into debt to meet their dependants' expectations, the sad fact is that those miners are among the top 10 per cent of earners in South Africa, where at least 30 per cent of adults have no job.[11]

Despair and depression drove the strike; the strikers' anger was stoked by their proximity to wealth. Yet throughout the strike and the massacre's aftermath, those who should speak for the voiceless – the media – were conspicuously silent. Rights activist and Rhodes University academic Jane Duncan's study on the media coverage before and after the massacre found that just 3 per cent of stories or broadcasts used miners as a primary source.[12]

11 For the 2012 tax year, 4.8 million taxpayers submitted a tax return, out of a population of 55 million. See Paul Joubert, 'How many taxpayers are there really?' *Moneyweb*, 24 February 2013, http://www.moneyweb.co.za/archive/less-taxpayers-than-sars-reports-solidarity/ (last accessed September 2015).

12 Jane Duncan, 'South African journalism and the Marikana massacre: A case study of an editorial failure', *Political Economy of Communication*, 1(2), 2013, http://polecom.org/index.php/polecom/article/view/22/198 (last accessed September 2015).

The miners were invisible, their humanity denied time and again, even as they were at the centre of international attention.

Not quite as desperate as the migrant denizens of the shantytown are the original people who settled the area hundreds of years before, the Bapo ba Mogale. Lonmin mined on the community land and paid the small Tswana-speaking group royalties, and also offered preferred jobs to some Bapo. The Bapo were initially offered a royalty deal back in 1969, but in 2014 Lonmin converted those royalty payments to cash and a 3.6 per cent equity share in Lonmin plc.[13] Like many of the deals made, this one was complicated and shrouded in secrecy, and thus open to controversy. The internal machinations of the Bapo royal family, as well as other community power factions, further exacerbated the difficulties of knowing whether the community was truly behind the deal or not. In 2015, members of the Bapo took Lonmin to court in an attempt to ensure that the full details of the deal were made public.[14] Lonmin gave up the equity as part of ensuring that they met the government rule that all mining companies have 26 per cent black ownership by 2014. In the preceding decades, the money owed to the Bapo was paid into a trust fund controlled by the province, which has shown no accounting for the money therein. Prior to 2014, R300 million of the R370 million paid into the trust fund went missing, with no one held responsible. It is little wonder that the Bapo are so suspicious of how their tribal royalties, and now equity, are managed. This has encouraged the rise of various splinter groups within the Bapo, all claiming they are the only ones acting for the good of the community. Lonmin and the North West province, as well as the Department of Mineral Resources, have all been equally opaque, diminishing faith in the process. Lonmin's financial woes deepened towards the end of 2015, with yet another share-price dilution on the cards and an estimated 6 000 miners expected to be retrenched.

The koppie, Thaba, has become a site of pilgrimage: white crosses have been erected there to memorialise the thirty-four working-class martyrs, even though none of the miners died at Thaba itself. Every year, thousands gather to commemorate the massacre, and the families of the dead miners

13 Then worth about R423 million; see Jana Marais, 'Lonmin in murky BEE plan', *TimesLive*, 27 July 2014, http://www.timeslive.co.za/local/2014/07/27/lonmin-in-murky-bee-plan (last accessed September 2015).

14 Setumo Stone, 'Lonmin to face Bapo ba Mogale in court', *BDLive*, 12 June 2015, http://www.bdlive.co.za/business/mining/2015/06/12/lonmin-to-face-bapo-ba-mogale-in-court (last accessed September 2015).

have called on the government to erect a monument, with Lonmin said to contribute,[15] though both the government and Lonmin have been conspicuously absent from the annual events.

In light of the trauma suffered by the survivors of 16 August, it comes as little surprise that some of them gave up the daily battle. One winch operator, Marvellous Zulu, who had been shot in the leg by police on the 16th and witnessed his comrades being killed, hanged himself in his shack several months later. Another, mired in debt, chose to hang himself from a tree at Small Koppie, Scene 2. To do this, he used the strong nylon straps that Lonmin utilises to close the massive bags of platinum-ore waste. Keeping things neat. The shantytowns around Marikana are rife with rumours of other despairing suicides of Lonmin miners.

Commissions of inquiry are regarded by the more cynical as a government device to draw the political energy out of problematic situations. This was certainly true of Jacob Zuma's desire for Marikana to recede from the forefront of the news ahead of the ANC's electoral conference in December 2012. The commission was initially set to run for four months, but in the end it sat for almost three years, during which time Marikana did not cease to deliver one mortification after the next for the police force, the state and Lonmin. Yet they appeared to ignore it all. The moral and political deafness of both the ANC and government to the outrage of the massacre revealed the extent to which the ruling party had drifted from common citizens. The ANC's slavish desire to protect and enable Zuma's network of patronage and nepotism had overtaken every aspect of government. One of the world's most respected liberation movements had debased itself to serve one man and his clique, and to entrench the exploitation of black South Africans in the service of international capital.

For Shadrack Mtshamba, the strike began a series of changes in his life. He was diagnosed with skin cancer during the course of the commission, and he separated from his wife, committing to his relationship with his Marikana girlfriend. The extra money from the strike settlement enabled him to move from his corrugated-iron room with no water or electricity to a nicer rented room, one that is built of cement breeze blocks and has a window and electricity. There is a water point just a few metres from

15 Gia Nicolaides, 'Marikana families call for monument for fallen miners', *EWN*, 17 August 2014, http://ewn.co.za/2014/08/17/Marikana-Families-Call-for-monument-for-fallen-miners (last accessed September 2015).

his door and the pit latrine is new and clean. He now has a fridge and a television, though the television has been bought on lay-by, yet another form of high-interest rent.

After the strike, a bar renamed itself the Survivors Pub and a fast-food outlet offers 'extreme deals on delicious meals' including the Strike Meal, a serving of three mini Russian sausages and chips for R39.

The residents of Nkaneng continue to use Small Koppie as a toilet, defecating on places where men's corpses once lay. Every spring, shortly after the anniversary of the massacre is commemorated, the wild pear trees blossom, bringing beauty to a place forever haunted by murder.

Acknowledgements

This book belongs to the miners and drillers who helped me understand their world, as well as the residents of Marikana, Nkaneng and Wonderkop who let me commit journalism during the most trying of times. Not all of these people wish to be mentioned by name, but my special thanks to the redoubtable Chris Molebatsi of the Bench Marks Foundation, Primrose Sonti, Jackson Mjiki, Bhele Dlunga, the Ntsenyeho family, Mandisa Yuma and Sobopha, Thembele Sohadi, 'Anele', 'Themba', 'Xolani' and especially Shadrack Mtshamba. Thapelo Lekgowa was the most enjoyable of travelling companions, as well as translator and guide through a tangle of truth, lies and omissions.

Without everyone at the *Daily Maverick*, especially its courageous editor and publisher Branko Brkic, the truth of what happened at Small Koppie most likely would have taken years longer to emerge. I thank my colleagues who worked with me in many and various ways: Styli Charalambous, Ranjeni Munusamy, Brooks Spector, Greg Nicolson, Sipho Hlongwane, Khadija Patel, Mandy de Vaal, De Wet Potgieter and Erin McLuckie. Thanks also to George Mazarakis and the *Carte Blanche* team.

There are some people whose incredible work uncovered the truth of what happened at Marikana. Their desire for justice allowed us to know what happened. These include Bonita Meyersfeld, Kathleen Hardy, Michelle le Roux and Toby Fisher, all from the Centre for Applied Legal Studies; on behalf of the commission, the evidence leaders and counsel Matthew Chaskalson and Geoff Budlender; and the fantastic George Bizos, Dumisa Ntsebeza, Dali Mpofu, Mary Rayner, Cees de Rover, Cobus Steyl, Dr Reggie Perumal and Professor Steve Naidoo.

Various people who have illuminated my path and offered support through these years include Songezo Zibi, Peter Alexander, Botsang Mmope, Bongani Xezwi, Archie Palane, John Brand, Jane Duncan, Vusi Sampela, Jean and John Comaroff, Sue Cook, Gavin Hartford, Alex Lichtenstein,

the Capello family, Patrick Walter, Dinky Mkhize, Rehad Desai, Poloko Tau, Kwanele Sosibo, Felix Dlangamandla, Siphiwe Sibeko, Inigo Gilmore, Dick Forslund, Leon Sadiki, Kevin Sutherland, Chevan Rayson, Shadley Lombard, Ben Fogel, David Bruce, Jared Sacks, Aliki Saragas, and Matthew and Raphael Chaskalson. Others prefer to remain anonymous for political or career reasons. A heartfelt thanks to all of you for your help, guidance and support.

Invaluable financial assistance was given by the Taco Kuiper Foundation, administered by Wits Journalism. Here, thanks to Margaret Renn and Anton Harber. I am grateful to Graham Philpott (and Richard Pithouse) of the Church Land Programme for their unsolicited grant at a time when it was really needed.

I am indebted to the cartographic skills of Ines Boussebaa and Mary Eden Schlichte, my students at Boston University.

Special thanks to my friend and literary agent Jonathan Diamond, and at Penguin Random House South Africa Robert Plummer and the eagle-eyed Bronwen Maynier. If I have inadvertently not included anyone, my sincere apologies.

The writing of this book would have been a dull affair without my glorious wife and muse, Leonie, the first and most incisive of readers and who constantly encouraged me to write better. I am grateful. She was also the one who urged me to head out to Marikana in the days before the massacre, displaying a nose for news she otherwise disclaims. Thank you, Madeline, for advising me to tell the Marikana story just like the bedtime tales I make up for you; Luc, I am ever motivated by your instinctive sense of justice and for helping me not get bogged down in distractions.

GREG MARINOVICH
DECEMBER 2015

Glossary

amaBerete: 'men in berets'; members of the SAPS Tactical Response Team, recognised by their distinctive dark-blue berets

amadoda: isiZulu or isiXhosa for 'men' or 'fathers'; 'the elders'

amaJohnny: isiXhosa and Mfengu word for British soldiers during the 1877–8 frontier war. The name derives from the generic term the British redcoats used for all indigenous men – Johnny. The Xhosa called the British soldiers 'Johnny' in return, and even in the late-twentieth century there was a tendency to turn the de-individualisation of apartheid and the labour laws back on whites by referring to white men as John or Johnny

amaZioni: isiZulu word for 'Zionists'; members of any of hundreds of African churches that meld Christian with traditional beliefs

AMCU: Association of Mineworkers and Construction Union

ANC: African National Congress

apartheid: system of white supremacy disguised as benign racial segregation

APC: armoured personnel carrier

baasskap: control by the white boss

baba: father/sir

bantustan: imaginary Bantu state within South Africa; akin to the homelands, which are often referred to as bantustans

BEE: black economic empowerment

bladdy: bloody

bosberaad: a meeting of leaders at a rural location, often used in the context of a company get-together; Afrikaans, literally 'bush consultation'

braaivleis: barbecue

Bushveld: hot and dry regions of the north and east of the country

CALS: Centre for Applied Legal Studies

Casspir: armoured, mine-proof vehicle designed for use by the South African military and the South West African police unit Koevoet during the bush war of the seventies and eighties. The vehicle is now widely sold to police forces and armies around the world

chisaboy: Fanagalo for 'assistant miner'; literally 'fire or hot boy'

clevas: educated Africans, perceived by some rural folk as out of touch with

their roots

COSATU: Congress of South African Trade Unions

EFF: Economic Freedom Fighters

eGoli: Nguni term for Johannesburg, 'the place of gold', but occasionally used more broadly to refer to the mining regions and industrialised interior of South Africa

Fanagalo: isiZulu-based pidgin with some vocabulary from English and Afrikaans, spoken mainly among miners in South Africa; meaning 'do it like this'

homelands: ten former quasi-independent or autonomous regions based on ethnic groups under apartheid's social engineering plan

impimpi: spy

intelezi: magic potion used for protection, sometimes in sport, but most famously for battle; prepared by a sangoma or nyanga

IPID: Independent Police Investigative Directorate

Izikhothane: from the isiZulu word meaning 'bush', it is now township slang referring to impoverished gangs of youth who live extravagant lifestyles

'kasie style: fashion trends specific to black townships or locations; from the Afrikaans word *lokasie*

knobkierrie: short, heavy wooden club with a knob on one end, used for striking and throwing

kraal: cattle enclosure

kragdadigheid: apartheid-era South African policy of using brute force to quell political opposition; Afrikaans, meaning 'forcefulness'

LRC: Legal Resources Centre

makhukhu: shack

malaisha: Fanagalo for 'the person who wields the shovel'; lowest-grade worker in the underground social hierarchy

Mamba: modern, small armoured personnel carrier

mashonisa: moneylenders, mostly informal lenders charging high interest rates; isiZulu, meaning 'the people that take you down (or sink you)'

massacre: 'the act or an instance of killing a large number of human beings indiscriminately and cruelly' (http://www.thefreedictionary.com/massacre); 'the act or an instance of killing a number of usually helpless or unresisting human beings under circumstances of atrocity or cruelty' (http://www .merriam-webster.com/dictionary/massacre)

miner: mineworker who has a blasting certificate; it does not mean a mineworker in general. A job previously forbidden to black Africans, it involves inspecting the rock faces, marking the places where holes must be drilled for explosives, and igniting the explosives

Motswana: member of the language group known as the Tswana

muti/umuthi: isiXhosa/isiZulu word referring to a wide range of herbal

medicines or magic potions, usually prepared by traditional healers

NEC: National Executive Committee of the ANC

Nguni: language group including isiZulu, isiXhosa, isiNdebele and siSwati

NIU: National Intervention Unit

NMF: National Management Forum (of the police's upper management)

NPA: National Prosecuting Authority

NUM: National Union of Mineworkers

Nyala: squared-off armoured vehicle used for policing; from the Tsonga and Venda word for a small antelope that lives in wooded thickets

nyanga/inyanga: Xhosa/Zulu traditional healer or diviner, especially one who uses herbs

nyatsi: girlfriend or lover; Sesotho

Operational Response Services: police division dealing with 'tactical' matters

panga: broad-bladed machete used for cutting thick bush and sugar cane

pap: mealie pap, the staple starch of southern Africa; Afrikaans, meaning 'corn porridge'

POP: public order police

RDO: rock drill operator, also known as drill operator or driller. RDOs are often disparagingly referred to as machine boys, no matter their age

RDP: Reconstruction and Development Programme, a sort of post-apartheid South African Marshall Plan which was superseded by the more neoliberal Growth, Employment and Redistribution (GEAR) plan. One of the most noticeable manifestations of the RDP was the little sub-economic houses that sprang up in vast tracts across the country, still known as RDP houses

SACP: South African Communist Party

sangoma: diviner or healer, insultingly referred to as a witchdoctor

SAPS: South African Police Service

Senzeni Na?: traditional struggle lament, meaning 'What have we done?'

shebeen: unlicensed establishment selling alcohol, often a place of ill repute; from the Irish word *sibin*, or 'mugful'

shisanyama: meat grilled on an open fire; isiZulu/isiXhosa, literally 'burnt meat'

Sikhathele: isiXhosa for 'We are tired'

skaf'tin: Fanagalo for 'lunchbox'

STF: Special Task Force

Thaba: koppie/Wonderkop

Thaba Nyana: Small Koppie

TRT: Tactical Response Team

Index

Photographs are indicated by **bold** page numbers.